The Fundamentals of
DRAWING
LANDSCAPES

The Fundamentals of
DRAWING
LANDSCAPES

A PRACTICAL AND INSPIRATIONAL COURSE

BARRINGTON BARBER

ARCTURUS

Arcturus Publishing Ltd
26/27 Bickels Yard
151–153 Bermondsey Street
London SE1 3HA

Published in association with
foulsham
W. Foulsham & Co. Ltd,
The Publishing House, Bennetts Close, Cippenham,
Slough, Berkshire SL1 5AP, England

ISBN 0-572-03015-0

British Library Cataloguing-in-Publication Data: a catalogue record for this
book is available from the British Library

Printed in China

Contents

Introduction

LANDSCAPE – WHAT DO WE MEAN BY THIS WORD?
It has been in use for a few hundred years, and is understood to mean the picture of a large area of land viewed from a specific place. This fairly generalized description is further adjusted or defined by such terms as 'urban' or 'rural', 'industrial' or 'pastoral', or even 'idyllic' or 'fantastic', giving a more conceptual approach to the fact of some depiction of a particular landform by an artist, photographer or film-maker for our interest.

Most people tend to think of the landscape as the particular countryside with which they are most familiar. Given that most people inhabit towns and cities, rarely is this familiar scene somewhere we live. The word 'landscape', therefore, has idyllic connotations. Ask most people and they will describe an atypical place where people, industry and the practical realities of life in the 21st century are not in evidence. For the purposes of this book, we shall be taking a rather broader definition and thus examining a great variety of views of the landscape, including where we actually live and not just those areas of 'unspoilt' countryside that are usually considered to be the only places worth recording. We shall look at many places that are not easy to get near, even without a sketchbook, as well as imaginative versions of landforms that have never actually existed. Landscape art is usually thought of, wrongly, as being a topographically accurate portrayal of an area of land. This is a very limiting way of viewing the genre. Most landscape artists manipulate what they see in front of them, especially in its details, to produce a picture that fits their vision. So be prepared for some surprises, especially

if you have not yet practised this form of picture making to any great extent.

In the historic tradition of picture making, landscape was the third in importance after what were termed history painting and portrait painting. Landscape was not really considered as a separate art form until the 17th century, when it took off in no uncertain way, its great popularity lasting through to the 19th century. By attempting landscapes you will be following a long tradition of famous artists who produced some of the most powerful and beautiful works of art ever seen. Many of these artists found their inspiration in the patterns of daily life going on around them. You can do the same by looking for subjects in your neighbourhood – it really is not necessary to travel widely to find scenes worthy of your attention. Observe the day to day background of your life and you will find plenty to take your interest and invigorate your imagination.

As with the other titles in this series, we start by looking at basic approaches and explaining the first steps you will need to be mindful of as you embark on this area of drawing. No matter where you are in terms of your artistic development, I hope you find all aspects of this book useful and thought provoking.

Barrington Barber

Wimbledon, September 2003

Starting Points

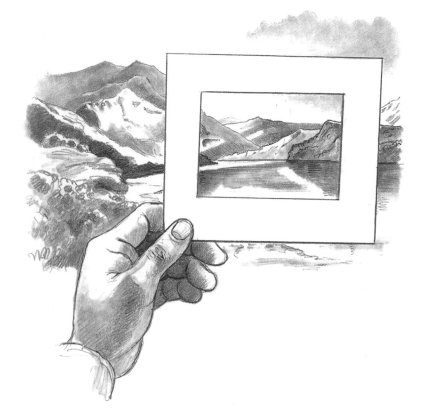

*T*HE HISTORY OF LANDSCAPE painting in Western art is relatively long; it began with the Greeks and Romans, who produced landscapes as murals. After the fall of Rome the idea of painting a landscape seemed to disappear and when it was taken up again, in the 15th century, it was literally kept in the background as an accompaniment to religious scenes or figure compositions. Not until the time of Peter Paul Rubens and the flourishing Flemish and Dutch schools did it became possible to produce paintings

with no intention other than to show the landscape. From that time onwards landscape painting has become a recognized medium to work in.

Landscape is what we see all around us, wherever we are. It can be a view of an open area of countryside or town. As soon as you sample the view outside a building there is some element of landscape available. What you see will be made up of a variety of things but essentially it will be sky; vegetation; man-made edifices; open space; and, possibly, water. People, animals or vehicles may be there as incidentals, but not as focal points.

When tackling a landscape the artist's first task is to select a view, to decide on how much of that view to show, and from which angle. Complementary with this selection process is analysis of the proportion and organization of the shapes evident within your landscape and how these may be clarified or emphasized. In the next few pages that make up this introductory section you will find examples of selection and analysis which we hope you will use as building blocks and take with you into the sections that follow.

Producing landscapes, in any medium, is an excellent pursuit. Apart from getting you out into the world and helping you to appreciate its beauties and structure, it calms the mind and soothes the emotions. As you draw and observe, observe and draw, a certain detached acceptance of what is there in front of you takes over. It is also fascinating to discover ways of translating impressions of an outside scene into a two-dimensional set of marks on the paper. Whether or not you share some of the experience of your observation with others, it is a truly beneficial activity.

THE WORLD AROUND US

To begin to draw landscapes, you need a view. Look out of your windows. Whether you live in the countryside or in the town, you will find plenty to interest you. Next go into your garden and look around you. Finally step beyond your personal territory, perhaps into your street. Once we appreciate that almost any view can make an attractive landscape, we look at what lies before us with fresh eyes.

The three views shown here are of the area around my home.

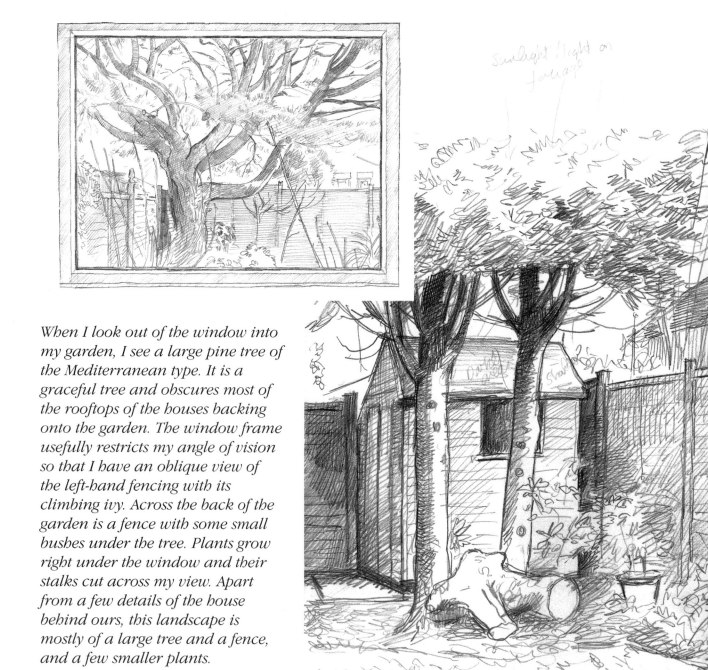

When I look out of the window into my garden, I see a large pine tree of the Mediterranean type. It is a graceful tree and obscures most of the rooftops of the houses backing onto the garden. The window frame usefully restricts my angle of vision so that I have an oblique view of the left-hand fencing with its climbing ivy. Across the back of the garden is a fence with some small bushes under the tree. Plants grow right under the window and their stalks cut across my view. Apart from a few details of the house behind ours, this landscape is mostly of a large tree and a fence, and a few smaller plants.

In this outside view of the garden we are looking away from the pine. Behind the fence can be seen the roof of a neighbour's house and some trees growing up in the next door garden. In the corner of my own garden there is a small shed with two small fir trees growing in front of it with a large log at their foot. The flowerbed to the right is full of plants, including a large potted shrub, with ivy growing over the fence. Closer in is the edge of the decking with flowerpots and a bundle of cane supports leaning against the fence. A small corner of the lawn is also visible. The main features in this view are a fence, two trees and a garden hut.

The third drawing is of the view from my front gate. Because all the houses in my road have front gardens and there is a substantial area of trees, shrubs and grass before you reach the road proper, the scene looks more like country than suburb. We see overhanging trees on one side and walls, fences and small trees and shrubs on the other, creating the effect of a tunnel of vegetation. The general effect of the dwindling perspective of the path and bushes either side of the road gives depth to the drawing. The sun has come out, throwing sharp shadows across the path interspersed with bright sunlit splashes. The overall effect is of a deep perspective landscape in a limited terrain.

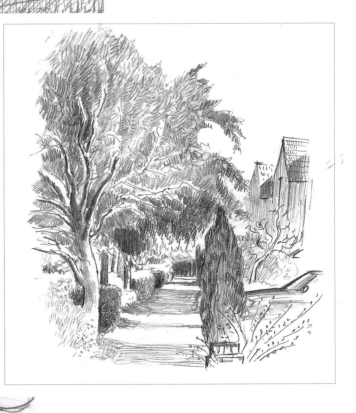

FRAMING A VIEW

One way to get a better idea of what you are going to draw when you attempt a landscape is to use a frame. The first drawing on page 10 was isolated in this way by the ready-made frame of the window. Most artists use a frame at some time as a means of limiting the borders of their vision and helping them to decide upon a view, especially with large landscapes.

In the first example below a very attractive Lakeland view has been reduced to a simple scene by isolating one part of it. With landscape drawing it is important to start with a view you feel you can manage. As you become more confident you can include more. You will notice how the main shapes are made more obvious by the framing method.

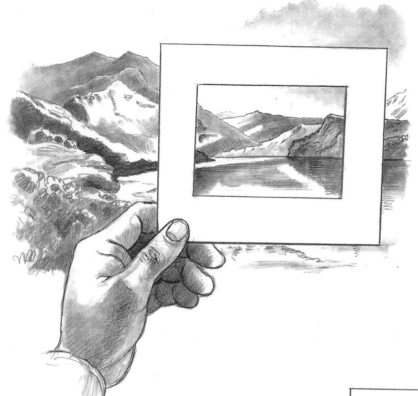

By cutting out a rectangle of card not much larger than 2 inches by 1–1½ inches and holding it up against your chosen landscape you can begin to control exactly what you are going to draw. Move it closer to your eyes and you see more, move it further away and you see less of a panorama. In this way you can isolate the areas that you think will make a good composition and gradually refine your choice of image.

This rather more sophisticated frame, consisting of two right-angled pieces of card, enables you to vary the proportion of your aperture and allows greater scope for variation.

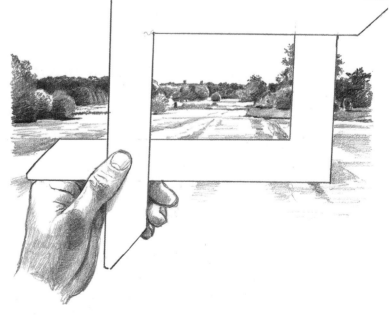

CHOOSING A SIZE

At some point you will have to decide how large your picture is going to be. In the beginning you may only have a small pad at your disposal, and this will dictate your decision. Starting small and gradually increasing the size of your picture is advisable for the inexperienced, but you will quickly get beyond this stage and want to be more adventurous.

Ideally you should have a range of sketchbooks to choose from: small (A5), medium (A4) and large (A3). If this seems excessive, choose one between A5 and A4 and also invest in a larger A3. A5 is a very convenient size for carrying around but isn't adequate if you want to produce detailed drawings, so a hybrid between it and A4 is a good compromise. The cover of your sketchbook should be sufficiently stiff to allow it to be held in one hand without bending while you draw.

The grade of paper you use is also important. Try a 160g cartridge, which is pleasant to draw on and not too smooth.

When it comes to tools, soft pencils give the best and quickest result. Don't use a grade harder than B; 2B, 4B and 6B offer a good combination of qualities and should meet most of your requirements. See Materials and their Uses for additional information (pages 64–83).

It is not too difficult to draw a landscape on an A5 pad, but it does limit the detail you can show.

When you are more confident, try a larger landscape on an A2 size sheet of paper. This can be placed on a board mounted on an easel or just leant against a convenient surface.

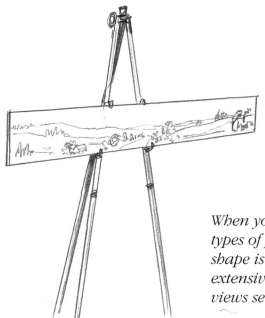

When you are really confident it is time to look at different types of proportion and size. One very interesting landscape shape is the panorama, where there is not much height but an extensive breadth of view. This format is very good for distant views seen from a high vantage point.

VIEWPOINTS

Finding a landscape to draw can be very time consuming. Some days I have spent more time searching than drawing. Never regard search time as wasted. If you always just draw the first scene you come to, and can't be bothered to look around that next corner to satisfy yourself there is nothing better, you will miss some stunning opportunities. Reconnaissance is always worthwhile.

Let's look at some different kinds of viewpoint and the opportunities they offer the artist.

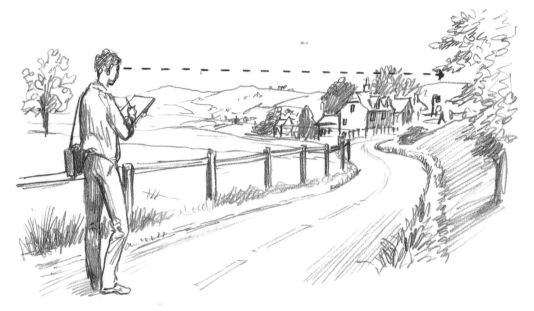

A view along a diminishing perspective, such as a road, river, hedge or avenue, or even along a ditch, almost always allows an effective result. The change of size gives depth and makes such landscapes very attractive. Well-drawn examples of this type suggest that we, the onlookers, can somehow walk into them.

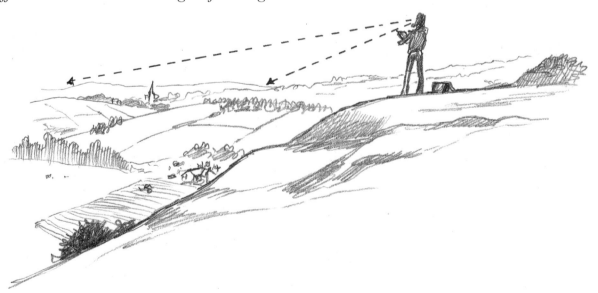

A landscape seen from a high point is usually eye-catching, although not always easy to draw. Look for a high point that offers views across a valley to other high points in the distance. From such a perspective the landscape is somehow revealed to the viewer. If you try this approach, you will have to carefully judge the sizes of buildings, trees and hillsides to ensure the effect of distance is recognized in your picture.

EDITING YOUR VIEWPOINT

A good artist has to know what to leave out of his picture. You don't have to rigorously draw everything that is in the scene in front of you. It is up to you to decide what you want to draw. Sometimes you will want to include everything, but often some part of your chosen view will jar with the picture you are trying to create. Typical examples are objects that obscure a spacious view or look too temporary, or ugly, for the sort of timeless landscape you wish to draw. If you cannot shift your viewpoint to eliminate the offending object, just leave it out. The next two drawings show a scene before and after 'editing'.

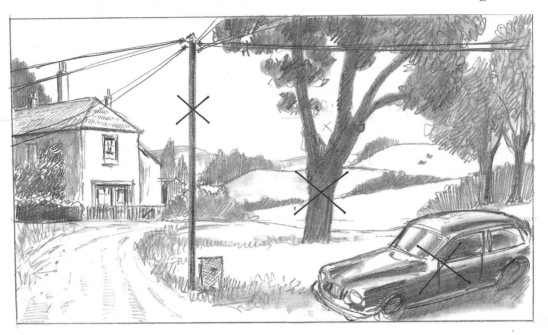

In this view a telegraph pole and its criss-crossing wires, a large tree and a car parked by the road are complicating what is an attractive landscape.

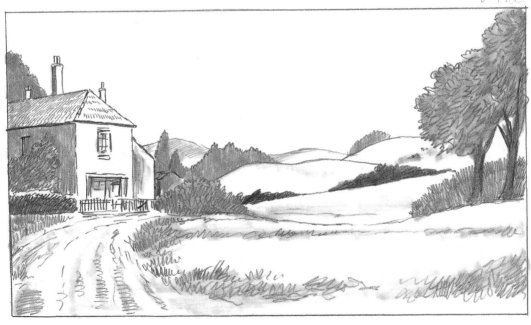

Eliminate those offending objects and you are left with a good sweep of landscape held nicely between the country cottage and unmade road, and the coppice of trees over to the right.

15

THE ARTIST'S EYE

We can learn a great deal from the compositions of professional photographers and painters and how they 'see' landscape. Here are examples of different kinds of landscapes; two of the drawings are taken from photographs and the other two from paintings.

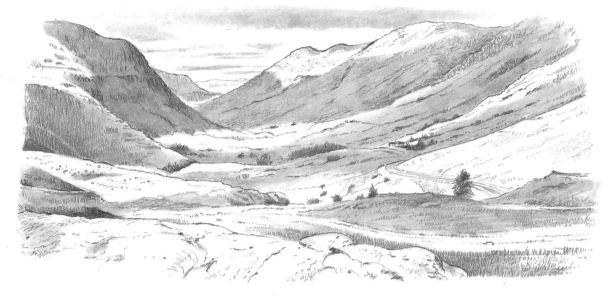

This marvellous open sweep of mountainous landscape shows the valley of Glencoe in the Scottish Highlands. The original photograph catches the effect of sunlight and cloud shadows flitting across the land. The drawing reflects this by showing one side of the valley much more clearly. The side with the sharper perspective has one large bluff or spur in the shadow of the cloud, which helps to create depth and drama. A sense of scale is given by the road seen winding across the width of the valley and the minute cottage in the distance.

The second photograph-based scene is quite different, with a very localized view. Here we are close to trees and bushes viewed across an expanse of long grass and cow parsley. There is no distance to speak of and the interest lies in the rather cosy effect of a flattened path through the long grass, turning off suddenly with the luxuriant vegetation of summer hemming in the view. The effect is of a very English shire-like landscape; pleasant but without drama.

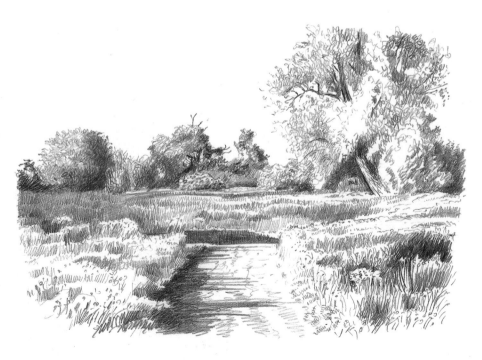

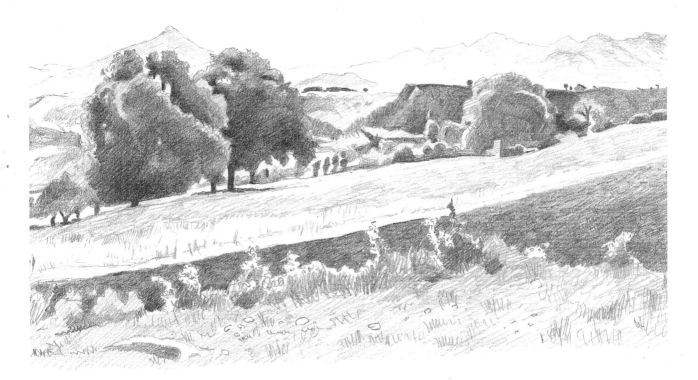

A beautiful sweep of landscape (after Corot) set in the Haute Savoie. The scope of the viewpoint is broad and shows mountain ranges in the distance. Closer up we see slopes and large trees in full foliage with in the foreground, a large empty slope of grass, scrub and ploughed land. The broad movement from the high left towards the lower right side of the picture is balanced by the large group of trees at left of centre.

A view of Venice (after Monet) which combines compactness with a great effect of depth, thanks to the masterly handling of foreground details and distant buildings. Close up we see water and mooring poles rising out of the ripples to the left. Across the centre and right background, looking through mist, are the domes of Venetian churches caught in the light of the setting sun.

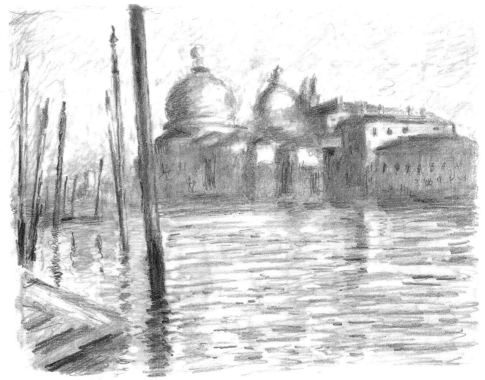

TYPES OF LANDSCAPE

Put very simply, there are four possible types of landscape to be considered in terms of the size and shape of the picture you are going to tackle. Your landscape could be large and open, small and compact, tall and narrow or very wide with not much height.

SMALL AND COMPACT

The emphasis here is on the close-up details and textures in the foreground, with a good structural element in the middleground and a well defined but simplified background. The direction of the light helps the composition, showing up the three-dimensional effects of the row of small cottages with the empty road between them and the solid looking hedges and walls in the foreground. Look at the way the pencil marks indicate the different textures and materiality of these various features.

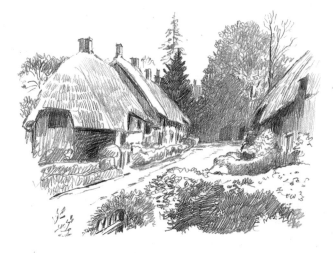

OPEN AND SPREADING

The most impressive aspect of this example is the sculptural, highly structured view of the landscape. This has been achieved by keeping the drawing very simple. Note that the textures are fairly homogenous and lacking in individual detail. The result is a landscape drawing that satisfies our need for a feeling of size and scope.

TALL

Because most landscapes are horizontally extended, generally speaking, the vertical format is not appropriate. However, where you are presented with more height than horizontal extension the vertical format may come into its own, as here. The features are shown in layers: a road winding up a hill where a few cypresses stand along the edge of the slope, sharply defined; behind it another hill slanting off in the opposite direction; and above that the sky with sun showing through mist.

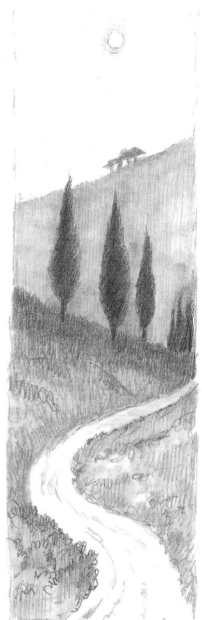

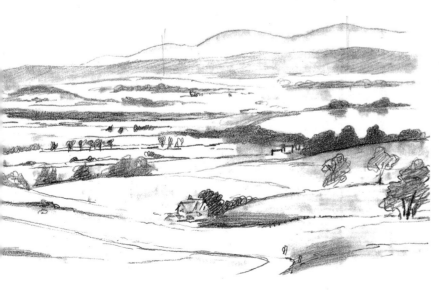

PANORAMIC

The basis of landscape is the view you get when you rotate your head around 90 degrees and cover a very wide angle of vision. However, this type is not easy to draw because you have to keep changing your point of view and adjusting your drawing as you go. Remember: the vertical measurement of a panoramic drawing is always much less than the horizontal measurement.

VIEWING THE GROUND

All landscapes have, at most, three layers of depth or vertical development: background, middleground, and foreground.

How well you manipulate the space occupied by these areas is very important – see pages 122–153 for more on this.

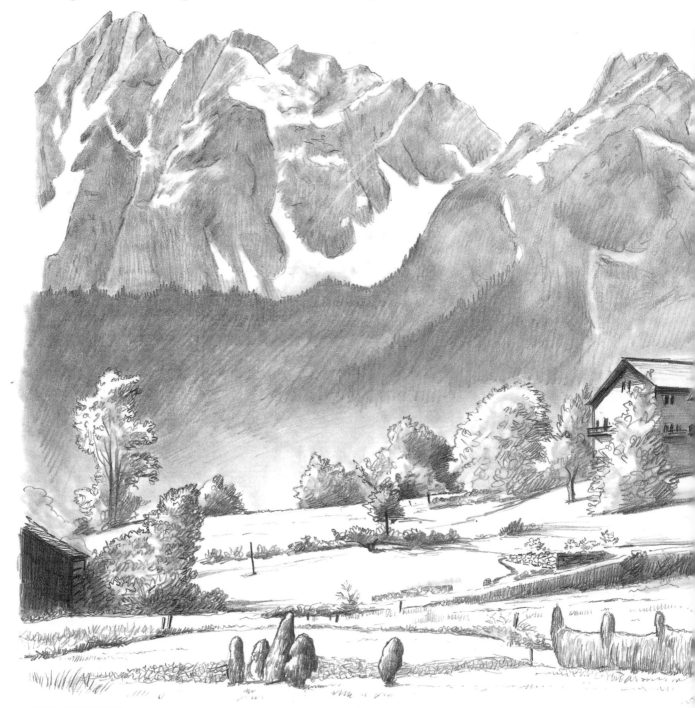

FOREGROUND

The foreground is important to the overall effect of a composition, its details serving to lead the eye into a picture, and also to the observation of the more substantial statement made by features in the middleground.

Intentionally there is usually not much to hold the attention. The few features are often drawn precisely with attention given to the textures but not so much as to allow them to dominate the picture.

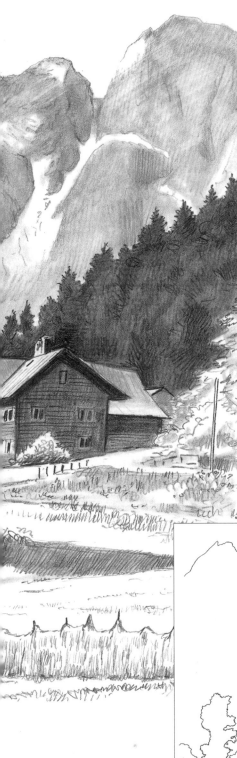

BACKGROUND
The background is the most distant part and is usually less defined, less textured and softer in effect.

MIDDLEGROUND
The middleground forms the main part of most landscapes, and gives them their particular identity. The structure of this layer is important because the larger shapes produce most of the interest. However, any details can vary in clarity.

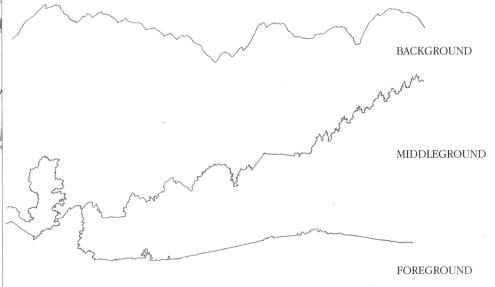

BACKGROUND

MIDDLEGROUND

FOREGROUND

SKIES AND HILLS

Any landscape will be made up of one or more of the features shown on the following pages. These are sky, hills, water, rocks, vegetation, such as grass and trees, beach and buildings.

Obviously each grouping offers enormous scope for variation. For the moment I want you to look at each set of comparative examples and note how the features are used.

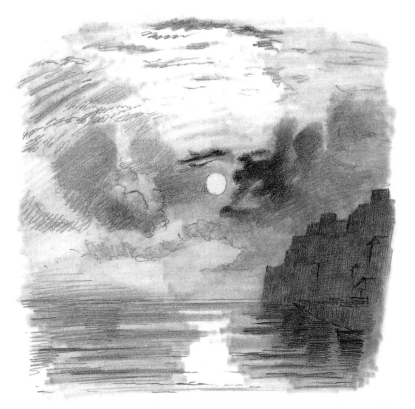

A very simple landscape/ seascape is brought to dramatic life by the contrast of dark and light tones. The moon shines through clouds that show up as dark smudges around the source of light. The lower part of the picture features calm water reflecting the light, and the dark silhouette of a rocky shore.

A halcyon sky takes up almost three-quarters of this scene and dominates the composition, from the small cumulus clouds with shadows on their bases to the sunlight flooding the flat, open landscape beneath.

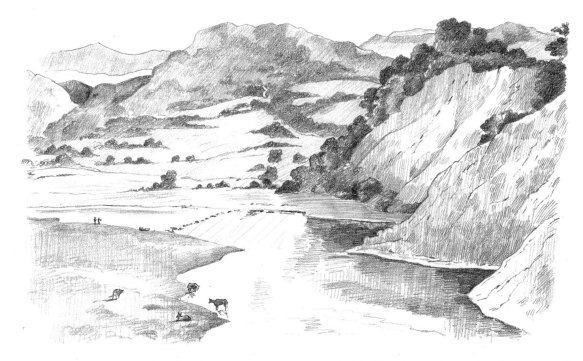

In this example the high viewpoint allows us to look across a wide river valley to rows of hills receding into the depth of the picture. The tiny figures of people and cattle standing along the banks of the river give scale to the wooded hills. Notice how the drawing of the closer hills is more detailed, more textured. Their treatment contrasts with that used for the hills further away, which seem to recede into the distance as a result.

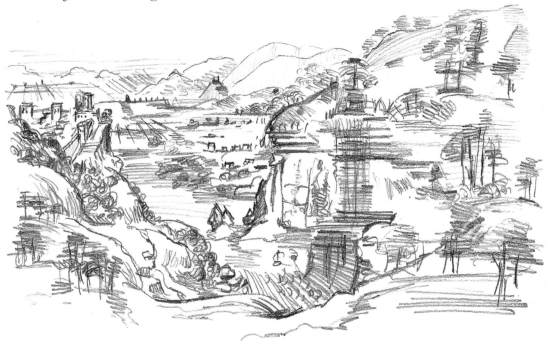

The myriad layers of features make this type of landscape very attractive to artists. This example is after Leonardo. Notice the way details are placed close to the viewer and how the distance is gradually opened up as the valleys recede into the picture. Buildings appear to diminish as they are seen beyond the hills and the distant mountains appear in serried ranks behind.

WATER AND ROCKS

The reflective qualities of water make it a very useful addition to a landscape. It can also introduce movement to contrast with stiller elements on view. Below we look at three of the possibilities given by the addition of water. On the opposite page we consider the raw power that the inclusion of rocks can bring to a picture.

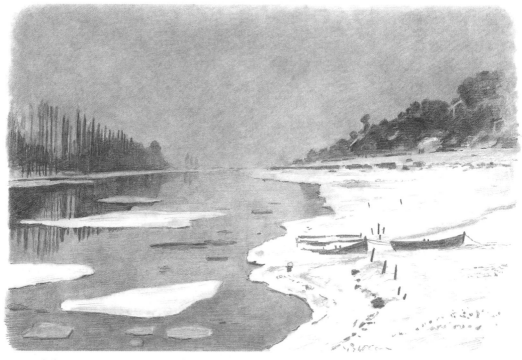

The impact of this wintry scene (after Monet), is made by the contrasts in darks and lights. These are noticeable between the principal features and especially within the river. Contrast the dark of the trees on either bank of the river with the white of the snow-covered banks; the inky blackness where the tall poplars on the far bank reflect in the water; the grey of the wintry sky reflecting in other areas of the river; and the brilliance of the white ice floes. On the bank a few smudgy marks help to define the substance of the snowy landscape.

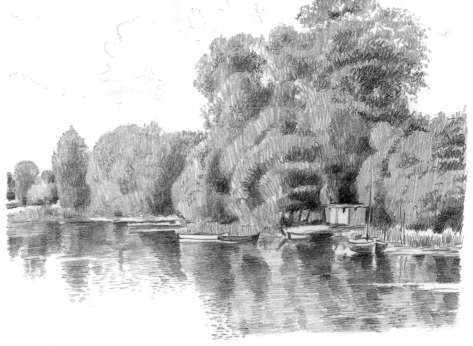

The River Oise in summer (after Perrier) looks more inviting than Monet's depiction of the Seine. The leafy trees are presented as a solid mass, bulking up above the ripples of the river, where the shadowed areas of the trees are strongly reflected. The many horizontal strokes used to draw these reflections help to define the rippling surface of the calmly flowing river.

The turbulence of the water and its interaction with the static rocks is the point of this small-scale study. Note how the contrast between the dark and light parts of the water intensifies nearer to the shore. As the water recedes towards the horizon the shapes of the waves are less obvious and the tonal contrast between the dark and light areas lessens.

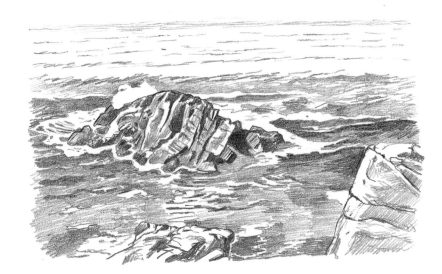

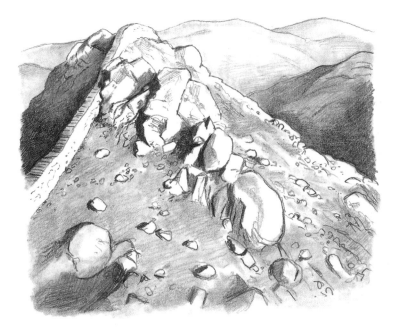

This close up of a rocky promontory shows starkly against a background of mountaintops drawn quite simply across the horizon. The rock wall effectively shadows the left-hand side of the hill, creating a strong definite shape. In the middleground large boulders appear embedded in the slope. Smaller rocks are strewn all around. Note how the shapes of the rocks and the outline of the hill are defined by intelligent use of tone.

The main feature in this landscape is the stretch of rocky shoreline, its contrasting shapes pounded smooth by heavy seas. Pools of water reflect the sky, giving lighter tonal areas to contrast with the darker shapes of the rock. This sort of view provides a good example of an important first principle when drawing landscapes: include more detail close to the viewer, less detail further away.

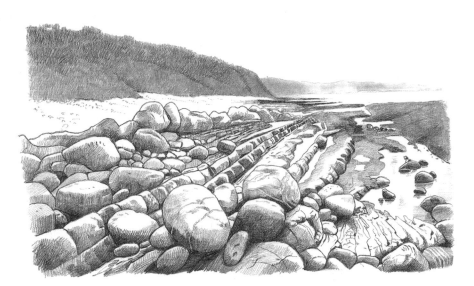

GRASS AND TREES

Grass and trees are two of the most fundamental elements in landscape. As with the other subjects, there are many variations in type and in how they might be used as features.

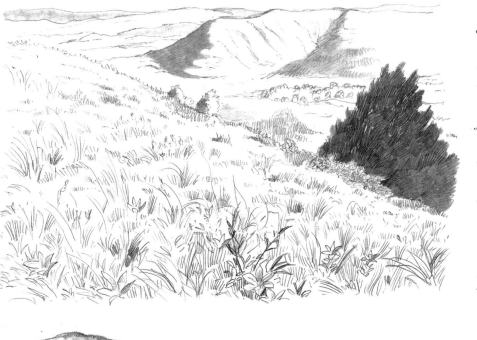

Tufts and hummocks of grass mingle with flowers in this close-up of a hillside. The foreground detail helps to add interest to the otherwise fairly uniform texture. The smoothness of the distant hills suggests that they too are grassy. The dark area of trees just beyond the edge of the nearest hill contrasts nicely with the fairly empty background.

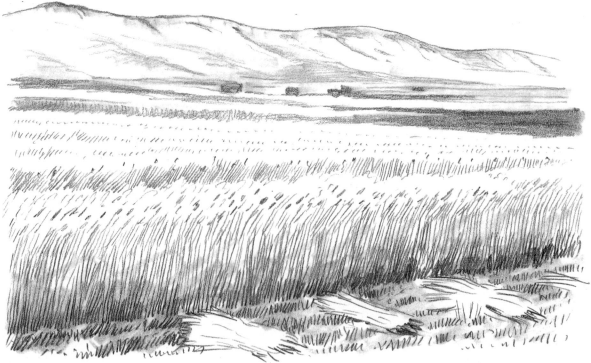

Cultivated crops produce a much smoother top surface as they recede into the distance than do wild grasses. The most important task for an artist drawing this kind of scene is to define the height of the crop – here it is wheat – by showing the point where the ears of corn weigh down the tall stalks. The texture can be simplified and generalized after a couple of rows.

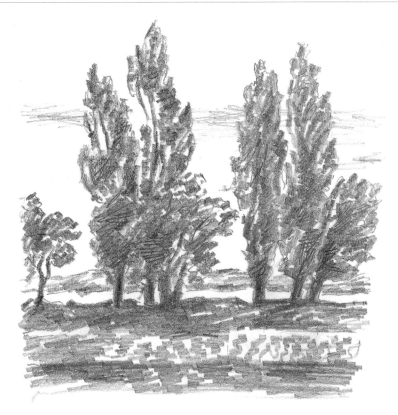

When you tackle trees, don't try to draw every leaf. Use broad pencil strokes to define areas of leaf rather than individual sprigs. Concentrate on getting the main shape of the tree correct and the way the leaves clump together in dark masses. In this copy of a Constable the trees are standing almost in silhouette against a bright sky with dark shadowy ground beneath them.

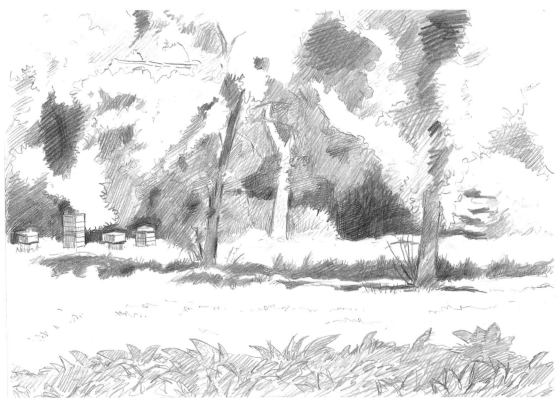

The trees in this old orchard were heavy with foliage when I drew them, on a brilliant, sunny day. Nowhere here is there a suggestion of individual leaves, just broad soft shapes suggesting the bulk of the trees. They presented themselves as textured patches of dark and light with a few branches and their trunks outlined against this slightly fuzzy backdrop. An area of shadow under the nearest trees helps define their position on the ground. At left some old beehives show up against the shadow. In the immediate foreground the texture of leafy plants in the grass helps to give a sense of space in front of the trees.

27

BEACHES

Beaches and coastline are a rather specialized example of landscape because of the sense of space that you find when the sea takes up half of your picture.

Our first view is of Chesil Bank in Dorset, which is seen from a low cliff-top looking across the bay. Our second is of a beach seen from a higher viewpoint, from one end, and receding in perspective until a small headland of cliffs just across the background.

This view looks very simple. A great bank of sand and pebbles sweeping around and across the near foreground with a lagoon in front and right in the foreground, and hilly pastureland behind the beach at left. Across the horizon are the cliffs of the far side of the bay and beyond them the open sea. Notice the smooth tones sweeping horizontally across the picture to help show the calm sea and the worn-down headland, and the contrast of dark tones bordered with light areas where the edge of sand or shingle shows white.

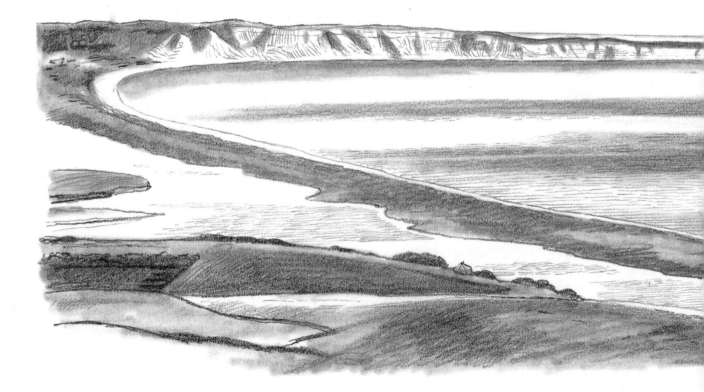

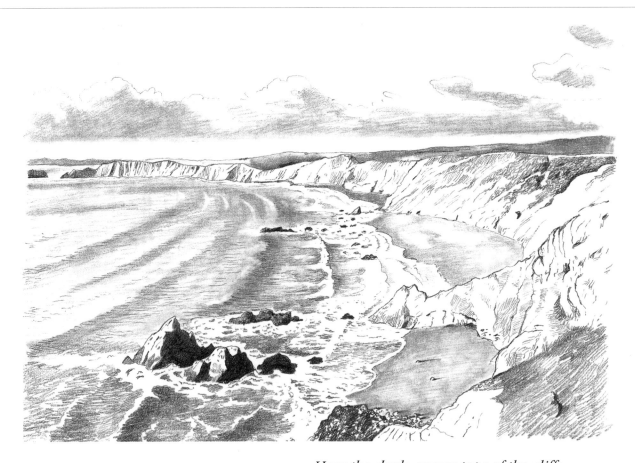

Here the dark, grassy tops of the cliffs contrast with the lighter rocky texture of the sides as they sweep down to the beach. The beach itself is a tone darker than the cliff but without the texture. The hardest part of this type of landscape is where the waves break on the shore. You must leave enough white space to indicate surf, but at the same time intersperse this with enough contrasting areas of dark tone to show the waves. The tone of the rocks in the surf can be drawn very dark to stand out and make the surf look whiter. The nearest cliff-face should have more texture and be more clearly drawn than the further cliff-face.

BUILDINGS

Unless you are drawing in the wilderness, buildings will often feature in your landscapes and may offer interest because of their arbitrary appearance against the sky and/or vegetation. Where they form the main subject of a landscape, they will tend to dominate and appear as a mass of verticals and horizontals against geometric hard shapes.

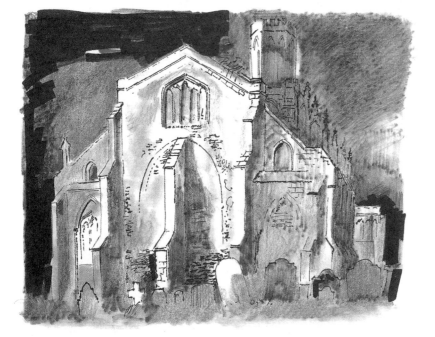

In this copy of John Piper's view of Fotheringay Church at night the building is etched sharply against a very dark sky, with the architectural outlines of the main shapes put in very strongly. The texture of the crumbling surface of the old church is well judged, as is the decorative effect provided by the mouldings around the doors and windows. The depth and contrast in the shadows ensures that the effect of bright moonlight comes across well.

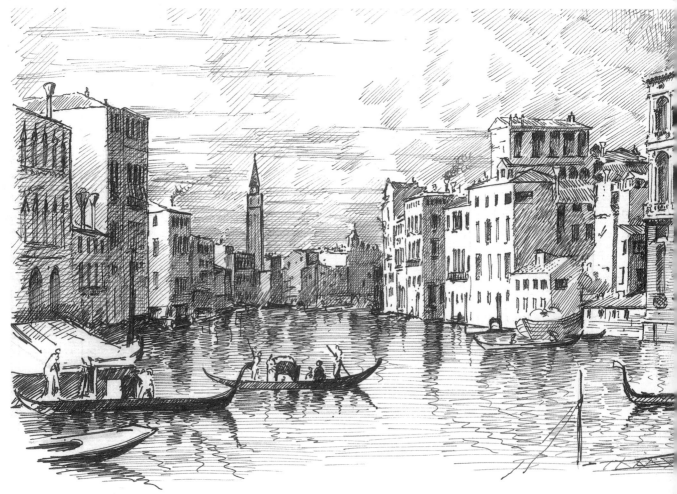

In this copy of a Pissarro study of a street in Rouen the emphasis is on the vertical character of the Gothic church and old houses. Only the narrow space of the street is allowed to project into these verticals, which are also etched sharply against the sky. Notice how the contrasting textures created by the house fronts pull the vertical shapes closer together as they recede down the street.

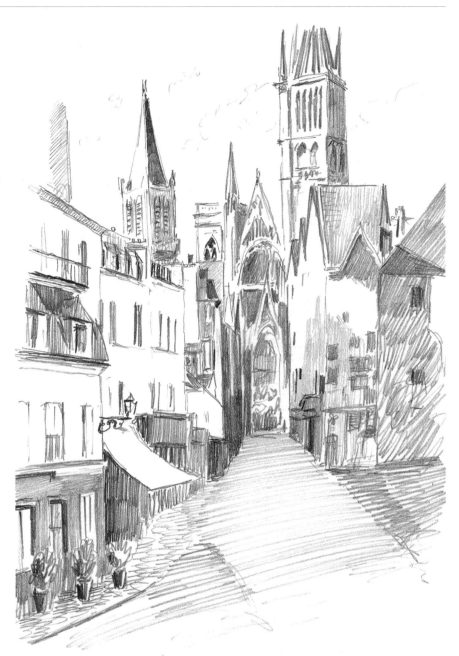

It is easy to become confused with the details of texture in a scene such as this – of the Grand Canal in Venice (after Canaletto). It exemplifies one of landscape's golden rules: always put the main shapes of buildings in first. The repetition of architectural details must be kept as uniform as possible, otherwise the buildings will look as though they are collapsing. Never try to draw every detail: pick out only the most definite and most characteristic, such as the arches of the nearer windows and doors, and the shapes of the gondolas in the foreground. The reflections of the buildings in the water are suggested, with the darkest shadows depicted by horizontal lines under the buildings. Multiple cross-hatching has been put in to denote the darker side of the canal. On the lit side, white space has been left and the sky above lightly shaded to enhance the definition and provide greater contrast.

Structure and Anatomy of Landscape

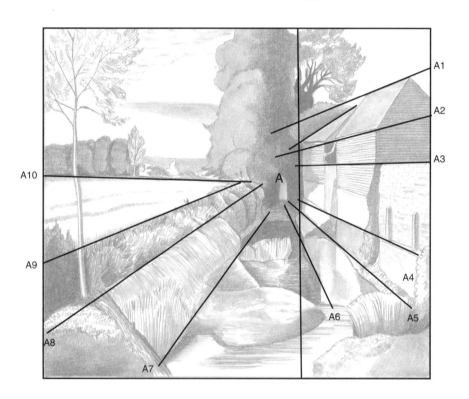

THE STRUCTURE OF LANDSCAPE is the way we see the basic shapes of the various features found in the landscape in relation to the underlying shape of the earth supporting them. If we use the analogy of the human form and its anatomy we can envisage the rock formation as the basic skeleton and then everything laying over this or growing out of it as the flesh and organs.

In terms of drawing, the main consideration for the artist

is how to use the information taken in by the eye and organize it in such ways that it makes sense to the observer. One of the artist's principal aids in this regard is perspective. Another is the ability to simplify the layers of the landforms into a series of geometric shapes such as triangles, rectangles, circles, ellipses and angles. This helps us to construct the shape of the landscape in a drawing so that it captures the effect of the shape received by the eye.

Never forget that the world is three dimensional and that your eyes see it as such. When we commit a view of the world onto a flat surface such as paper, we have to employ techniques to give the illusion of depth, distance and spaciousness. In this section of the book you will learn about these techniques. You will see how a few simple construction lines can give an impression of depth and space, and how constructing a sort of scaffolding of geometric shapes can help you to organize what you see into a flat picture.

The multiplicity of shapes that appear before the eye in any landscape can be daunting, especially for the beginner. However, don't panic! What you can see you can also analyze. By taking the main forms and ignoring the details to start with, you will be able to tackle the problem. Most drawing problems can be solved through the use of quite straightforward measures. You need to know how to control and manipulate these multiple shapes in order for your drawing to be satisfying to look at. Set about the process as outlined in this section. Study it carefully, taking it one step at a time, and don't hurry. Absorb its lessons and you should find your task simpler.

UNDERSTANDING PERSPECTIVE

The science of perspective is something with which you will have to become acquainted in order to produce convincing depth of field. This is especially important if you want to draw urban landscapes. The following diagrams are designed to help you understand how perspective works and so enable you to incorporate its basic principles in your work.

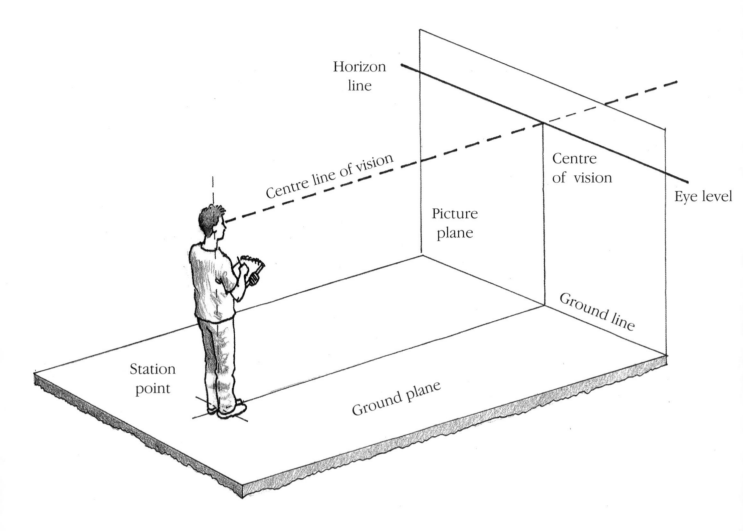

Like any science, perspective comes with its own language and terms. This diagram offers a visual explanation of the basic terms as well as giving you an idea of the depth of space. The centre line of vision is the direction you are looking in. The horizon line or your eye level produces the effect of the distant horizon of the land or sea. The picture plane is effectively the area of your vision where the landscape is seen. The other terms are self-explanatory.

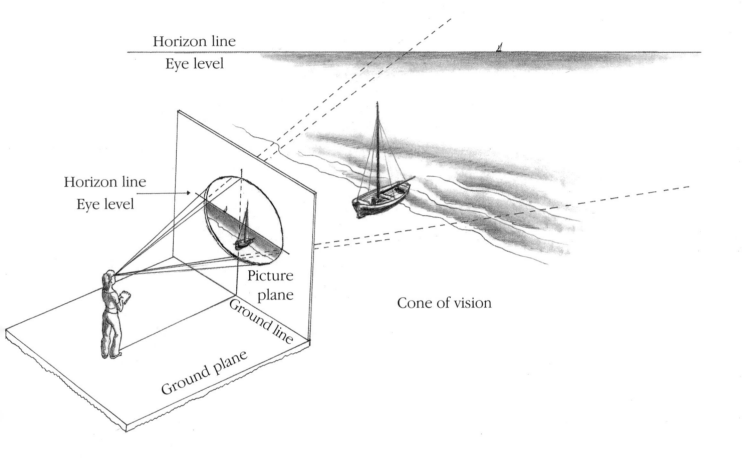

Horizon line
Eye level

Horizon line
Eye level

Picture plane

Ground line

Ground plane

Cone of vision

The cone of vision is a sort of mental construct of how much you can draw without the effects of distortion appearing in your picture. In practice it is what you can take in of a scene without turning your head; it extends to about 60 degrees across. The cone of vision in our illustration encompasses the whole view right to the distant horizon. When you look through the lens of a camera, you may have noticed that the shapes of the objects on the periphery of your vision appear to be slightly different than when you look directly at them. Here, the impression of the scene through the cone of vision is that the nearer areas are much larger than the distant areas, whereas in reality the reverse is true. The cone of vision is of necessity a narrow view of a scene.

TYPES OF PERSPECTIVE

The eye being a sphere it comprehends the lines of the horizon and all verticals as curves. You have to allow for this when you draw by not making your perspective too wide, otherwise a certain amount of distortion occurs.

Below we look at three types of perspective, starting with the simplest.

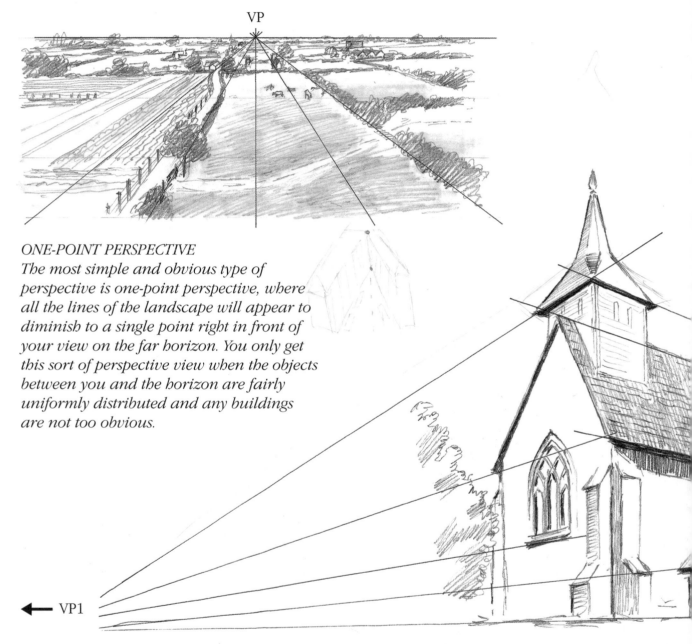

VP

VP1

ONE-POINT PERSPECTIVE

The most simple and obvious type of perspective is one-point perspective, where all the lines of the landscape will appear to diminish to a single point right in front of your view on the far horizon. You only get this sort of perspective view when the objects between you and the horizon are fairly uniformly distributed and any buildings are not too obvious.

TWO-POINT PERSPECTIVE

Where there is sufficient height and solidity in near objects (such as houses) to need two vanishing points at the far ends of the horizon line, two-point perspective comes into play. Using two-point perspective you can calculate the three dimensional effect of structures to give your picture convincing solidity and

depth. Mostly the vanishing points will be too far out on your horizon line to enable you to plot the converging lines precisely with a ruler. However, if you practise drawing blocks of buildings using two vanishing points you will soon be able to estimate the converging lines correctly.

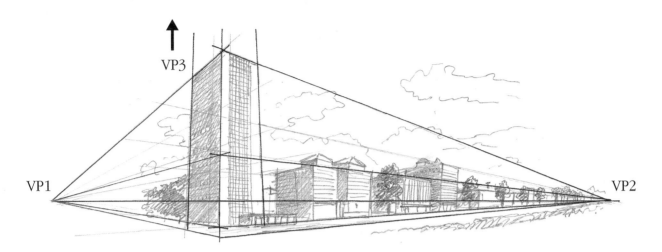

THREE-POINT PERSPECTIVE

When you come to draw buildings that have both extensive width and height, you have to employ three-point perspective. The two vanishing points on the horizon are joined by a third which is fixed above the higher buildings to help create the illusion of very tall architecture. Notice in our example how the lines from the base of the building gently converge to a point high in the sky. Once again, you have to gauge the rate of the convergence. Often, artists exaggerate the rate of convergence in order to make the height of the building appear even more dramatic. When this is overdone you can end up with a drawing that looks like something out of a comic book.

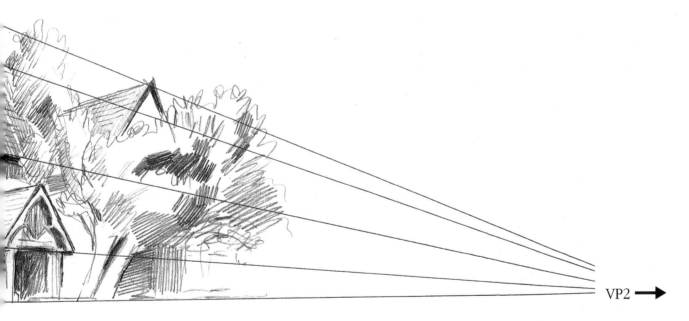

USING PERSPECTIVE

After you have absorbed the terminology and theory of perspective, it is time to look at how this knowledge is used by artists to give an impression of depth when they are confronted by a real landscape. In the following examples, we identify the various features and objects that have been used to give space and depth to the picture plane.

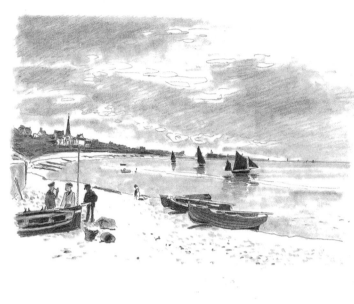

Size and light give clues to the depth of this picture, of the Bay of St Ardresse (after Monet). In the foreground, human figures and small fishing boats give us the proportion of the close-up foreground. Across the expanse of water are dotted sailing vessels, which diminish in scale as they recede from our point on the beach. Note the curve of the beach moving away to the left and then curving around to the right, behind the fishing vessels in the middle ground. The buildings on the shoreline diminish as they recede into the distance around the curve of the bay. On the far horizon we see very small marks denoting vessels and buildings. The lines of clouds in the sky also help to support the illusion of depth. Lastly, note how silhouette has been used, especially in the fishing boats, to proclaim their closeness to us in relation to the far distant shore.

In this second scene (also after Monet), of the River Thames near Westminster, there are various clues to distance including, most tellingly, clever use of layers of tone. The contrast between the differently sized objects tells us clearly that the jetty is closer to us than Big Ben and that the steam tug is closer to us than the bridge. However, most persuasive is the change in tonal values of the buildings and objects as they recede into the background, aided by the misty quality of the atmosphere. In the near foreground the jetty is strongly marked in dark tone, contrasting with the embankment wall and the dark and light surface of the water. Behind this is the rather softer tone for the bulk of the tower of Big Ben and the small tugboat on the bright water. Beyond, other buildings are faintly outlined against a pale sky.

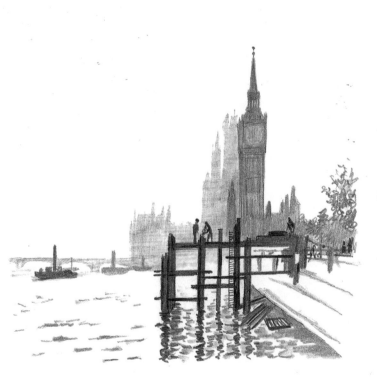

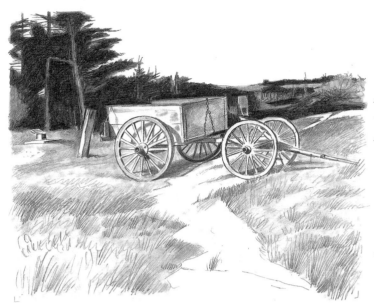

Objects are often used to achieve perspective, as we have already seen. In this drawing (after a picture by Andrew Wyeth) an old dump cart acts as a reference point between the viewer and the background. The device of taking something that can be related to the size of the human form quickly gives us information about the distance in front of the cart and the distance behind it.

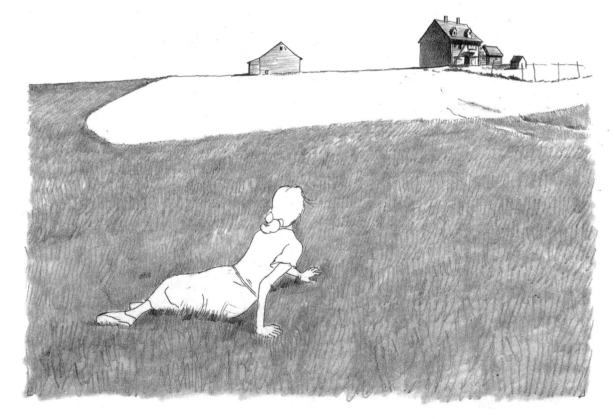

The same device is taken a stage further in a copy of one of Wyeth's most famous pictures, 'Christina's World'. The key is the figure of the woman in the foreground and the barn and houses set up on the skyline in the background. The device creates a space between the viewer and the horizon. We can tell from the proportion between the woman's figure and the house, which she can obviously go into, that the house is at least 100 metres from our position. The texture of the grass reinforces this information. The curve of the edge of the uncut hay gives our eye a lead into the skyline. This is closer to us because we are down on the crippled Christina's level. With this dramatic method of showing space, even close objects appear to be on the skyline.

USING PERSPECTIVE

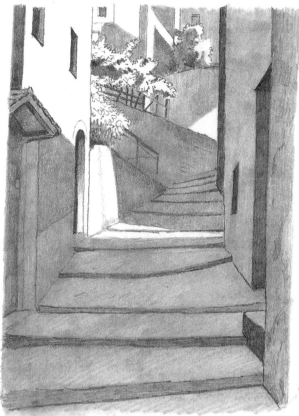

This drawing of the entrance to the mountain town of Boveglio in Tuscany gives many clues to our position and that of the buildings in front of us. The angle of the steps upwards, the change in size of the windows provide information that helps us to detect how the path winds up into the old town.

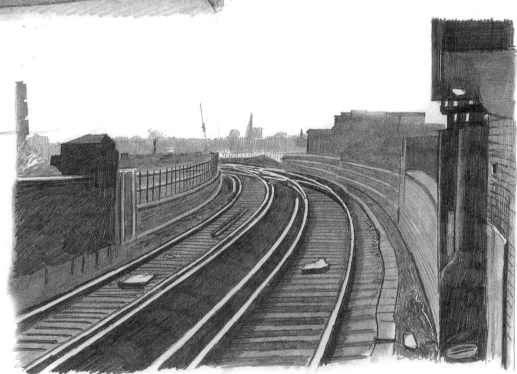

A classic image of perspective is instantly shown in this drawing of railway lines. The drama of the curve as the rails sweep around to the left where they merge and disappear takes us into the picture and shows us the clarity of perception of the viewer. All that we see beyond the rails are softly silhouetted buildings about half a kilometre away.

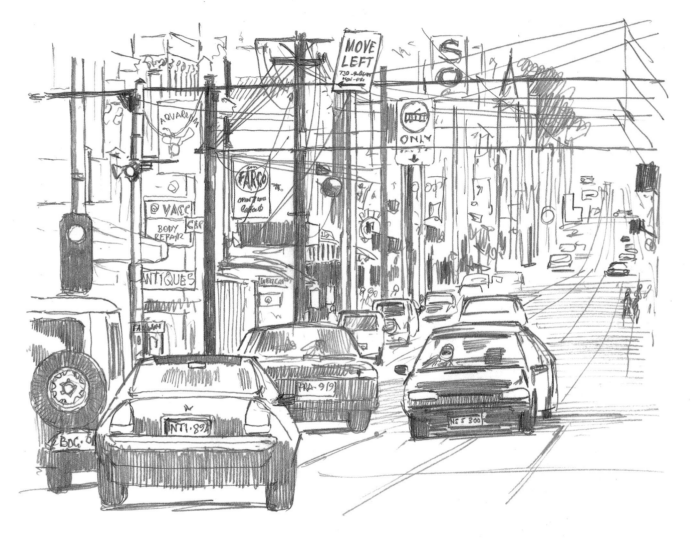

The chaos of signs and telephone wires along a Melbourne street give us a sense of the texture of Australian city life. The sweep of the road and the diminishing sizes of the vehicles certainly convince us of the distance observed, and yet the signs and posts flatten out the depth, making it difficult to judge distances.

USING PERSPECTIVE

In the three examples shown here formal perspective is conspicuous by its absence. In all cases the effect the artist is after does not rely so much on perspective.

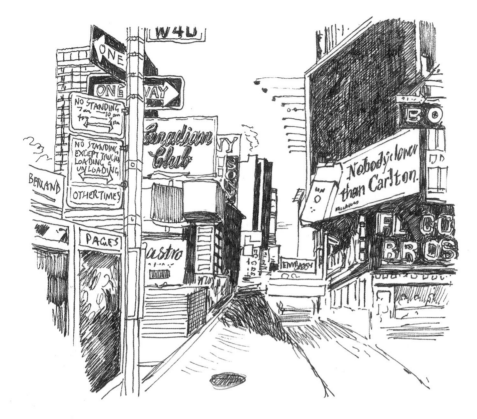

The complex artificial surface of city life is the point of this picture of information clutter, as sign vies with sign to confuse the eye. The only nod to the idea of perspective is the variation in the size of the lettering.

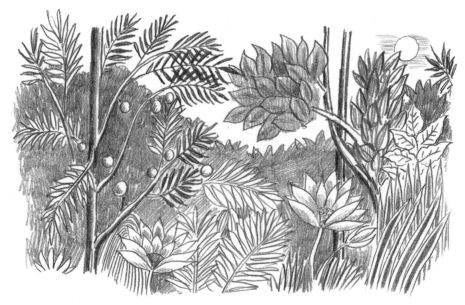

This close up of plant life (after primitive painter Henri Rousseau) is a huge jump stylistically from the first drawing. All the emphasis is on the pattern of jungle-like plants which have been rendered very painstakingly. There is no real depth in the picture, although each plant has its own solidity of form. What we have is a network of plant shapes that present a texture to the eye without any attempt to describe depth of perspective. See another example, also by Rousseau, on page 184 of Imaginary and Symbolic Landscapes.

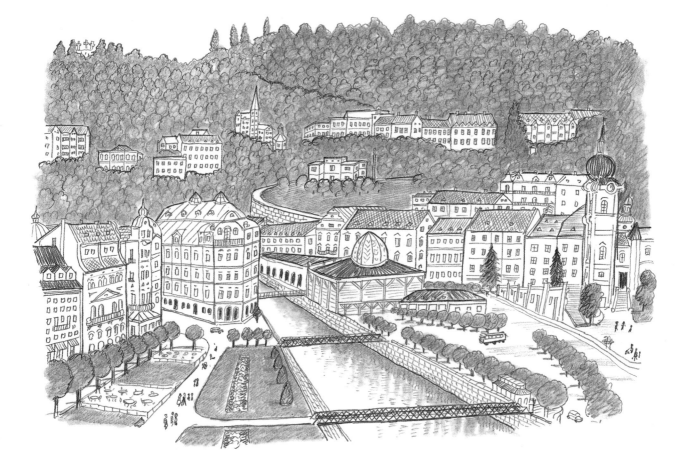

Perspective does not count much in our final picture either. Also from the Naïve school of drawing, this depiction of Karlsbad (after Antonin Rehak) gives an impression of perspective knowledge, but the actual detail of each part of the picture is the same whether near, far or in between.

GEOMETRIC CONNECTIONS

The structural strength of your composition will depend on you making geometric connections between the various features you decide to include. These connections are vital if your picture is to make a satisfying whole. Look at any picture by a leading landscape artist and you will find your eye being drawn to certain areas or being encouraged to survey the various parts in a particular order. Below are two examples where the connections have been made for you. Study them and then try to incorporate their lessons in your own compositions.

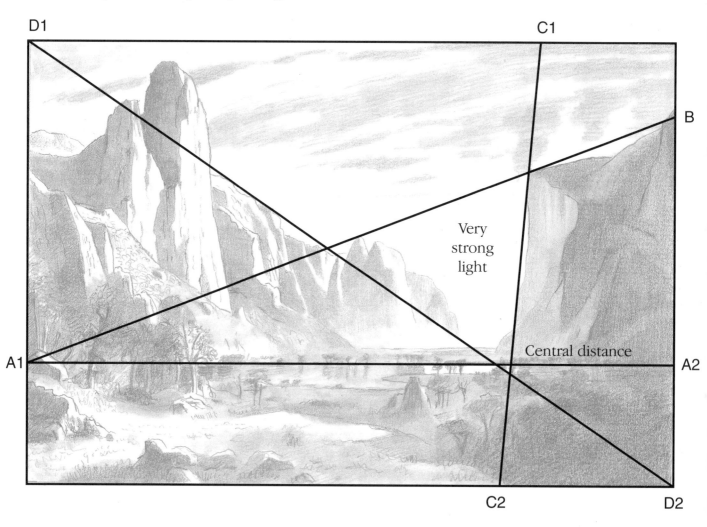

A very interesting geometric analysis can be made of this drawing of a valley in what is now Yellowstone Park (after American wilderness painter Albert Bierstadt).

• *A1–A2 follows the line of a stretch of water running through the valley and makes a very strong horizontal across the composition. Note that it is slightly below the natural horizon.*

• *D1–D2 traverses the composition diagonally from the top left corner to bottom right, cutting across the horizontal A where the sunlight shines brightly in reflection on the*

water. The line also gives a rough indication of the general slope of rocky cliffs on the left as they recede into the distant gap in the mountains.

• *A1– B makes a sort of depressed diagonal from the top of the mountain on the right side.*

• *The near vertical C1–C2 describes the almost perpendicular cliff on the right side.*

• *The very brightest part of the picture, where the sun glows from behind the cliff (right), resides in the triangle described by the lines A1–B, the diagonal D1–D2 and the vertical C1–C2.*

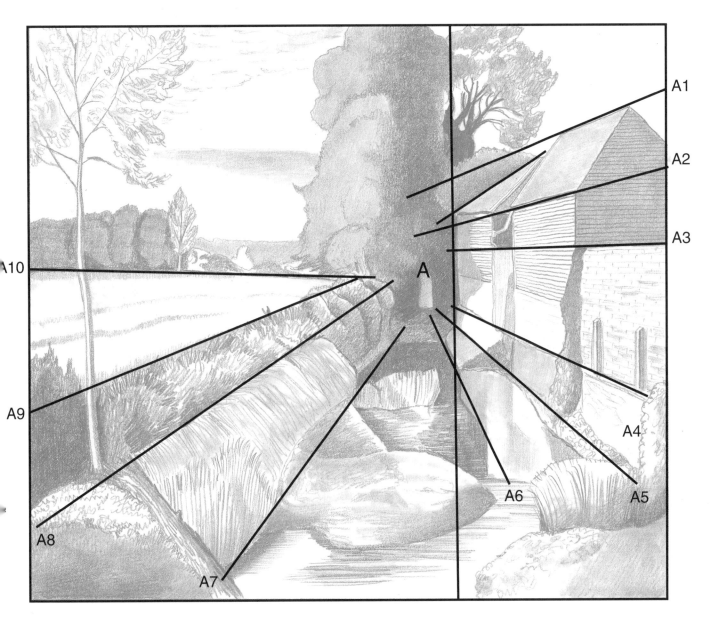

In this example (after John Nash) the eye is taken from all directions (lines A1–A10) to the light shape in the dark area slightly off-centre where the stream and the building converge onto an area of trees. This large solid clump of trees is set about two-thirds from the left-hand side of the composition and just below the horizon level. The stream winds its way from the central foreground towards the deep dark shape in the central middle- ground. Note also how the tree in the left foreground acts as a balance to the building and vegetation.

GEOMETRIC PERSPECTIVE

The design of your composition can be based on a number of geometric configurations. Here we look at two contrasts: an almost centrally based design and one that relies for its movement on a dramatic thrust across the picture plane.

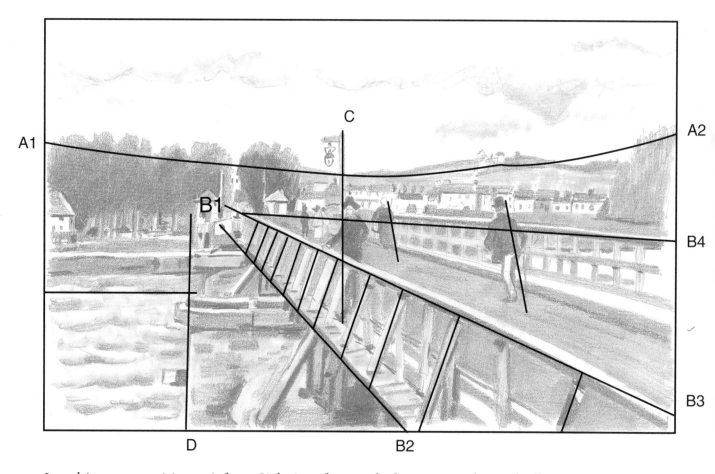

In this composition (after Sisley) of a footbridge over the Seine at Argenteuil, we are immediately struck by its off-centre geometric construction and the dramatic movement across the picture, carried by the perspective lines which show the thrust of the bridge (at B1 raying out to B2, B3 and B4). The main line of the horizon makes a shallow saucer-like curve (A1–A2) broken in the centre by a vertical lamppost and continued by the central standing figure (C). A simple vertical denoting the edge of the pier of the bridge, cutting the line of the river at right angles (D), defines the lower left-hand eighth of the picture.

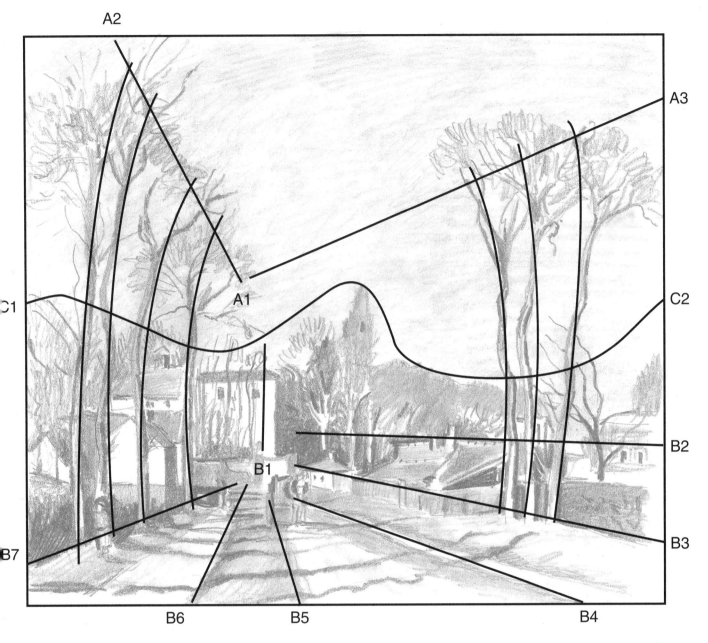

Pissarro's composition of a lane seen along an avenue of slender trees gives an almost classic perspective view, where the main lines subtly emphasize movement into the distance.

The lines A1 radiating to A2 and A3 give the heights of the avenue of trees. Lines B1 to B7 similarly indicate the lower ends of the trees and the edges of the path and roadway.

Everything radiates out or converges inwards to B1. At this point in the picture observe the strong line at the edge of the building behind the horse and cart. Note too how the two rows of trees are linked by means of the curving shadows thrown across the roadway. The wavy horizon line C1–C2 denotes the various heights of trees in the distance.

ENCLOSED LANDSCAPES

An enclosed landscape is characterized by a limitation of the spread of land. This limitation occurs either out of choice – ie, the artist choosing a viewpoint that purposely excludes a wider or deeper spread – or in a landscape where the number of features cuts off a view that might otherwise be more expansive. Artists sometimes choose enclosed landscapes when they want us to concentrate on a feature – perhaps a figure or figures – in the foreground, as in our first example, after Giorgone's painting 'Tempest'.

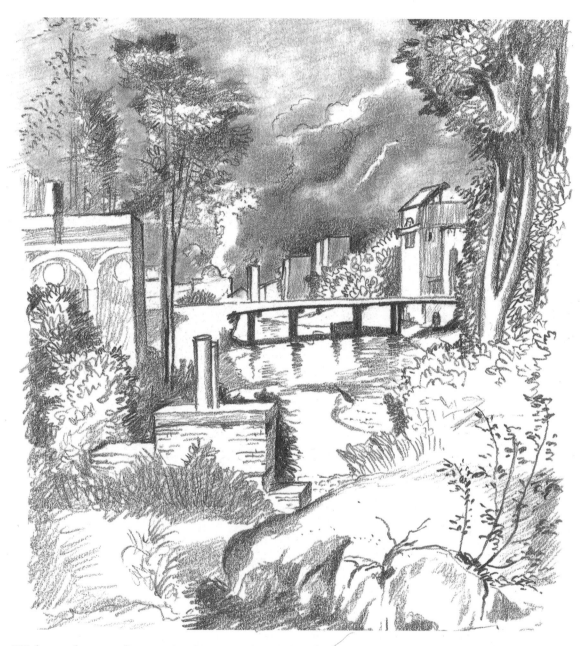

Without the two figures in Giorgone's original we can concentrate on how the artist succeeds in limiting the extent of our vision while achieving an impressive effect of depth. The composition is carefully framed by dark trees on the right and a tower-like edifice surrounded by trees and bushes on the left. The effect is to funnel our view towards the centre of the picture. The bridge and the buildings also ensure that our attention doesn't wander beyond the left bank of the stream and the broken pillars (where the figures are placed in the original).

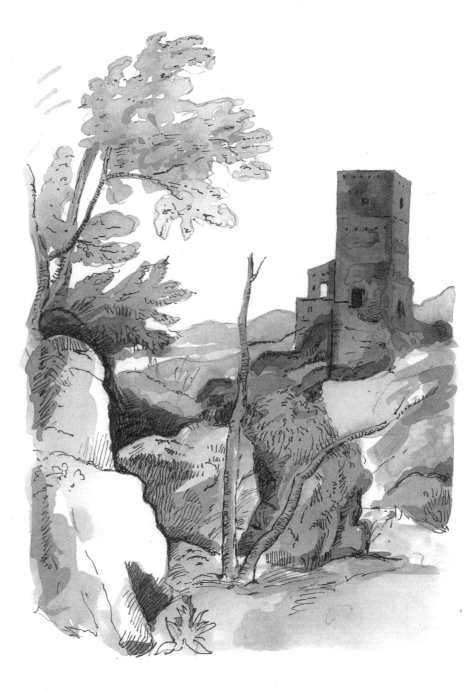

In this pen and wash drawing of the Roman countryside (after Claude Lorrain) the limit to our vision is by deliberate choice of the artist. We are viewing the scene from down in a hollow or small ravine with rocky outcrops to the left and in front. Up on the rocks in front is an old tower, sharply silhouetted against the sky. Our low viewpoint and the high rocky ridges prevent us from seeing much more of the landscape. Because of the position taken by the artist, our view is restricted to a few metres, forcing us to concentrate on the details in the foreground, both middleground and background being almost non-existent.

OPEN LANDSCAPES

As you will see from the following examples, an open landscape is one in which an effect of space combines with a feeling that we are looking at a view that has no limits. All that is visible goes into the horizon and beyond.

In the examples of an enclosed landscape we saw how the artists had chosen to focus the viewer's attention on features in the foreground by restricting their vision. Here you will see how exactly the same effect can be achieved seemingly by doing precisely the opposite.

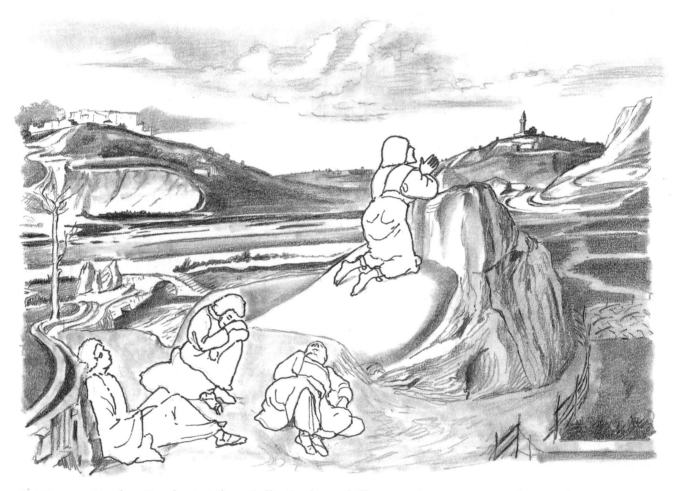

In 'Agony in the Garden' (after Bellini) the figure of Christ praying and three of his apostles sleeping are set in a landscape of immense vistas and spaciousness. The original painting is quite small, but the artist's understanding of the use of perspective suggests a much larger format.

The large rocks and figures are set against a flat, open landscape. A road or path can be seen winding back into the middle distance. To the left is a large hill sloping up to a town or village with cliffs and paths along its side. To the right in the middle distance is a high cliff. Beyond that in the far distance is a

hill sweeping up towards another town or village with a tower at the top as a focal point. The figure of Christ, who is placed so that his head is above the skyline, appears to be pointing towards this distant focal point.

The feeling of immense space in the landscape is beautifully suggested by this contrast between the close-up figures and landscape around them and the distant views of hilltop buildings and open spaces between. The careful graduation of highly detailed features in the foreground and diminishing detail as the landscape moves away from our gaze is masterly.

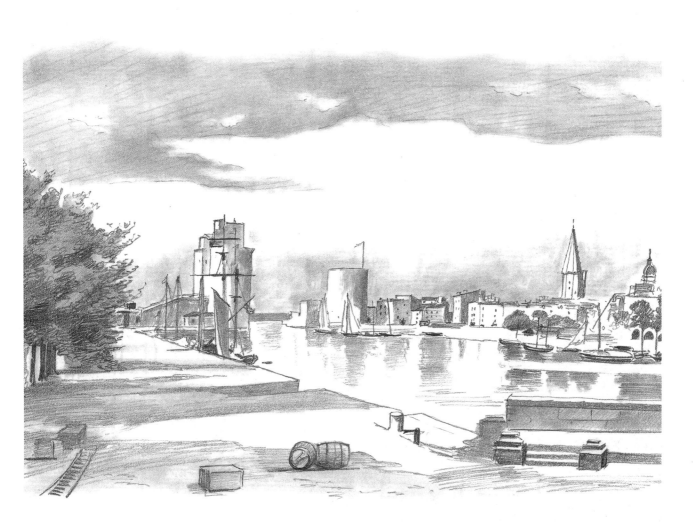

The effect in this landscape of the port of La Rochelle (after Corot) is of a vast space across the centre of the picture, nicely defined by the brightly lit buildings, but suggesting there is much more space beyond them and out to sea. The length of the quay recedes in perspective off to our left. The row of trees helps this effect by drawing our eye in this direction. (I have purposely left out a group of figures with horses dotted around this space, to allow us to concentrate on the spatial effect.) At the far end of the quay is a tower jutting out into the harbour with the masts of boats and ships projecting up to obscure part of the building. An expanse of water fills the middleground. Stretched out along the far right side of the harbour is a row of buildings including a church steeple and a small dome. A large round tower acts as a focus point marking the end of the quayside. Along the length of the far side of the harbour ships and boats are moored, and buildings are brightly lit by the sunlight, which reflects in the limpid water.

DIVIDING A PANORAMA

A large panorama of landscape can be very daunting to the inexperienced artist who is looking at it with a view to making a composition. There can appear to be so much to handle.

The first point to remember is that you don't have to draw all you see. You can decide to select one part of the landscape and concentrate on that area alone. This is what I have done with the drawing below, dividing it into three distinct and separate compositions.

See the next spread for assessments of the individual drawings.

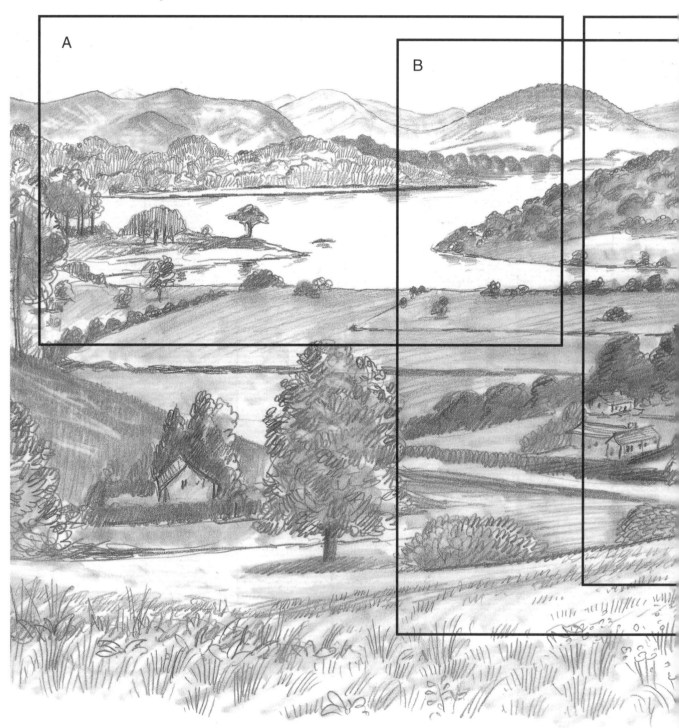

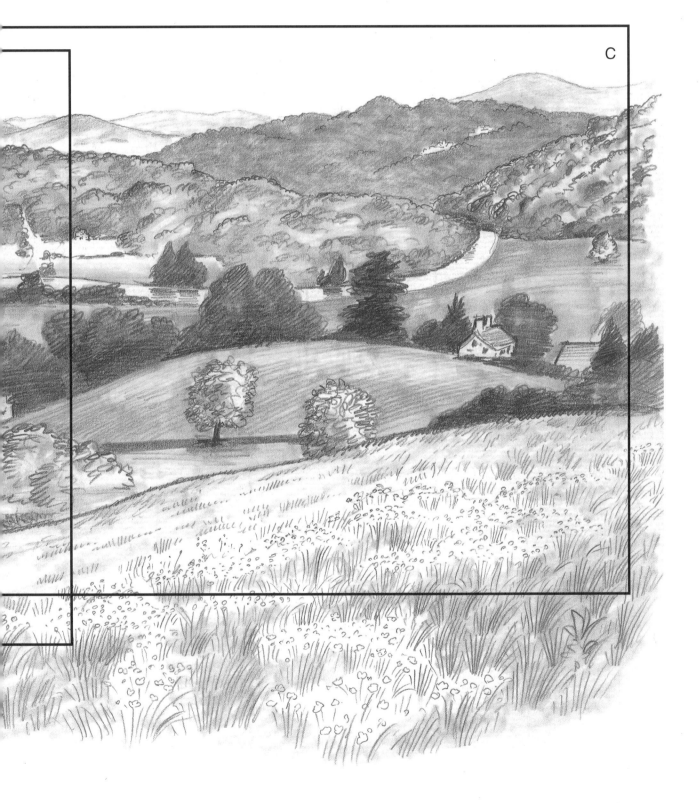

C

DIVIDING A PANORAMA

I have extracted three views from the large landscape on the previous spread, each of them equally valid. Read the captions to find out how they work compositionally.

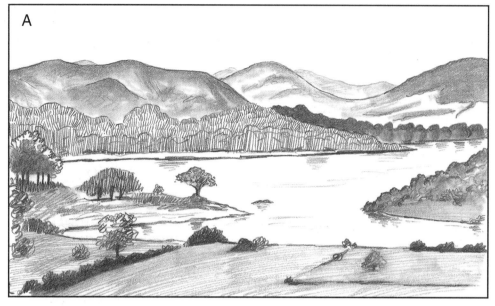

A: The main feature in this part of the landscape is a large area of water sweeping across the whole composition. The large hills in the background provide a backdrop to the more open landscape on the near side of the water. Two small spits of land jut out from either side just above the foreground area of open fields with a few hedges and trees.

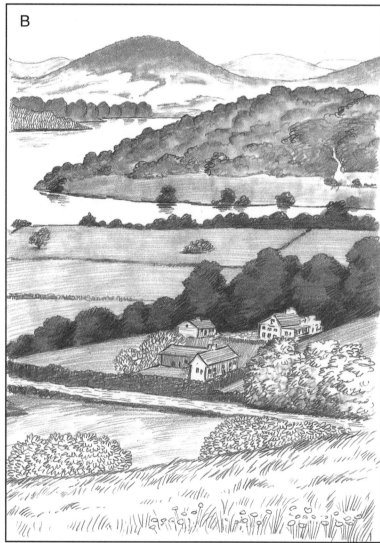

B: With its more vertical format this composition gives just a hint of the open water beyond the stretch of river in the middle ground. The extensive foreground contains hedges, trees, bushes and cottages. The wooded hill across the river provides contrast and the slope of hillside in near foreground also adds dimension. The distant hills provide a good backdrop.

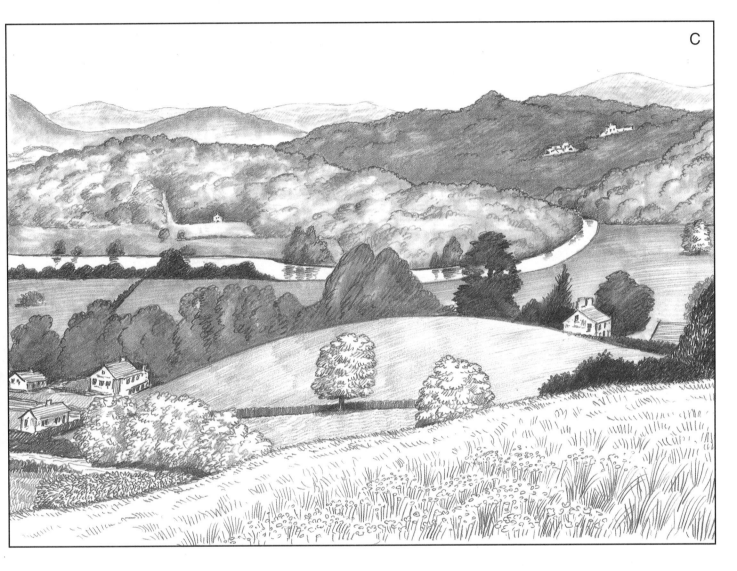

C: Here we have a horizontal layered set of features receding back into the picture plane. In the foreground is a close-up of hillside sloping across from right to left. Just beyond is a low rounded hill-form surrounded by trees and in the left lower corner some houses. Beyond the low hill is the river curving around a large bend and disappearing into wooded banks on the right. The banks slope up either side into wooded hills, and beyond these into another layer showing a larger darkly wooded hill with a couple of villages or properties to the right. At upper left is layer upon layer of hills disappearing into the distance.

SAME LANDSCAPE DIFFERENT WEATHER

One very significant feature in any landscape is, of course, the effect of weather. In every season there are different effects. These can be as simple as the change in the look of the sky. More dramatic changes will demand that you change the way you draw and perhaps the use of different techniques. We shall look at these techniques in detail later. For now, just note the changes that shifts from sunshine to rain, from snowfall to mist bring in their wake.

Shown here are four versions of the same landscape, of Fiesole in Tuscany, drawn almost in the same way, without the application of any special techniques, but merely adapting the same medium to the changing scene.

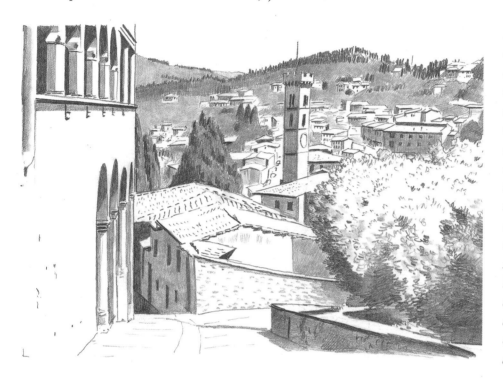

Intense sunlight is very typical of this region in summer. Everything in the picture is clearly defined with a lot of contrast between black and white. Shadows tend to be sharp-edged and strong. Where there is a medium shadow it is a smooth all-over tone. Even the distant hillsides are sharply defined with the trees darkly marked and clearly silhouetted against the skyline.

To emphasize and imitate the visual effect of rain, I've used downward strokes of the pencil. You'll notice the tones are rather soft overall and similar; the darkest shadows are not very much darker than the lighter ones, and even the lightest areas have some tone. The distant hillsides just become simple areas of tone in vertical strokes. The pattern of raindrops on the path helps to maintain the effect.

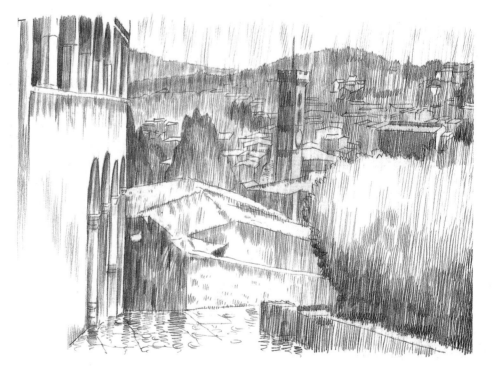

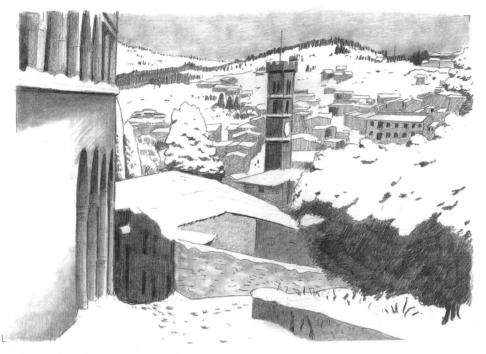

With the landscape covered in snow, there is a great deal of contrast between the snow and other features; here it is between the brightness of the snow lying on the ground, roofs and amongst foliage and the dark tones of the vertical walls of the buildings and the sky. The line of trees on the horizon stands out starkly against the snow-covered hills below it. The overall effect is almost like a negative photograph.

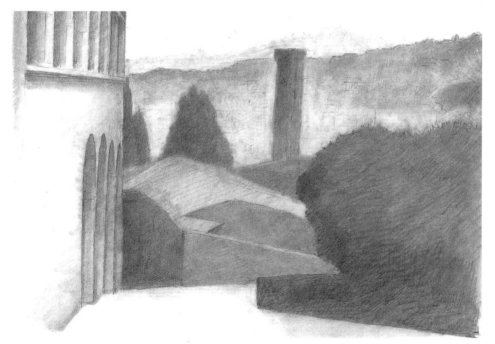

Seen in mist the same landscape is almost unrecognizable, with its contours softened and the tonal areas simplified. Shapes seem to loom up out of the background rather than show themselves clearly. The pencil tones have been smudged with a stump or stub to soften the contrasts.

SAME SCENE DIFFERENT VIEWPOINT

The view we get of a landscape is determined by our position. Take the same landscape and view it from three different positions and you will get three different compositions. In the next three drawings we view the landscape across the valley of the River Stour (after Constable), from three different positions. Compare the three and note how the change in position alters the balance of the elements as well as the overall appearance of the scene.

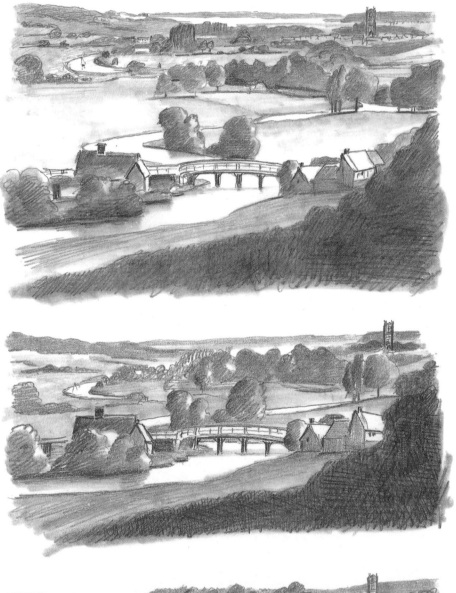

This is quite literally taking the highest viewpoint, which was where Constable chose to position himself to record the scene. From here we get a very broad, expansive view.

If we come down the hill a short way, although we still get quite a broad view, the land in the distance is greatly compressed. Our eye is drawn to the dominant nearer and middle-ground.

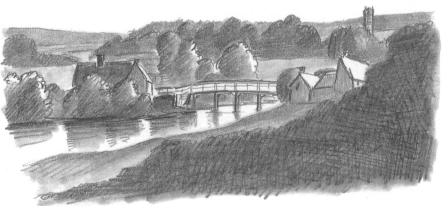

Lower still and the distant horizon is almost completely blocked out by the houses and trees in what is now the middle-ground. The only distant feature visible is the tower of the church.

SAME SCENE DIFFERENT TECHNIQUE

There is more than one way of drawing landscapes. People often think, erroneously, that everything has to be drawn exactly as it would be seen by the eye or lens of a camera, and if a high degree of verisimilitude is not achieved a drawing is worthless. Below are two different approaches to the same landscape. Beginners who are not confident of their drawing skills might find the technique used in the second of these worth considering.

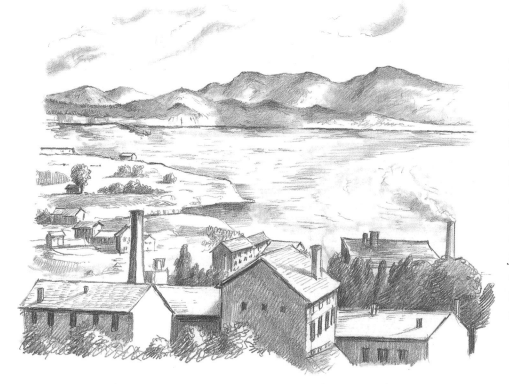

The difference between distant and close-up objects is made obvious by means of texture, definition and intensity. The weight and thickness of line varies to suggest the different qualities of features and their distance in relation to each other and the viewer.

Here an attempt has been made to create an extremely simple scheme of solid forms. The only difference between the treatment of nearer forms and further ones is in intensity. Every detail has been subsumed in the effort to describe the solidity of the forms in a very simple way. The result is a sort of sculptural model universe where the bulk of the form is clearly shown but the

differences in texture or detail are greatly reduced. The effect is of a very strong three-dimensional landscape, albeit one that is rather detached from the way our eyes would really see it. Nevertheless many artists have used this increase in total form successfully.

CENTRING A LANDSCAPE

Every landscape has particular features that can be used to focus the onlooker's attention. A road, building, mountain or river can serve to draw the eye into the heart of a composition. At the same time these methods of engaging the interest are what persuade the viewer to explore the depths and texture of a composition and evoke a similar response to that experienced when surveying a real landscape.

A road snakes across a fairly featureless rolling open landscape almost devoid of contrast in vegetation or form. The eye is drawn by the line of the road to the distant horizon and then is allowed to scan out either side to take in the rest.

A building isolated in flat marshland which, except for the foreground fence, is largely featureless; even the canal is hidden by its banks. But the church immediately catches the eye and engages the attention within the picture.

There are plenty of interesting contrasts in this example: water, trees, hills and a jetty in the front. However, the most dominant feature is the rocky hill in the middle distance standing out starkly against the skyline. This holds the attention and helps us to consider the depths shown in the picture.

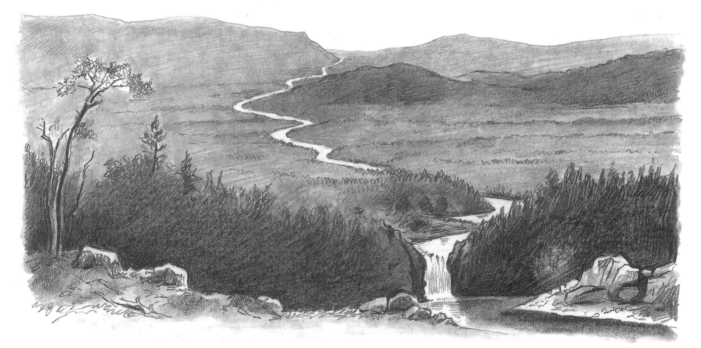

The river in this view of the Catskill Mountains (after S.R. Gifford) serves a similar purpose to the road in the first drawing. The contrast between the dark tree-clad contours of the land and the brightly reflecting river draws us into the composition and takes us right to the horizon.

DIFFERENT STYLES OF TREATMENT

The treatment you choose for a view will affect the look of your final drawing. The materials used have an effect, as does the artist's approach. Look at the three examples shown below – before reading their captions, see if you can work out why they differ so markedly.

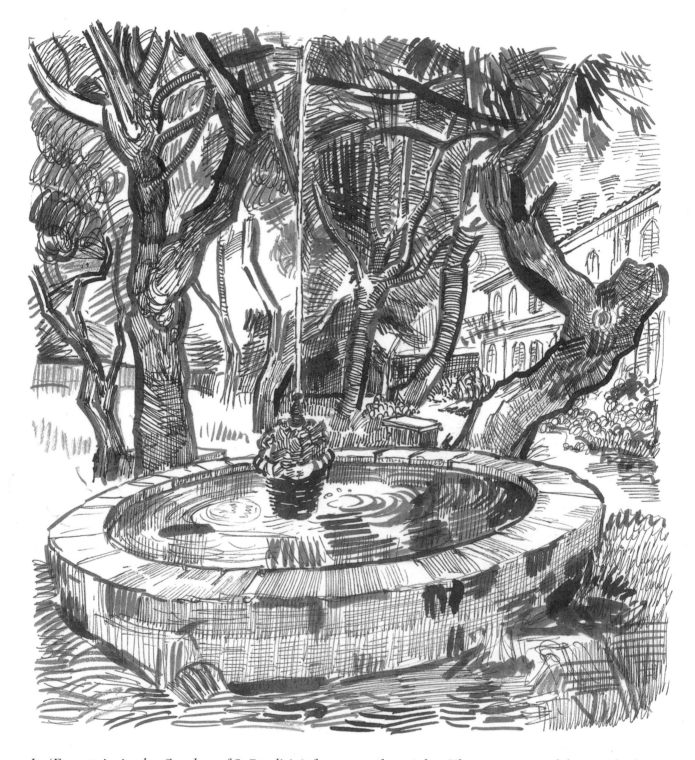

In 'Fountain in the Garden of St Paul's' (after Van Gogh), there is graphic emphasis on the lines of the various trees and stones and the handling of textural effects to create tone and weight. The mixture of large slashing marks and fine hatched lines builds a convincing and vigorous picture that packs quite a punch.

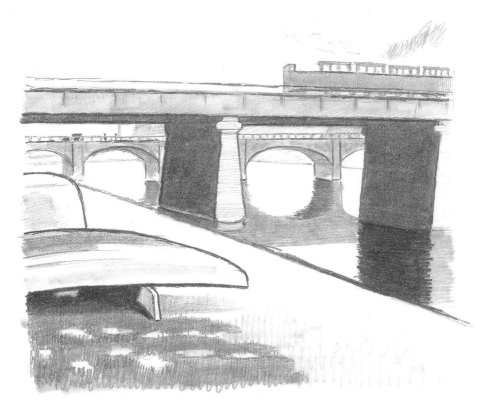

The bridge at Asnières was a favourite subject of the Impressionists. This copy is after Emile Bernard, whose interest in landscape centred on the basic geometric shapes it presented. The powerful simplicity of this method of drawing, with dramatic shapes cutting across the scene, relies largely on the contrasts between the shapes and the tones. The ambience created by atmosphere and texture were of secondary importance to Bernard, but of great importance to his compatriot, Monet.

Monet shows us a totally different way of producing a picture. You can almost feel the texture of hay, grass and even the air in this extremely evocative study, based on his 'Haystacks at Sunset'. The effect is achieved by the skilful blending of tones and expert handling of texture. Used so cleverly in combination, they suggest solidity and distance melting and coalescing together.

Materials and their Uses

YOUR CHOICE OF MATERIALS to portray the landscape is important. Each landscape presents a different set of circumstances and you will find some materials more appropriate than others. Pencil, pen and ink, charcoal, pastel, wash and brush and mixed media are all available. The base or paper that you work on is also variable; for example, good watercolour paper for wash and brush, a smoother cartridge for pen and ink, and a type that is not too smooth for pastel.

Some landscapes are much easier to express in, say, pen and ink and have more potency than if they were drawn in pencil. A watercolour brush and wash drawing, even in monochrome, does gives a vastly more atmospheric effect than any pencil could ever do. However, before making a decision on the medium you are going to use, consider the nature of your subject matter.

Don't always opt for the easiest medium – a little bit of experimentation will lend interest to your work and keep it fresh. Using the same materials can ensure that you become adept at handling them but at the risk of becoming mechanical and predictable. Try to gain as wide an experience as possible of different media and, by extension, of ways of drawing. Experimentation is rarely wasted. Even if you find limited uses for some methods, trying them out will teach you what works and what doesn't. Sometimes it can be fun just to try a medium for the sake of doing something different. Even invent methods of your own if you feel so inclined. Art has no limits. This approach will ensure that you don't become stale and will enhance your enjoyment of drawing, an enjoyment that will transmit into the finished drawing and evoke a similar response in the people who eventually look at it.

Variety in the use of mediums is an important part of the learning process for an artist. Part of its immense value lies in the confidence it will give you to be inquisitive about different approaches and not be shy of trying the unknown. As an artist you will never stop exploring new ways of expressing your vision, so try out all possibilities.

MATERIALS: PENCIL

Versatile, easy to use and to erase, pencil can be used to good effect when drawing landscapes and lends itself to the creation of many different visual effects. Many landscape artists favour it over other implements for its dual ability to produce realistic foliage shapes and broader areas of tone by the simple expedient of smudging. The very versatility of the medium makes it excellent for experimentation, so try playing with the way you make lines and marks.

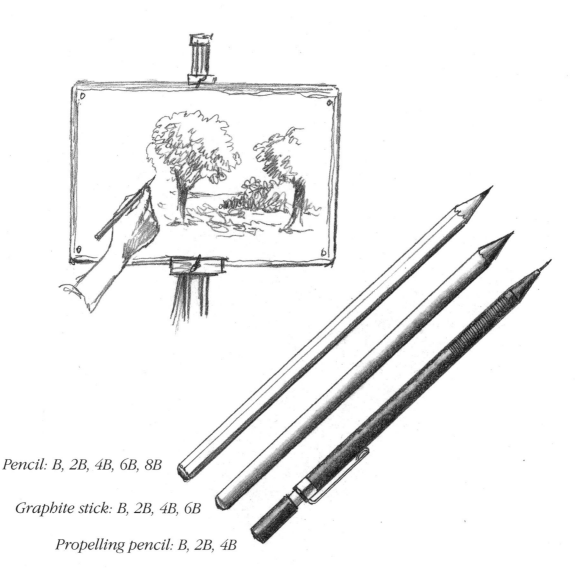

Pencil: B, 2B, 4B, 6B, 8B

Graphite stick: B, 2B, 4B, 6B

Propelling pencil: B, 2B, 4B

You will need to equip yourself with a range of fairly soft, dark pencils ranging from B through 2B, 3B, 4B, 6B to 8B. If buildings are high on your agenda of subjects, an HB can be useful. A propelling pencil will also help to give you a finer line and, unlike the traditional pencil, does not need constant sharpening. However its range of expression is limited. Generally speaking, soft pencil gives a drawing many more attractive qualities than does hard pencil. A graphite stick pencil is very useful because of its versatility and the sheer range of options it offers in terms of thickness of line.

When you go out drawing, always take a range of pencils with you. This will enable you to vary your mark making, and also reduce the amount of time you spend sharpening lead.

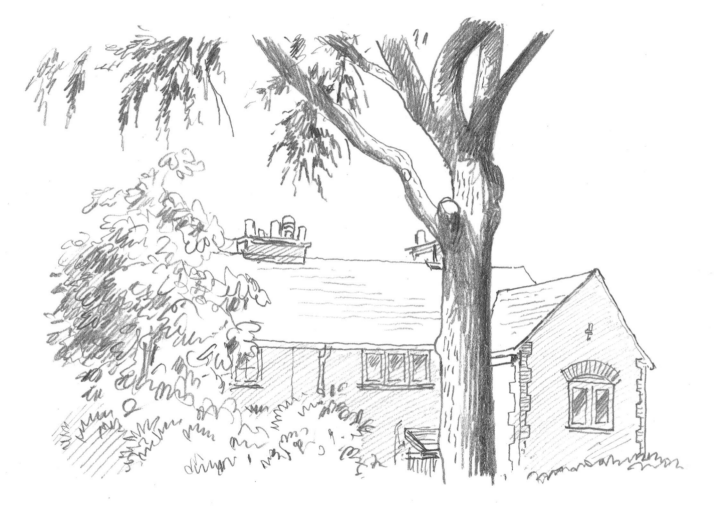

One of the characteristics of drawing with pencil is how widely the line varies depending on the grade you use. There is so much potential with pencil. All you need is a bit of imagination to give your drawing character.

PENCIL TECHNIQUES

The pencil is, of course, easily the most used instrument for drawing. Often though our early learning of using a pencil can blunt our perception of its possibilities, which are infinite.

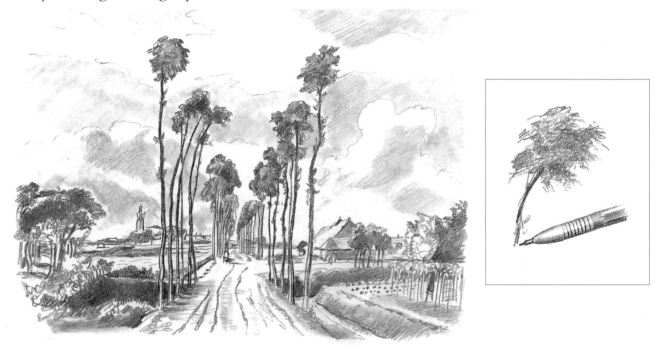

In 'Road to Middelharnis' (after Hobbema) we see a fairly free pencil interpretation of the original, using both pencil and stump. The loose scribble marks used to produce the effect in this drawing will seem simple by comparison with our next example.

American artist Ben Shahn was a great exponent of drawing from experience. He advocated using gravel or coarse sand as models to draw from if you wanted to include a rocky or stony place in your drawing but were unable to draw such a detail from life. He was convinced that by carefully copying and enlarging the minute particles, the artist could get the required effect.

When you tackle a detailed subject, your approach has to be painstaking and unhurried. If you rush your work, your drawing will suffer. In this drawing, after putting in the detail, I used a stump to smudge the tones and to reproduce the small area of sea.

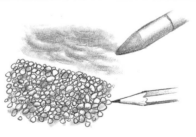

68

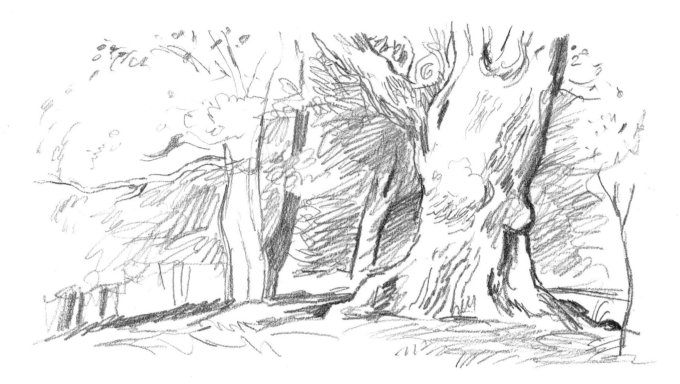

The pencil work used for this large old tree in a wood (after Palmer) is even looser in technique than that for the Hobbema. At the same time, however, it is very accurate at expressing the growth patterns of the tree, especially in the bark. It is best described as a sort of carefully controlled scribble style, with lines following the marks of growth.

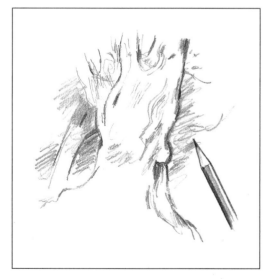

MATERIALS: PEN AND INK

The chief characteristics of pen and ink are precision, intensity and permanence. When using ink you have to make up your mind quite quickly and be sure of what you are doing – you can't change your initial decision halfway through. The medium can be used in a very decorative and formal way, in loose, flowing lines or scribbly marks. Any of these approaches can work well, but not if you mix them. The illusion you are trying to create will shatter if ink marks vary too greatly, with the formal lines becoming too rigid and the scribbled lines looking messy. In order to convince the eye and the mind, you have to decide whether your drawing is to be formal or loosely drawn.

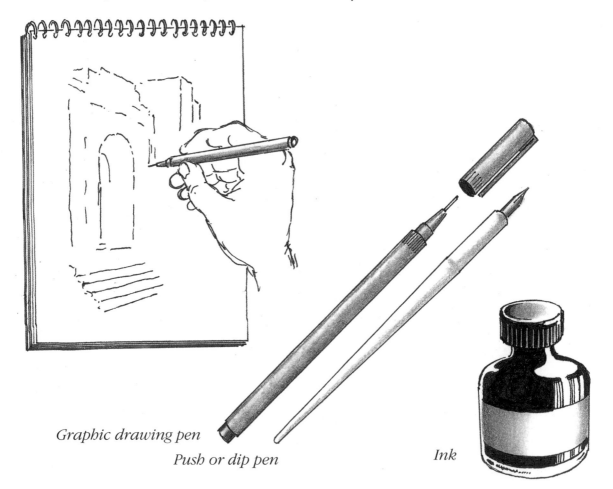

Graphic drawing pen

Push or dip pen

Ink

Pen and ink is an even more linear medium than pencil and particularly lends itself to the linear qualities of architecture. There are two main types of pen for the artist: the push or dip pen and the graphic drawing pen.

Graphic line pens give a consistent black line and come in varying thicknesses: 0.1, 0.5, 0.8 etc. Usually you will need only two line pens: one very fine and the other about twice that thickness.

The ordinary push or dip pen used with Indian ink is more flexible than the graphic drawing pen and allow you to vary your line width just by altering the pressure. Some pen nibs are very flexible, others stiffer, but you will need several different types, ranging from the finest point to a more flexible but rather thicker point.

There are various kinds of ink. The really black draughtsman's ink is consistent in quality and the non-waterproof Indian ink is easier to water down if you require lighter strokes. Art shops stock a range of inks; you just have to experiment to find out which you like best. I have found Chinese stick ink or that made from burnt oak apples most useful.

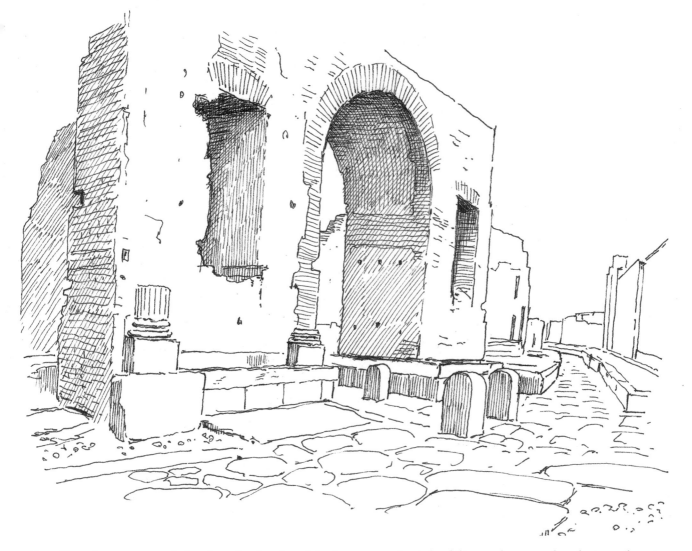

Pen-line is very good for hard-edged subject matter such as this Roman arch at Pompeii. Notice how the total areas are made up of cross-hatched lines drawn closely together to create an area of tone. The brighter areas you leave almost untouched.

PEN TECHNIQUES

Generally speaking any fine-pointed nib with a flexible quality to allow variation in the line thickness is suitable for producing landscapes. Compare the two examples below and you will notice that the effects achieved are markedly different. For his original drawing the Japanese master would probably have used a pen that was smoother on the paper but not so flexible or finely pointed as the type used for the other example.

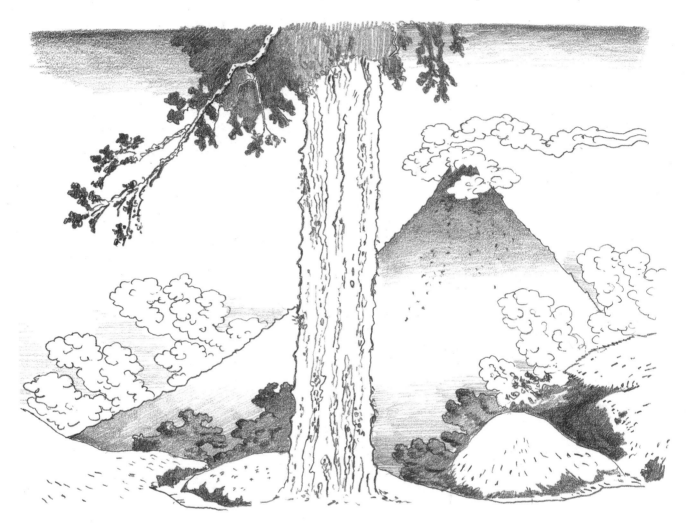

For his original of Mount Fuji the Japanese artist Hokusai probably made his marks with a bamboo calligraphic nib in black ink. We have made do with more conventional pen and ink, but even so have managed to convey the very strong decorative effect of the original. Note how the outline of the trunk of the tree and the shape of the mountain is drawn with carefully enumerated lumps and curves. Notice too the variation in the thickness of the line. The highly formalized shapes produce a very harmonious picture, with one shape carefully balanced against another. Nothing is left to chance, with even the clouds conforming to the artist's desire for harmonization. With this approach the tonal textures are usually done in wash and brush, although pencil can suffice, as here.

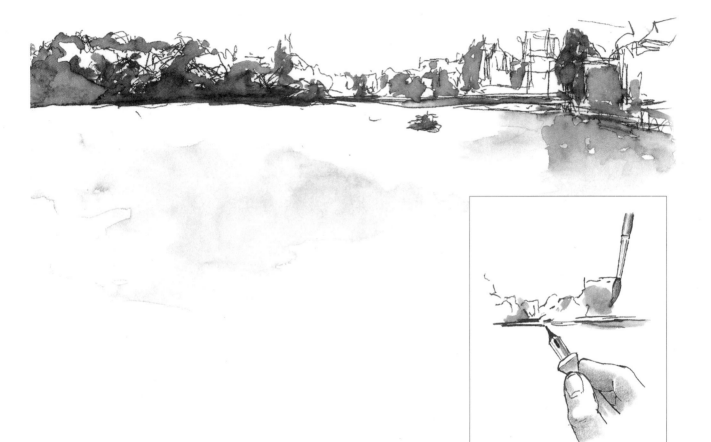

This small sketch of the Thames at Putney (after Elizabeth Knight) was done with great economy and speed, reducing all the shapes to scurrying pen lines with the occasional splash of tone executed with a watercolour brush. The pen strokes seem almost wayward, but are in fact consistent with the objects drawn: those for the trees more rounded and mixed together and for the buildings freely drawn horizontals and verticals. The patches of tone are put in with a brush and diluted ink. Achieving this type of free-flowing effect is not easy and takes time to master.

MATERIALS: BRUSH AND WASH

The medium of tonal painting in brush and wash is time-honoured and beloved of many landscape artists, largely because it enables the right effect to be created quickly and easily. It also enables you to cover large areas quickly and brings a nice organic feel to the creative process. The variety of brushstroke available enables the artist to suggest depth and all sorts of features in a scene. This imprecision is especially useful when the weather is a prominent part of the structure of your landscape and you want to show, for example, misty distance, rain-drenched trees or wind-swept vegetation.

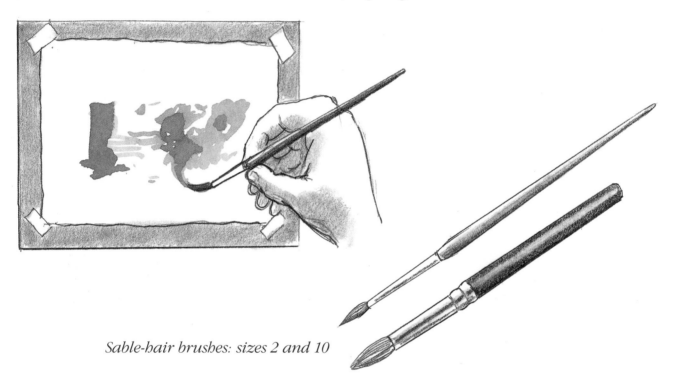

Sable-hair brushes: sizes 2 and 10

You need at least two very good brushes for this technique. Resist the temptation to buy cheap brushes: they don't last, they lose their ability to keep a point and the hairs fall out. Sable makes the best type of brush. You don't have to spend a fortune, and you certainly don't need to invest in a whole range of brushes. The largest brush you will need for anything of sketch-book size is probably a No 10. The No 2 is small enough to paint most subjects finely. These two are essential.

You can use either water-soluble ink or just some black watercolour. To go out sketching with this medium, you will need a screw cap pot for water and some kind of palette to thin out your pigment. I use a small china palette that will go in my pocket or just

a small box of watercolours with its own palette. You can get these in many sizes, but the smallest ones are very useful. As a water pot I generally use a plastic film roll canister with an efficient clip-on lid, or a plastic pill-bottle with a screw cap. These are small enough to put in a pocket and easy to use in any situation. Laying on a wash of tone is not always easy, so you will need to practise.

If you like this method of drawing, invest in a watercolour sketch book; its paper is stiff enough not to buckle under the effect of water, whereas regular heavy cartridge paper can buckle slightly. A good-quality watercolour paper (such as Arches or Bockingford) makes it very easy to get an effective wash of tone without too many brush marks showing.

The subject matter of this drawing (after Turner) is very appropriate for the medium, being rather soft in tone, contrast and simple in shape.

BRUSH AND WASH TECHNIQUES

Beginners generally do not get on well with brush and wash. Watercolour, even of the tonal variety, demands that you make a decision, even if it's the wrong one. If you keep changing your mind and disturbing the wash, as beginners tend to do, your picture will lose its freshness and with it the most important quality of this medium.

I have chosen two contrasting examples, one very classical the other very abstract.

In 'Gretna Bridge' (after English watercolourist John Sell Cotman) the approach is very deliberate. The main shapes of the scene are sketched in first, using sparse but accurate lines of pencil, not too heavily marked. At this stage you have to decide just how much detail you are going to reproduce and how much you will simplify, in the cause of harmony in the finished picture. Once you have decided, don't change your mind; the results will be much better if you stick to one course of action. The next step is to lay down the tones, being sure to put in the largest areas first. When these are in place, put in the smaller, darker parts over the top of the first, as necessary. You might want to add some finishing touches in pencil, but don't overdo them or the picture will suffer.

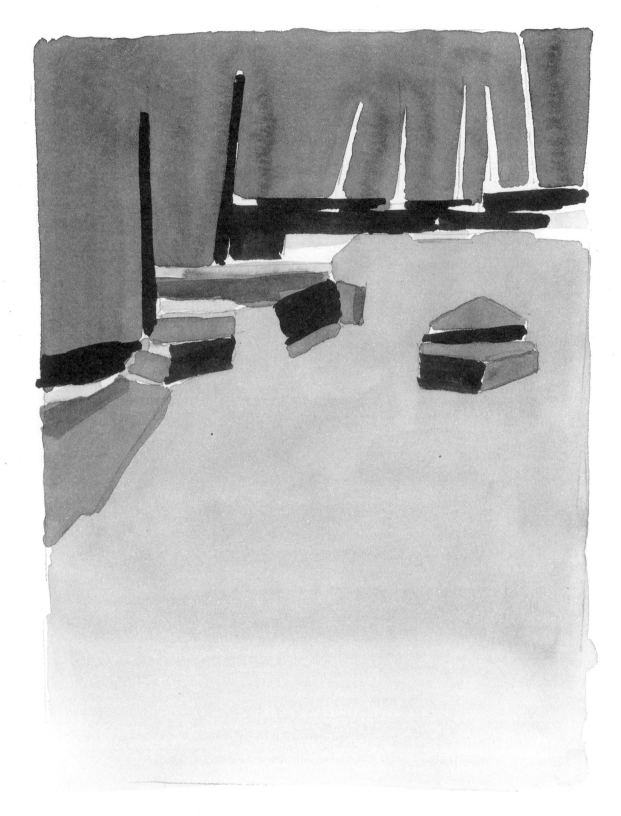

'Les Martigues' (after de Stael) looks easy by comparison, but getting those large simple areas of tone down is harder than it looks. If you find they look less than smooth, don't worry – they might still work, so carry on regardless. The main difficulty for the beginner is lack of confidence. It is much better not to use pencil to put down the main shapes, but to go straight in with wash and brush. If you feel it is absolutely necessary to use pencil, keep it to a minimum.

MATERIALS: CHALK

Chalk-based media, which include conté and hard pastel, are particularly appropriate for putting in lines quite strongly and smudging them to achieve larger tonal effects, as you will see from the examples shown, after Cézanne (below) and Vlaminck (right). In both cases the heavy lines try to accommodate the nature of the features and details they are describing.

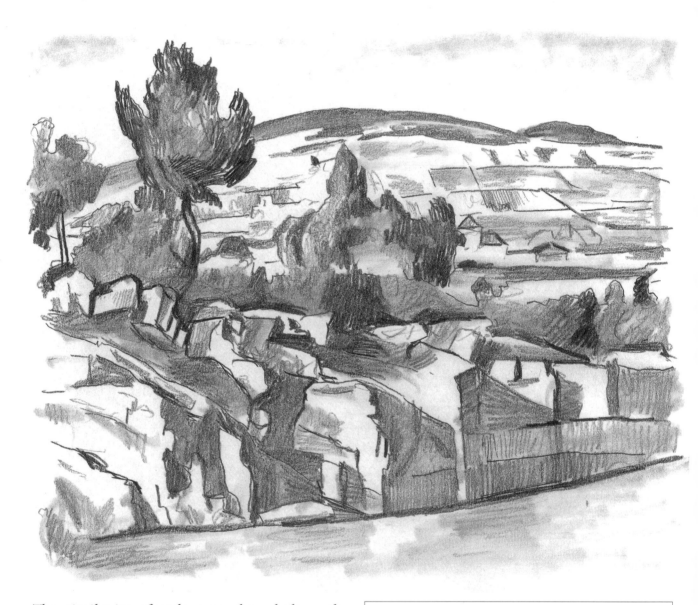

The similarity of style over the whole rocky landscape in this drawing (after Cézanne) helps to harmonize the picture. Compare the crystalline rock structures and the trees. Both are done in the same way, combining short, chunky lines with areas of tone.

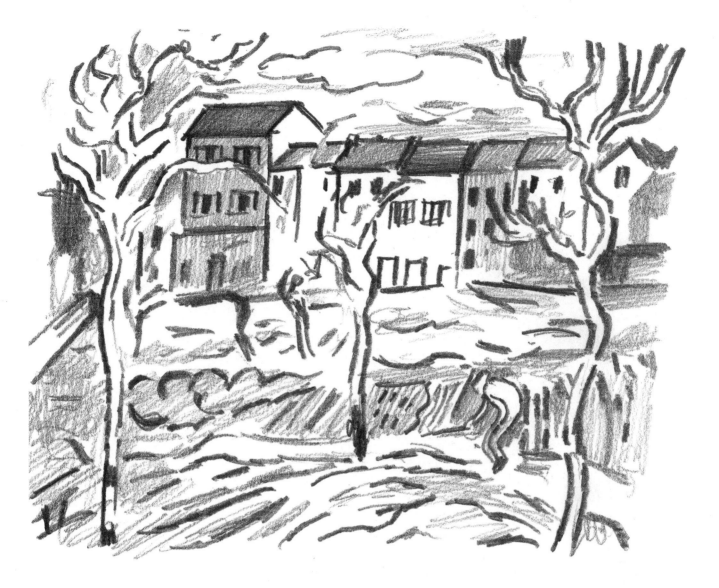

Here the lines are more rounded, the areas of tone softer and the total effect seems to have been achieved with a mass of swirling, strong, solid lines. No stylistic distinction is observed between the trees and the houses behind them. The impression conveyed is that the natural world is as substantial as man's.

MIXED MEDIA: A CLASSICAL APPROACH

The term mixed media simply means that an artist has used several different types of materials. For example, he might have drawn the basic shapes in pencil, sharpened up the foreground details with pen and then used chalk or brush and wash to soften parts of the work. There are many other types of mixed media, including cutting out paper shapes and drawing or painting over them. The example shown here (after Claude Lorrain) is straightforward and uses several common types of media in combination.

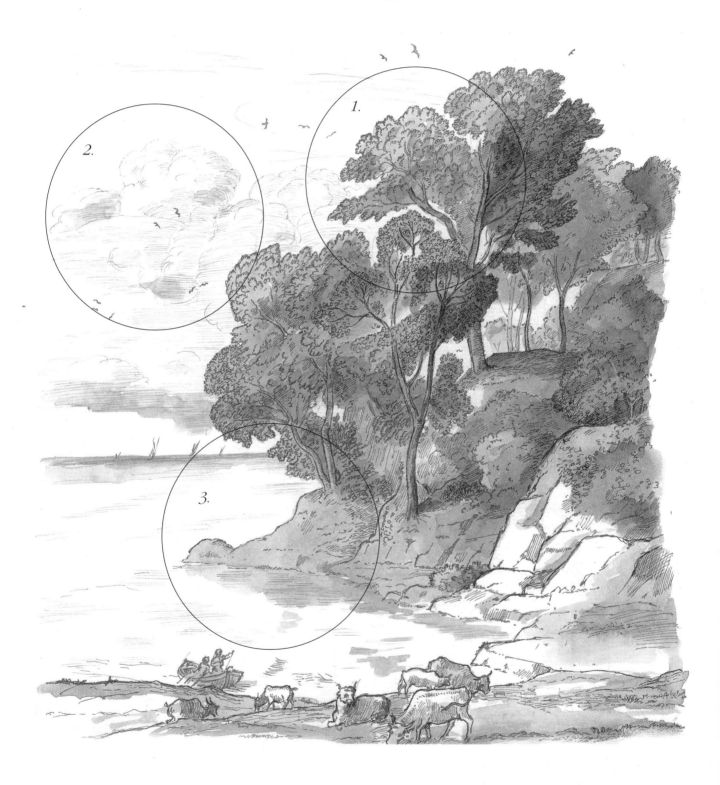

1.

1.Although Claude's treatment is fairly formal, it is not difficult. These leaves, for example, are quite easy to draw. Pen and ink were used to capture the required definition and then a tonal wash was applied to strengthen the effect of each clump.

2.

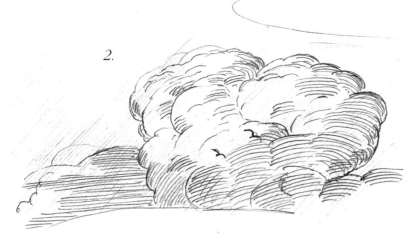

2. The mixture of mediums allowed Claude to graduate with great effect the softness of the clouds (here in graphite), which are sketched in very simply. They contrast with the wiry pen-line used for the trees and the soft, sombre shadows, in wash.

3.

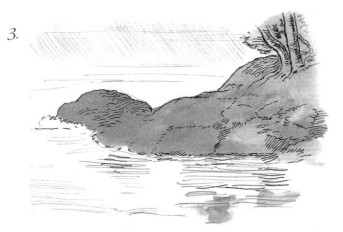

3. The handling of rocks and coastline is again beautifully simple, with deft and appropriate touches of ink, chalk and wash.

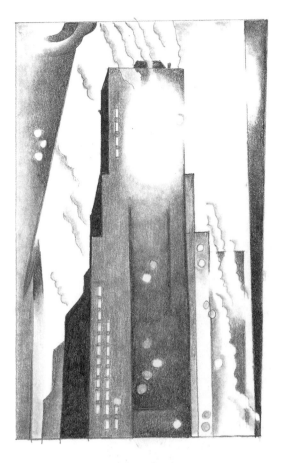

MIXED MEDIA: A MODERN APPROACH

All the examples of mixed media shown here are based on a style known as photo-realism. This approach requires a bit of technical dedication. You have to keep your work clean and sharply defined and ensure the tones make sense in the way they would in a photograph. In the beginning you can make the process easier by using photographs as a guide to the effect you are trying to achieve, which means incorporating in your drawing all the odd distortions that occur in the photographic medium. Photo-realism can work very well, as I hope you will appreciate from the following.

Reflections or sun spots are often seen when we view the world through a camera lens. In 'The Shelton' (after Georgia O'Keeffe) their effect is re-created as we view an impressive skyscraper depicted with the sun bouncing off it.

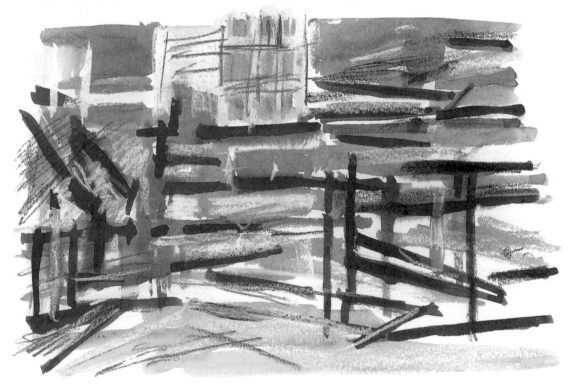

Based on Frank Auerbach's 'Mornington Crescent in Winter', this picture is very abstracted. The very dark strokes were done in ink with a brush, which was also used to put in some areas of lighter tone. The effect of solid mass was achieved with chalk, built up in layers and with each new layer of strokes sometimes nearly obliterating the layers beneath.

'Bridges' (after James Doolin) is more realistic than the O'Keeffe and quite a tour de force. The tonal values required a great deal of work. The more trouble you take with this aspect of a picture done in photo-realist style the better the final result will be.

Basic Elements of Landscape

WHEN WE BEGIN TO STUDY LANDSCAPE the sheer amount of material available to our vision can be confusing and create a state of overload. It can be difficult to know where to start. A vital first step is to identify the components of the landscape we are contemplating drawing. We do this by spending time analysing the scene. What are the elements before us?

Wel, there are several very obvious elements that we need to consider. The first is the vegetation and how it clothes the

landscape. In an urban environment any vegetation is less obvious than it is in open countryside, and the architecture tends to take over. In temperate climates you will notice the amount and variety of vegetation. Can you differentiate between the types of trees, grasses and bushes you see in front of you?

Next we should consider the skeleton or underlying structure of a scene, which is evident from the formation of rocks, hills and mountains. Note the contours and undulations they make.

The element of water, if present, provides a large part of many landscapes. Still or moving, it is extremely important, on account of the brightness and reflection it gives within the general shape of the countryside. It carves out the valleys and produces the growth that makes the land look so attractive. At the edge of the land you may appreciate the spacious and mobile qualities of the sea, which again changes our view of the space in front of us. Indeed the sea can be considered almost as a separate entity, so great can be its role.

The sky is the backdrop to everything else and is constantly changing to give a new look to the substance of the landscape.

Your awareness of the structure and make-up of the landscape will eventually become second nature and part of the enjoyment you get from drawing. This refinement of your perception will also improve your drawing skills and make your pictures more powerful and beautiful. So keep looking and allow your view to both differentiate and harmonize all the various parts of the landscape you are drawing.

TREES IN THE LANDSCAPE

When tackling a landscape with trees, beginning artists often make the mistake of thinking they must draw on every leaf. Survey such a scene with your naked eye and you will discover that you can't see the foliage well enough to do this. You need to be bold and simplify. If you understand the general outline and appearance of different trees, you will convey a sense of the unity that exists in the landscape space.

The following series of drawings is intended to help you to capture the shapes of a range of common trees seen in full foliage and from a distance. You can see that differences in leaf type are indicated entirely by marking the general texture and shape. Let's look at these examples.

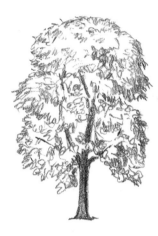

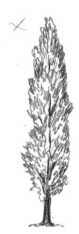

OAK	ASH	LOMBARDY POPLAR

The Oak makes a compact, chunky cloud-like shape, with leaves closely grouped on the mass of the tree.

By contrast the Ash is much more feathery in appearance.

The Poplar is indicated by long, flowing marks in one direction, whereas with the aspen marks have to go in all directions.

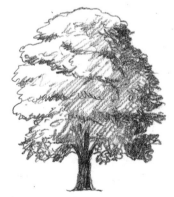

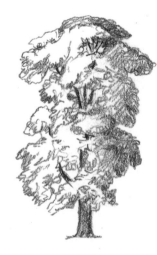

HORSE CHESTNUT	ELM	LIME

Some trees, such as the Horse Chestnut, can be blocked in very simply, just needing a certain amount of shading to indicate the masses.

The Elm and Lime are very similar in structure. The way to tell them apart is to note the differences in the way their leaves layer and form clumps.

CYPRESS

The Cypress holds itself tightly together in a flowing, flame-like shape; very controlled and with a sharp outline.

WALNUT

The Walnut requires scrawling, tight lines to give an effect of its leaf texture.

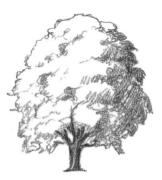

SYCAMORE

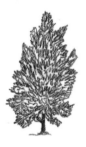

HOLLY

The Holly tree is shaped like an explosion, its dark, spiky leaves all outward movement in an expressive organic thrust.

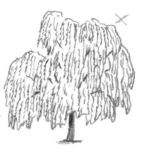

WEEPING WILLOW

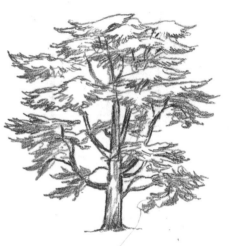

CEDAR OF LEBANON

You will also have to take note of where a darker or lighter weight of line or tone is required. Compare, for example, the weight of line needed for trees with dense dark leaves, such as the Cypress and Holly, with the light tone appropriate to the Willow and Cedar.

ASPEN

YEW

Although they are of a similar family, the Cedar of Lebanon and Yew are easily told apart. Whereas the yew is dense and dark the stately Cedar is open-branched with an almost flat layered effect created by its canopies of soft-edged leaves.

SWEET CHESTNUT

ACACIA

ALDER

HORNBEAM

MOUNTAIN ASH/ROWAN

CHERRY

PEAR

LARCH

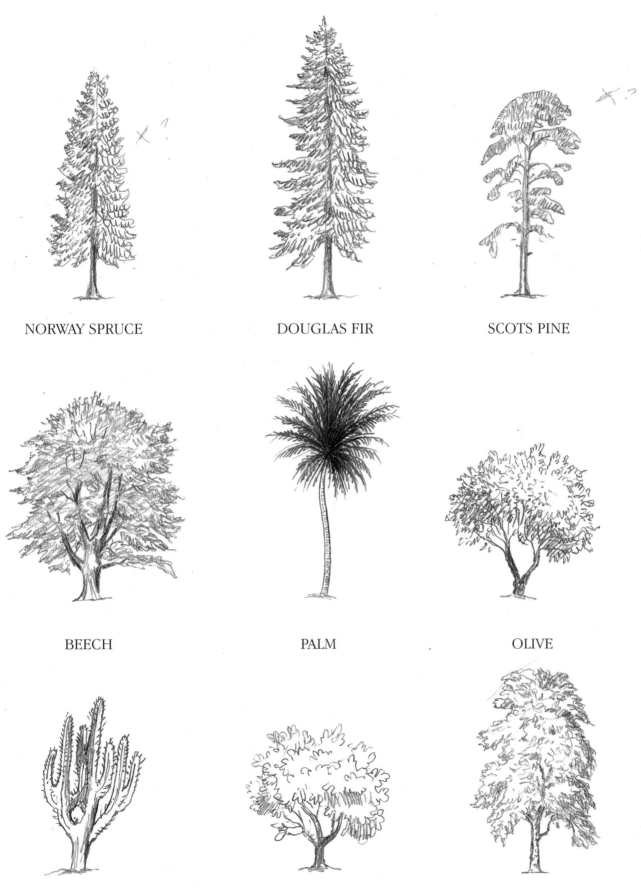

NORWAY SPRUCE DOUGLAS FIR SCOTS PINE

BEECH PALM OLIVE

CACTUS FIG PLANE

FOLIAGE: THE CLASSICAL APPROACH

Drawing trees can be quite daunting when first attempted. It a common misconception that every leaf has to be drawn. This is not the case. Over the next few pages you will find examples by Italian, French and Dutch masters which demonstrate how to solve the problem of showing masses of small shapes that build up to make larger, more generalized outlines.

In these examples a lively effect of plant growth is achieved, by the use of vigorous smudges, brushed lines and washes, and finely detailed penlines, often in combination.

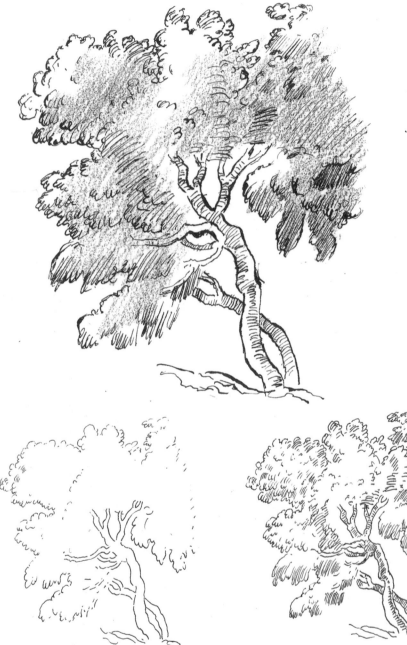

Notice the soft, almost cloud-like outline given to the groups of foliage in this example after Titian (drawn in pen, ink and chalk). No individual leaves are actually shown. Smudges and lines of tone make patches of light which give an impression of thick bunches of leaves. The branches disappear into the bulging form, stopping where the foliage looks most dense.

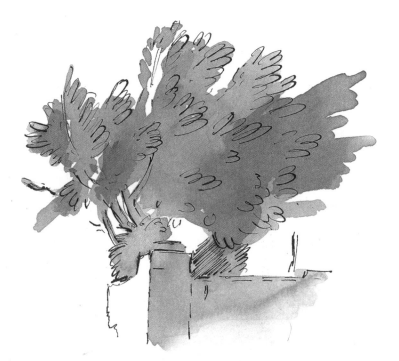

Despite the minimal drawing, this example after Tiepolo (in pen and ink) is very effective.. The solidity of the wall has been achieved with a few lines of the pen. A similar technique has been used to capture the general effect of the longish groups of leaves. The splash of tone has been applied very freely. If you try this yourself, take time painting on the wash. Until you are sure of what you are doing, it is wise to proceed with care.

The approach in this drawing after Boucher (in black chalk) is to put in the sprays of branches and leaves with minimal fuss but great bravura. The technique of using squiggles to describe bunches of leaves evokes the right image, as does drawing in the branches more heavily but with no effort to join them up. The approach works because our eyes expect to see a flow of growth, and seen in context the leaves and branches would be easily recognizable.

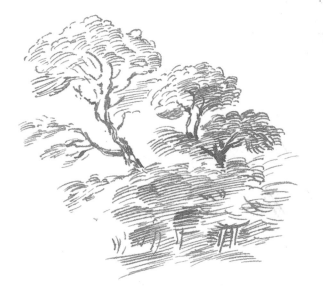

The emphasis here, in an example after Guercino, is on giving unity to the whole picture while producing an adequate representation of trees in leaf.
The lines around the outside edges of the clumps of leaves give a good impression of tree-like shapes. Simple uni-directional hatching, smoothing out as the lines get further from the edge, give the leafy areas solidity without making them look like a solid wall. Darker, harder lines make up the branches and trunk. The suggestion of softer and harder tone, and the corresponding tonal contrasts, works very well.

FOLIAGE: THE CLASSICAL APPROACH

With your first attempts try to get a general feel of the way branches and foliage spring out from the trunk of the tree, and also how the bunches of leaves fan and thrust out from the centre of the plant. Note from the examples shown below what gives a convincing effect: weaving, crinkly lines; lines following the general layering of leaves; uneven thicks and thins with brush or pen; the occasional detail of leaves in the foreground to help the eye make the assumption that this is also seen deeper in the picture. Whatever type of foliage you draw, try to give a lively, organic shape to the whole.

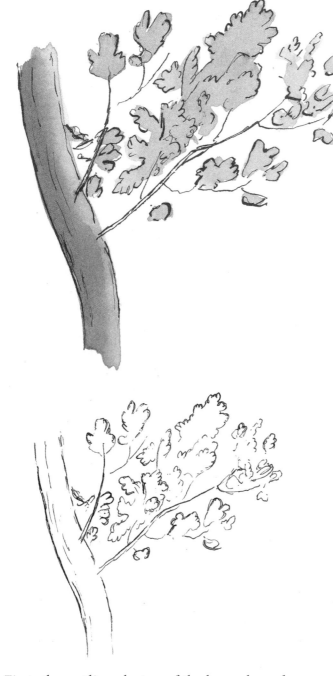

Very efficient methods have been used in this drawing of a branch (after Lorrain) to convince us of its reality. The combination of line and wash is very effective for branches seen against the light. If any depth is needed, just a few extra marks with the brush will supply it.

The two basic stages before the finished drawing are given below.

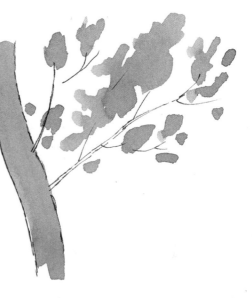

First, the outline shapes of the branch and leaves are drawn in pen; the approach is very similar to that adopted for the sketch after Titian on page 90.

Next a wash of tone is applied over the whole area of the branch and each bunch of leaves.

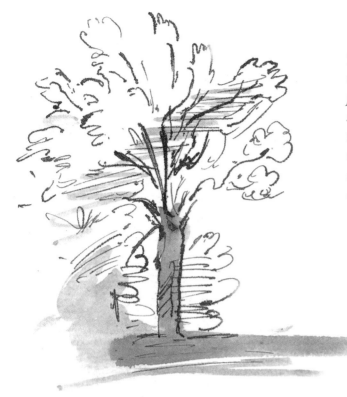

There is no hesitation in this pen, ink and wash drawing after Rembrandt. Minimal patches of tone are just enough to give solidity to the trunk and ground. Look at the quick scribble of lines, horizontally inscribed across the general growth of the branches, suggesting there are plenty of leaves in the middle of the tree.

In this graphite drawing (also after Rembrandt) very firm, dark slashes of tone are accompanied by softer, more rounded scribbles to describe leaves at different distances from the eye. The growth pattern of the tree is rendered by a strong scrawl for the trunk and slighter lines for the branches.

This neat little copse of trees (after Koninck), lit from one side with heavy shadows beneath, looks very substantial, even though the drawing is not very detailed. The carefully drawn clumps of leaves around the edges, and where some parts of the tree project towards us, help to give the impression of thick foliage. The closely grouped trunks growing out of the undergrowth are clearly drawn.

93

MOUNTAINS, HILLS AND ROCKS

Handling the skeleton of a mountain, hill or rock depends on the nature of the feature you are drawing. Your subject might be presented as a bare, hard mass against a clear, cloudless sky or perhaps be softened by vegetation and/or cloud formations. The shape, texture and materiality of these natural features in the landscape are various and require individual approaches. Below are two extremes for you to consider before we look at how to draw them.

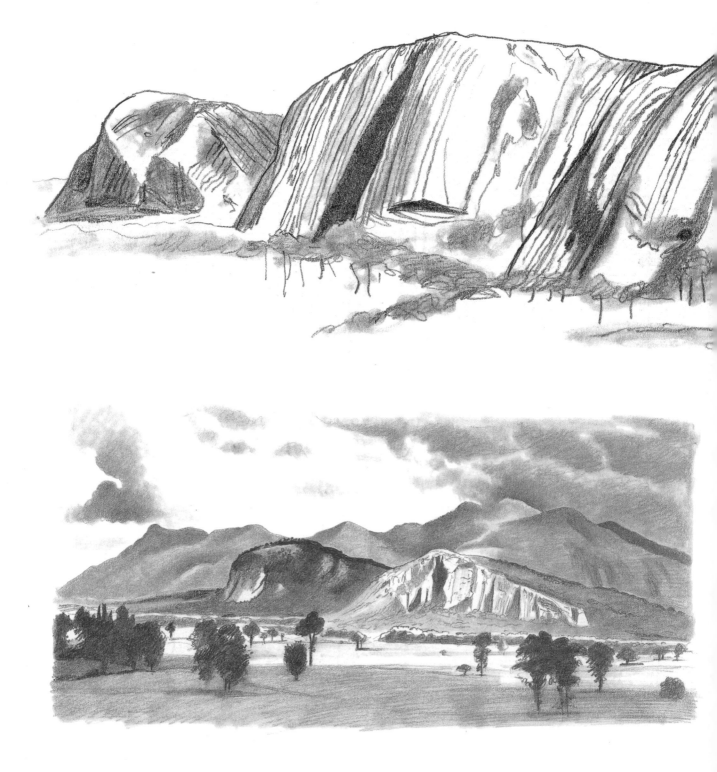

This depiction of Ayer's Rock (after Michael Andrews) accentuates the striations and folded layers of what is one of the world's most curious hill features. Little attempt has been made to create texture. The shadows are put in very darkly and sharply to give an effect of *strong sunlight falling on the amazing shapes. The rock's strange regularity of form, devoid of vegetation, almost makes it look like a manufactured object. As a contrast the trees at ground level are drawn very loosely and in faint, scribbly lines.*

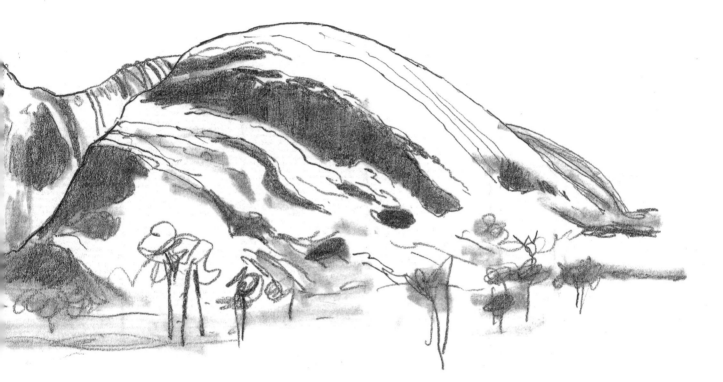

In contrast to the previous drawing, Moat Mountain (after Albert Bierstadt) includes several elements that combine to soften its aspect. The vegetation growing over the folds of the rocky slopes brings additional tonal values to the picture. The fairly well worn appearance of the rocks, visible signs of glaciation in the remote past, has a softening effect. The dark clouds sweeping across the mountain tops and the silhouetted trees looming up from the plain in the foreground also help to unify the harmony of tone all over the picture.

ROCKS: ANALYSIS

The visual nature of a mountain range will change depending on your viewpoint. Looked at from a considerable distance the details recede and your main concern is with the mountain's overall structure and shape. The nearer you get the softer the focus of the overall shape and the greater the definition of the actual rocks.

Below we analyse two examples of views of rocks from different distances.

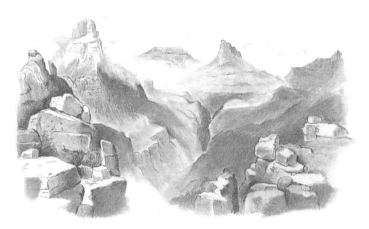

In our first example, from a mountain range in Colorado, the peaks and rift valleys are very simply shown, giving a strong, solid look to the landscape. The main shape of the formation and the shadow cast by the light defines each chunk of rock as sharply as if they were bricks. This is partially relieved by the soft misty patches in some of the lower parts. The misty areas between the high peaks help to emphasize the hardness of the rock. Let's look at it in more detail.

1.

2.

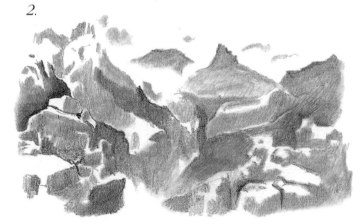

1. Sketch in with a fairly precise line the main areas of the mountain shapes, keeping those in the background very simple. For the foreground shapes, clearly show the outlines of individual boulders and draw in details such as cracks and fissures.

2. The real effect comes with the shading in soft pencil of all the rock surfaces facing away from the light. In our example the direction of the light seems to be coming from the upper left, but lit from the back. Most of the surfaces facing us are in some shade, which is especially deep where the verticals dip down behind other chunks of rock. The effect is to accentuate the shapes in front of the deeper shade, giving a feeling of volume. In some areas large shapes can be covered with a tone to help them recede from the foreground.

All the peaks further back should be shaded lightly. Leave untouched areas where the mist is wanted. The result is a patchwork of tones of varying density with the line drawing emphasizing the edges of the nearest rocks to give a realistic hardness.

You will find this next example, drawn exclusively in line, including the shadows, a very useful practice for when you tackle the foreground of a mountainous landscape or a view across a valley from a mountainside.

The cracks in the surfaces and the lines of rock formation help to give an effect of the texture of the rock and its hardness. The final effect is of a very hard textured surface where there is no softness.

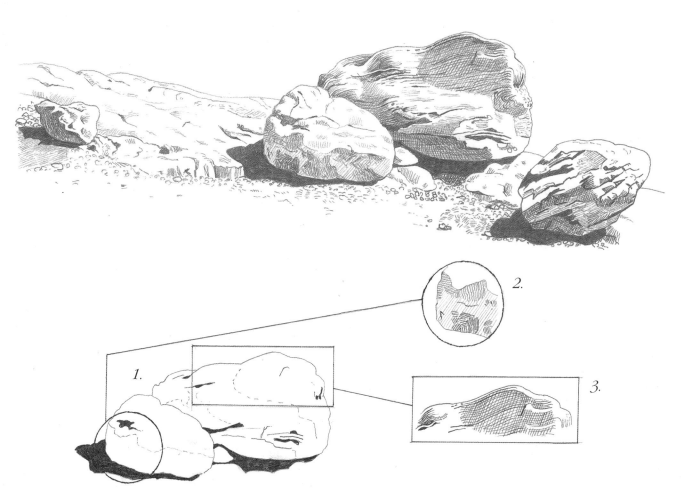

1. Draw in the outline as in the previous example, then put in areas of dark shadow as a solid black tone. Indicate the edges of the shaded areas by a broken or dotted line. Now carefully use cross-hatching and lines to capture the textured quality of the rock.

2. These particular rocks have the striations associated with geological stratas and as these are very clearly shown you can draw them in the same way. Be careful that the lines follow the bending shape of the stone surface and when a group of them change direction, make this quite clear in your drawing. This process cannot be hurried, the variation in the shape of the rock demanding that you follow particular directions. Some of the fissures that shatter these boulders cut directly across this sequence of lines. Once again they should be put in clearly.

3. Now we come to the areas of shadow which give extra dimension to our shapes. These shadows should be put in very deliberately in oblique straight lines close enough together to form a tonal whole. They should cover the whole area already delineated with the dotted lines. Where the tone is darker, put another layer of straight lines, close together, across the first set of lines in a clearly different direction.

WATER FEATURES NEAR AND FAR

Water is a most fortunate feature to portray as it gives the landscape an added dimension of space, rather as the sky does. The fact that water is reflective always adds extra depth to a scene. The drawing of reflections is not difficult where you have a vast expanse of water flanked by major features with simple outlines, as in our first example. Use the technique shown, which is a simple reversal and you will find it even easier.

Here the water reflects the mountains in the distance and therefore gives an effect of expanse and depth as our eyes glide across it to the hills. The reflection is so clear because of the stillness of the lake (Wastwater in the Lake District), and the hills being lit from one side. Only the ripples tell us this is water.

The mountains were drawn first and the water merely indicated. The drawing of the reflection was done afterwards, by tracing off the mountains and redrawing them reversed in the area of the water (see inset). This simple trick ensures that your reflection matches the shape of the landscape being reflected, but is only really easy if the landscape is fairly simple in feature. The ripple effect was indicated along the edges of each dark reflection, leaving a few white spaces where the distant water was obviously choppier and catching the sun.

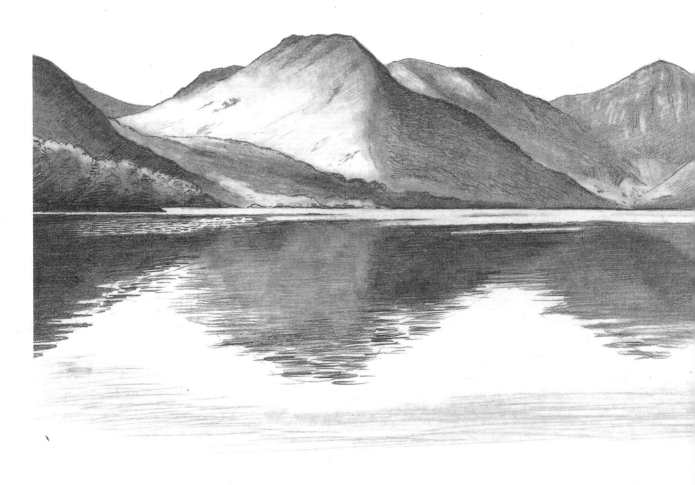

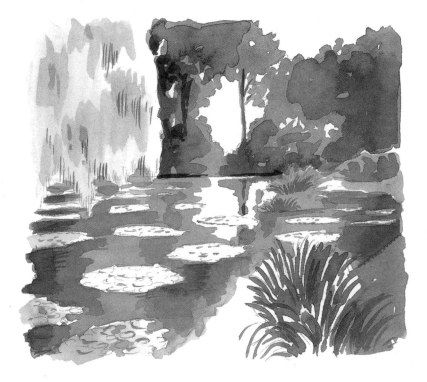

This view of Monet's pond at Giverny is seen fairly close-up, looking across the water to trees and shrubs in the background. The light and dark tones of these reflect in the still water. Clumps of lily pads, appearing like small elliptical rafts floating on the surface of the pond, break up the reflections of the trees. The juxtaposition of these reflections with the lily pads adds another dimension, making us aware of the surface of the water as it recedes from us. The perspective of the groups of lily pads also helps to give depth to the picture.

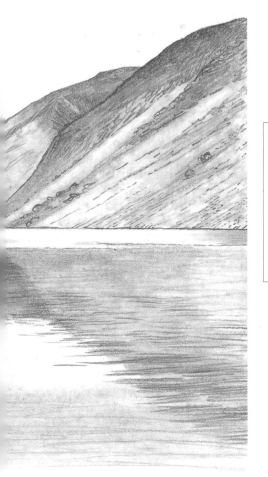

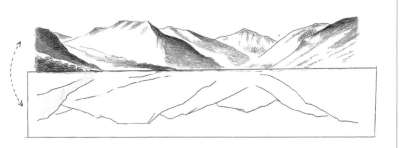

How to draw in a reflection – see main caption, left.

WATER ON THE MOVE

You need time to capture accurately the swirls and shifting reflections in moving water. Leonardo da Vinci is said to have spent many hours just watching the movement of water, from running taps to torrents and downpours, in order to be able to draw the myriad shapes and qualities which such features present. So a bit of study is not out of place here. If you are able to draw still reflections, that is a good start. You will find the same reflections, only rather more distorted, in moving water.

We look next at a representative range of types of moving water for you to study.

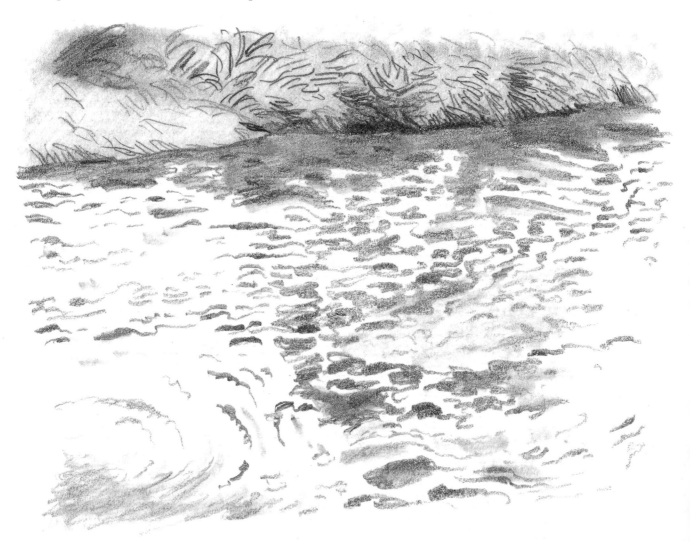

REPEAT PATTERNS

Notice how in this moorland stream the surface of the water is broken up into dark and light rippling shapes that come about from the proximity of the stony bed of the stream to the surface. Everything that is reflected falls into this swirling pattern. After a few attempts you will find it is not that difficult to draw. The trick is to follow the general pattern rather than trying to draw each detailed ripple to perfection. With this type of stream the ripples always take on a particular formation which is repeated in slightly differing forms over and over again. Once you see the formation, it is just a question of putting down characteristic shapes and allowing them to fit together over the whole surface of the water, taking note of the dark tones in order to give structure to the whole scene.

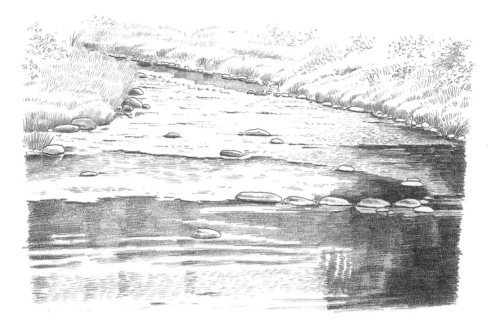

CONTRASTING DIRECTIONS AND TONES

A small river running across shallows creates a minute series of rapids. There are enough small worn stones jutting above the surface to give structure to the area of water. Ensure that the marks you use to show the grassy banks contrast with the marks you use for the water. The texture of water and grass is markedly different, and you must differentiate through your mark-making. Nearly all the marks made for the banks are with a vertical bias, whereas nearly all the marks made for the water have a horizontal bias.

Now let's look at the tones in detail. Notice the very light patches of reflection wherever the water ripples over or close to stones. These occur because the light tends to flicker on the ripples of the more broken surfaces in the stream. Where the water is deeper or slowed down by a bend in the river, you will find the reflections of overhanging trees making strong dark areas with much smoother ripples. Any stones projecting above the surface of the stream will help to define these different areas of tone.

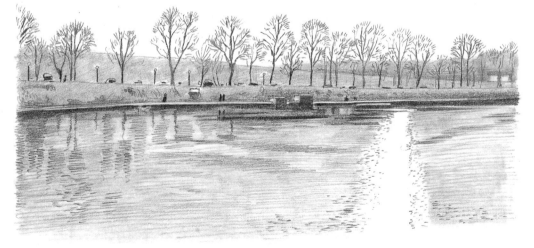

SMOOTHER, BRIGHTER, SIMPLER SURFACE

Large rivers present fewer problems to the artist than small streams, partly because of the depth and partly because of the width. With a large river the flow of the water is smoother. Well built-up banks will ensure it is also very even. In this scene the sun is setting and this cuts a bright path across the water, with reflections of the winter trees projecting into the surface nearer the bank.

FALLING WATER

One of the problems with drawing waterfalls is the immense amount of foam and spray that the activity of the water kicks up. This can only be shown by its absence, which means you have to have large areas of empty paper right at the centre of your drawing. Beginning artists never quite like this idea and usually put in too many lines and marks. As you become more proficient, however, it can be quite a relief to leave things out, especially when by doing so you get the right effect. The spaces provide the effect.

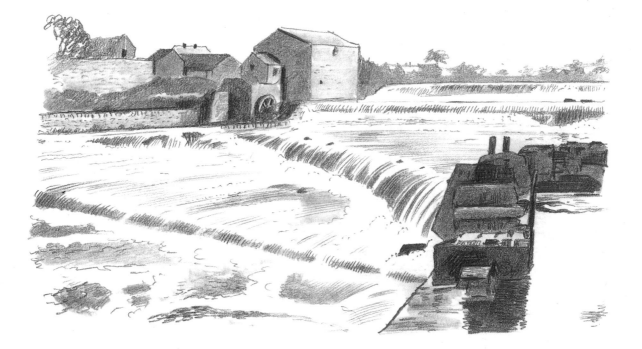

The rapids at Ballysadare produce the most amazing expanse of white water. Most of the drawing has gone into what lies along the banks of the river, throwing into sharp relief the white area of frothing water. These features were put in fairly clearly and in darkish tones, especially the bank closest to the viewer. The four sets of small waterfalls are marked in with small pencil strokes, following the direction of the river's flow. The far bank is kept simple and the farthest away part very soft and pale in tone.

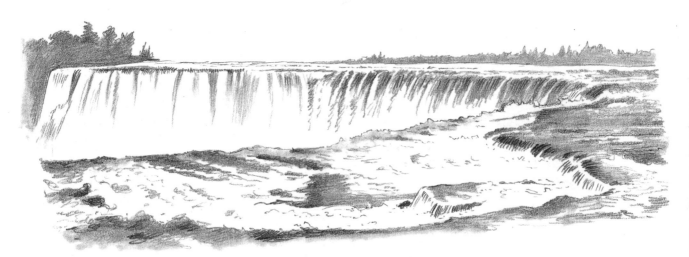

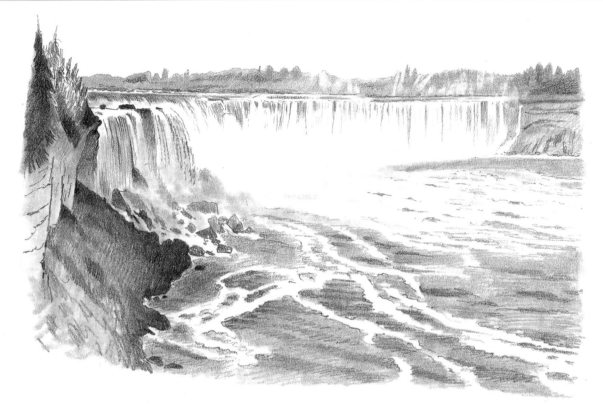

The Daddy of all falls – Niagara. The view at the bottom of page 102 is after F .E. Church and shows the Horseshoe from above. The drawing shown above is after Albert Bierstadt and looks at the Falls from below. In both examples the falling water is mostly left as white paper with just a few streaks marked to indicate it. The contrast between the almost blank water, the edges of the bank and the tone of the plunge pool gives a good impression of the foam-filled area as the water leaps down into the gorge it has cut in the rock. Drawing such a scene is not difficult as long as the tonal detail is limited.

HOW TO DRAW NIAGARA

For this exercise I have chosen to ignore the details on the lower river to concentrate on the area of the falls themselves. Mark in the top line of the falls clearly and carefully, but leave a strip of white paper between the distant grey line of the banks and the series of vertical marks of line and tone that denote the tumbling water. These verticals must not be carried too far down or they will destroy the effect of the cloud of spray rising from the bottom of the fall and obscuring our view of the fall itself. You will notice that at either end of the falls the lines continue from top to bottom. At these points the spray is not so dense. In the central area, where the water is boiling with agitation, there is almost nothing to draw. The gaping hole gets across the idea of water being dissolved, almost into mist.

FALLING WATER: PRACTICE

The scale of High Force waterfall in the Pennines is of a different order to that of Niagara, and presents other challenges. Where Niagara is broad, High Force is narrow and, of course, the volume of water that rushes down its steep sides and over its series of steps is much less. As with drawing Niagara, it is mostly the strong tones of the banks that provide contrast with the almost white strip of the waterfall.

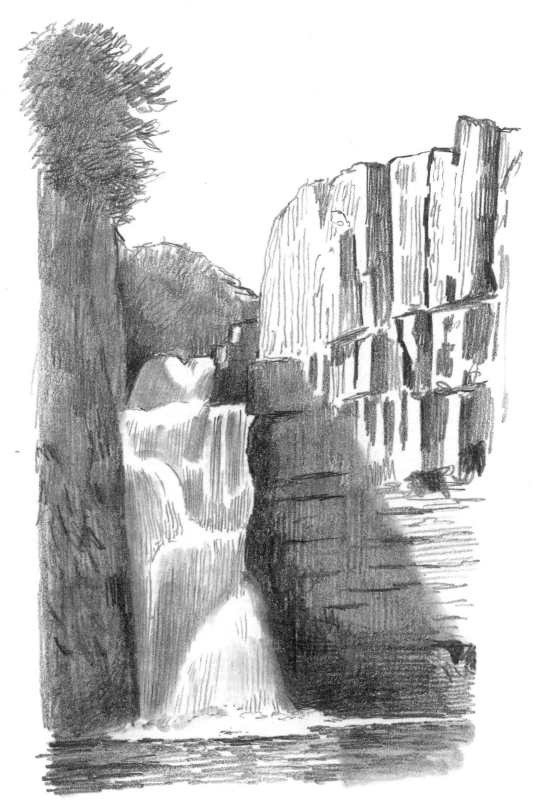

1. *Start with the cliffs on either side. Where they are in shadow, use dark tone to block them in. Where they are not, draw them in clearly. In our view the area all around the falls is in shadow and it is this deep tonal mass that will help to give the drawing of the water its correct values. Leaving the area of the falls totally blank, put in the top edges of each ledge in the cliff face. Draw in the plunge pool and the reflection in the dark water at the base of the falls.*

2. *Leaving a clear area of white paper at the top of the ledges, indicate the downward fall of the water with very lightly drawn closely spaced vertical lines. Don't overdo this. The white areas of paper are very important in convincing us that we are looking at a drawing of water.*

SEA: LITTLE AND LARGE

When you want to produce a landscape with the sea as part of it, you have to decide how much or little of the sea we want to show. The viewpoint you choose may mean you have to draw very little sea, a lot of sea, or all sea. In the next series of drawings we examine these propositions and look at ways of using the sea in proportion to the land.

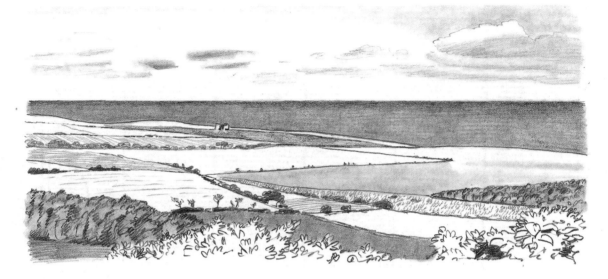

In our view of the Norfolk coast the sea takes up about one-eighth of the whole picture. Because the landscape is fairly flat and the sky is not particularly dramatic, the wide strip of sea serves as the far distant horizon line. The result is an effective use of sea as an adjunct to depth in a picture. The calm sea provides a harmonious feel to the whole landscape.

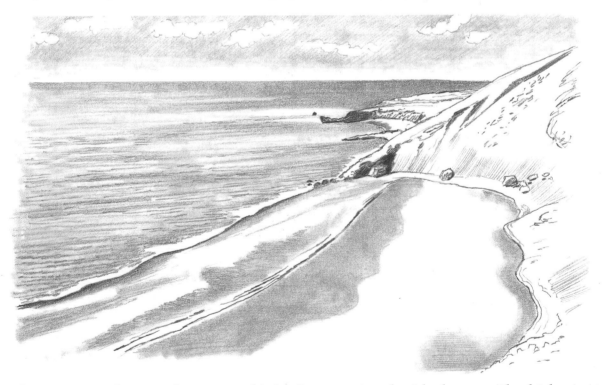

In the next scene the sea takes up two-thirds of the drawing, with sky and land relegated in importance. The effect is one of stillness and calm, with none of the high drama often associated with the sea. The high viewpoint also helps to create a sense of detachment from everyday concerns.

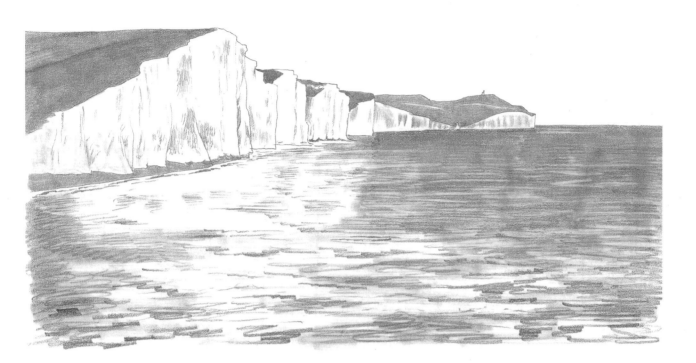

Such a large expanse of sea could be boring unless it was turbulent. What makes the scene interesting is the strip of solid earth jutting into the picture and dividing the sea from the sky. This transforms the sea into a foil for the rugged cliffs.

When the sea is the whole landscape the result is called a seascape. The boat with the three fishermen is just a device to give us some idea of the breadth and depth of the sea. If the sea is to be the whole scope of your picture, a feature like this is necessary to give it scale.

SEA IN THE LANDSCAPE: PRACTICE

The sea takes up two-thirds of this picture, which shows a wide bay with rocky cliffs enclosing a flat beach on Lanzarote. The sweep of the sea from the horizon to the surf on the beach creates a very pleasant and restful depth to the drawing. The close-up of rocky boulders adds a touch of connection to the onlooker, as does the viewpoint, which suggests we are viewing the scene from high up on the cliff. As with the previous drawing, it is the area of calm sea that sets the mood.

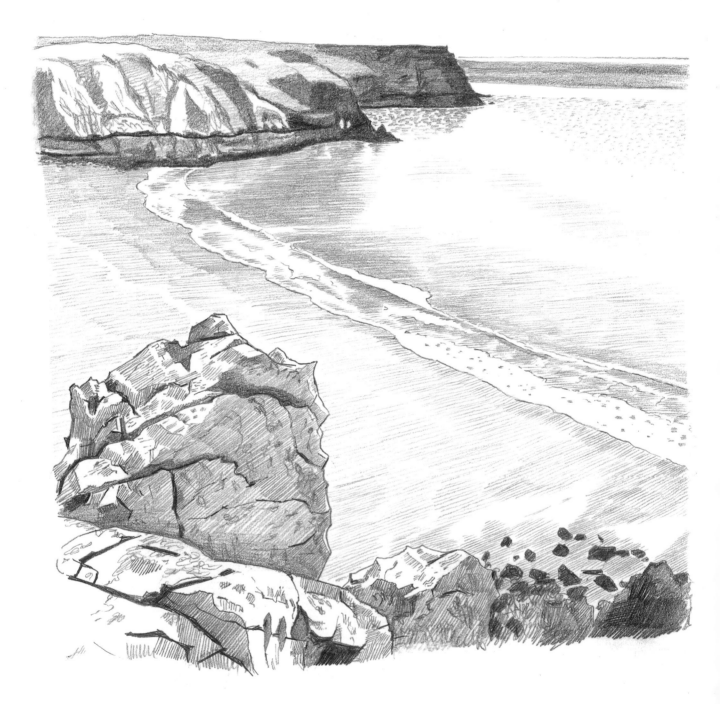

1.

2.

1. Outline the main areas, starting with the horizon and the cliffs in the background, then the edge of the water across the bay, and finally the close-up of the nearest rocks on the clifftop.

When the outline is in place, put in the very darkest areas of the background. This will establish the values for all the other tones you will be using. Keep it simple to start with, just blocking in the main areas. Then add the lighter tones to the background, including the furthest layers of tone to designate the sea near the horizon.

2. Add tones to the beach in two stages. First, mark in very gently and carefully the tone along the line of the surf. Keep this fairly light and very even and follow the slope of the beach with your pencil marks. Next, draw the slightly darker areas of the sea where it is closest to the surf line. The contrast between this tone and the white paper left as surf is important to get a convincing effect. Lastly, put in the larger areas of tone in the sea. Use dotted or continuous lines, but don't overdo them. Leave plenty of white space to denote reflections of light. Tonal lines similar to those already put in can be carefully stroked in all over the beach area. Don't vary your mark-making too much or you may end up with the effect of deep furrows, which would not look natural on a flat beach.*

3.

4.

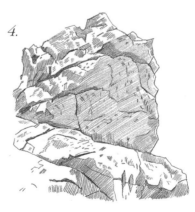

3/4. The rocks should be tackled in the same way as the boulders shown on pages 96–97. Use clear outlines, deep shadows where there are cracks, and carefully layered tones composed of closely drawn lines all in the same direction. Some of these should be in small patches, others in larger areas. Leave all well-lit surfaces as white paper, with only marks to show texture.*

SEA IN THE LANDSCAPE: PRACTICE WITH BRUSH AND WASH

One of the most effective, and fun, ways of capturing tonal values is to do them in brush and wash. In this view of the Venetian lagoon in early morning, looking across from the Guidecca to the island of San Giorgio, its Palladian church etched out against the rising sun, the use of wash makes the task of producing a successful result much simpler. Getting the areas of tone in the right places is the key to success. It doesn't matter if your final picture is a bit at variance with reality. Just make sure the tones work within the picture. More confidence is needed for this kind of drawing, and it is advisable to practise your brush techniques before you begin to make

sure the wash goes on smoothly. Don't worry if you make a mistake. You certainly won't get it right first time, but over time you will come to appreciate the greater realism and vividness this technique allows.

Begin by sketching out very lightly the outline shape of the background horizon and the buildings. Don't overdo the drawing; keep it to a minimum. If you are feeling very confident, use the brush for this first stage.

First the main shape of the island and its church was brushed in with a medium tone of wash. Then while it dried the far distant silhouette of the main part of Venice was brushed in with the same tone. Then the

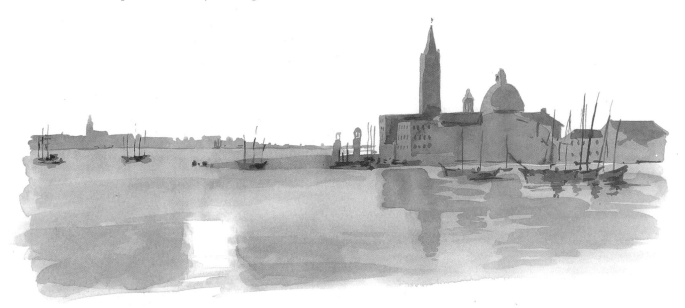

1. The first tone to put in is the lightest and most widespread which shows us the horizon line and the basic area of the buildings with differentiation except where they jut up above the horizon and are outlined against the sky. Leave a patch of white paper to indicate the lightest reflection in the water. Don't worry if your patch doesn't quite match the area that you can see.

2. Your second layer of tone should be slightly heavier and darker than the first. This requires more drawing ability, because you have to place everything as close as possible to effectively show up the dimension of the

buildings. Also with this tone you can begin to show how the reflections in the water repeat in a less precise way the shapes of the buildings. Once again, try to see where the reflections of light in the water fall.

3. The third layer of tone is darker still. With this you can begin to sharply define the foreground areas. The parts of the buildings strongly silhouetted against the sky are particularly important. Now put in the patches showing the boats moored near the quay and the dark, thin lines of their masts jutting up across the sky and buildings.

darker patches of tone on the main area were put in, keeping it all very simple. Now it was possible to wash in a fairly light all over tone for the water, leaving one patch of white paper where the reflected sun caught the eye. Even darker marks could now be put in with a small brush to define the roofs, the windows and the boats surrounding the island. The reflections in the water are put in next. After that, when all is dry, add the very darkest marks such as the details of the boats, to make them look closer to the viewer than the island and background.

1.

2.

3.

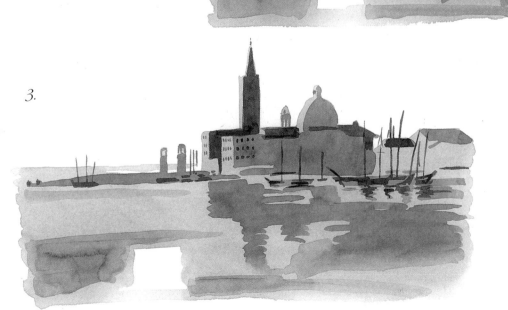

You can go on adding detail but these first three stages are the most important. If they're correct the rest will work. If they're badly out the additions won't redeem your picture, and it is better to have another shot.

SKY – ITS IMPORTANCE

The next series of pictures brings into the equation the basic background of most landscapes, which is, of course, the sky. As with the sea in the landscape, the sky can take up all or much of a scene or very little. We consider some typical examples and the effect they create. Remember, you control the viewpoint. The choice is always yours as to whether you want more or less sky, a more enclosed or a more open view.

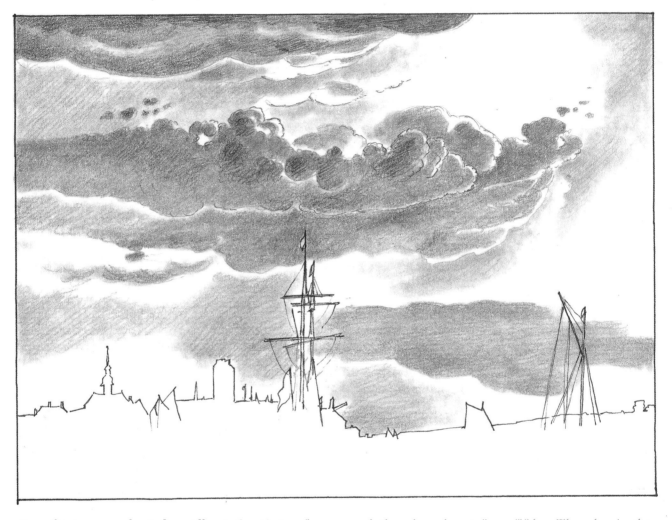

Our first example (after Albert Cuyp) is of a dramatic sky with a chiaroscuro of tones. Very low down on the horizon we can see the tops of houses, ships and some land. The land accounts for about one-fifth of the total area, and the sky about four-fifths. The sky is the really important effect for the artist. The land tucked away at the bottom of the picture just gives us an excuse for admiring the spaciousness of the heavens.

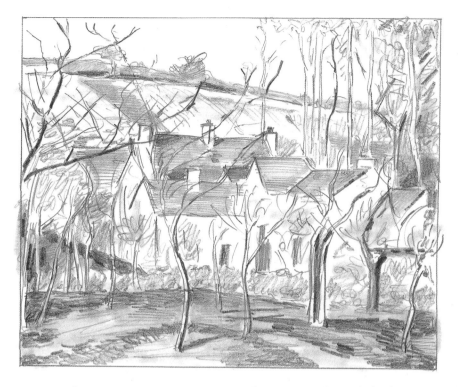

This country scene (after Pissarro) is a very different proposition. The downs behind the village, which is screened by small trees of an orchard allows us a glimpse of only a small area of sky beyond the scene. The fifth of sky helps to suggest space in a fairly cluttered foreground, and the latticework quality of the trees helps us to see through the space into the distance. It is important when drawing wiry trees of this type to capture their supple quality, with vigorous mark-making for the trunks and branches.

John Constable's view of East Bergholt church through trees shows what happens when almost no sky is available in the landscape. The overall feeling is one of enclosure, even in this copy. Constable obviously wanted this effect. By moving his position slightly and taking up a different view-point he could have included much more sky and banished the impression of a secret place tucked away.

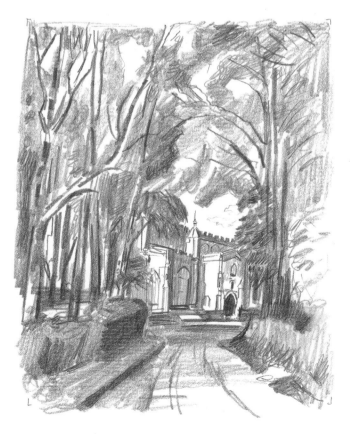

CLOUDS

The importance of clouds to suggest atmosphere and time in a landscape has been well understood by the great masters of art since at least the Renaissance period. When landscapes became popular, artists began to experiment with their handling of many associated features, including different types of skies. The great landscape artists filled their sketchbooks with studies of skies in different moods. Clouded skies became a significant part of landscape composition with great care going into their creation, as the following range of examples shows.

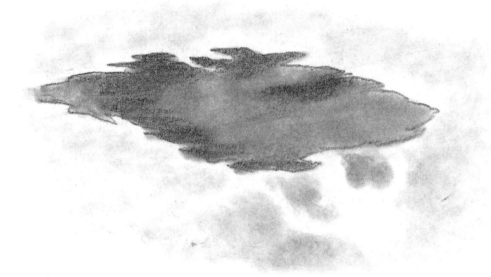

AFTER A FOLLOWER OF CLAUDE LORRAIN This study is one of many such examples which show the care that artists lavished on this potentially most evocative of landscape features.

AFTER CASPAR DAVID FRIEDRICH One of the leading German Romantic artists, Friedrich gave great importance to the handling of weather, clouds and light in his works. The original of this example was specifically drawn to show how the light at evening appears in a cloudy sky.

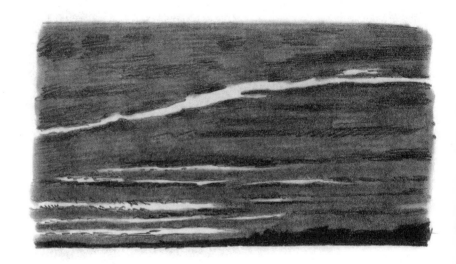

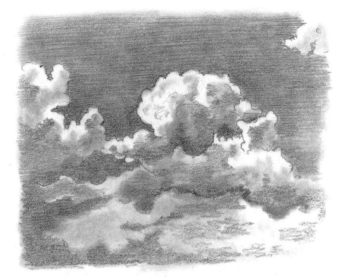

AFTER WILLEM VAN DE VELDE II
Some studies were of interest to scientists as well as artists and formed part of the drive to classify and accurately describe natural phenomena.

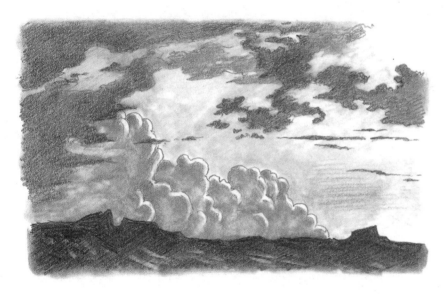

AFTER ALEXANDER COZENS
The cloud effects are the principal interest here. The three evident layers of cloud produce an effect of depth, and the main cumulus on the horizon creates an effect of almost solid mass.

AFTER J. M. W. TURNER
Together with many other English and American painters, Turner was a master of using cloud studies to build up brilliantly elemental landscape scenes. Note the marvellous swirling movement of the vapours, which Turner used time and again in his great land- and seascapes.

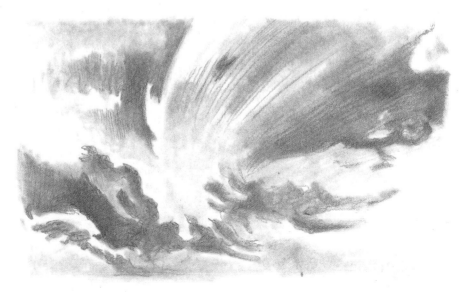

A DRAMATIC SKY: PRACTICE

Here is a large dramatic sky, after Constable, depicting a rainstorm over a coastal area, with ships in the distance. The sweeping linear marks denoting the rainfall give the scene its energy. The effect of stormy clouds and torrential rain sweeping across the sea is fairly easily achieved, as long as you don't mind experimenting a bit. Your first attempt might not be successful, but with a little persistence you will soon start to produce interesting effects, even if they are not exactly accurate. This type of drawing is great fun. Keep going until you get the effect you want.

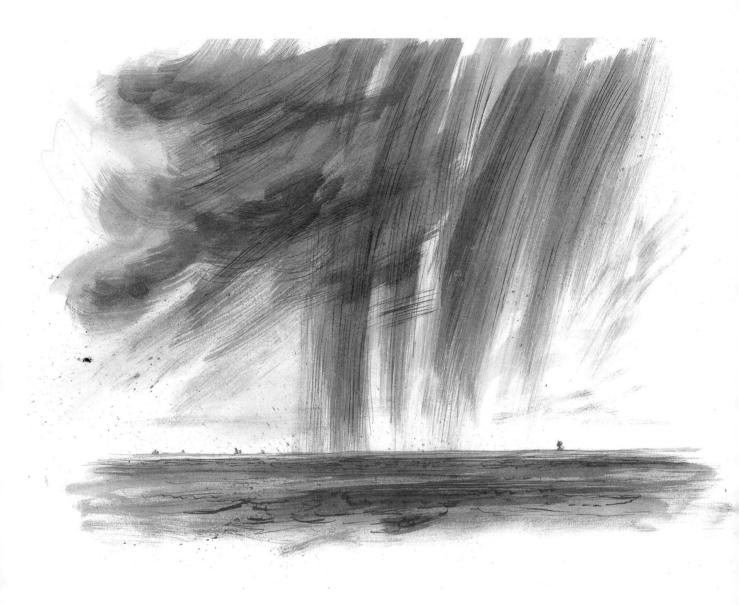

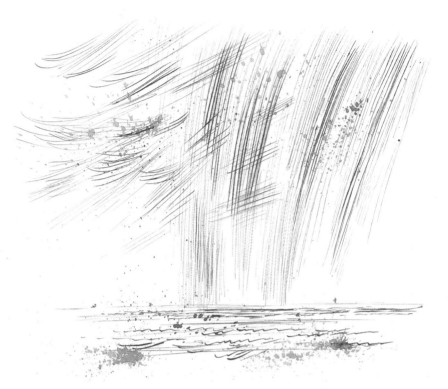

For the first stage use a fine pen with a bit of flexibility in the nib and black ink. Scribble in vertical and wind blown lines to suggest heavy rainfall. The sea can be marked in using both fine horizontal strokes and more jagged, fairly strong wave-like marks. To complete the effect, dip a hogs-hair brush into dark watercolour paint and splatter this across areas of the picture. This produces a more uneven texture to suggest agitated sea and rain.

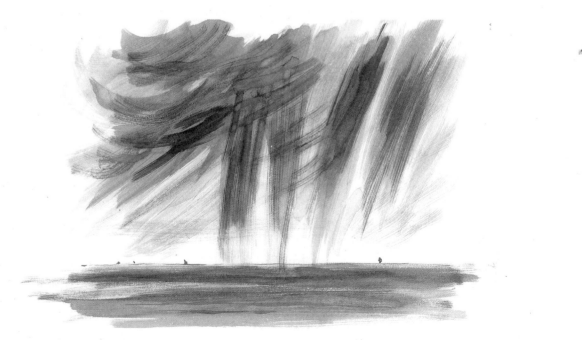

Then, using a large and small (size 12 and smaller) hogs-hair brush, put in pale washes of watercolour across the sweep of the rain and horizontally across the sea. Repeat this with a darker tone until you get the effect you require in the sky and sea. Allow the brush to dry out periodically and then apply almost dry brush marks to accentuate the effect of unevenness or patchiness.

SKY: EXPRESSIVE CLOUDS

The sky plays a very dramatic role in these two examples of landscapes: copies of Van Gogh's picture of a cornfield with cypress trees, and of Van Ruisdael's 'Extensive Landscape'. Although different in technique, both types of landscape are easier to do than they look.

The Van Gogh copy is characterized by strange, swirling mark making for the sky, trees and fields. The feeling of movement in the air is potently expressed by the cloud shapes which, like the plants, are reminiscent of tongues of fire. Somehow the shared swirling characteristic seems to harmonize the elements. The original painting was produced not very long before the artist went mad and killed himself.

Draw in the main parts of the curling trees and clouds and the main line of the grass and bushes. Once you have established the basic areas of vegetation and cloud, it is just a case of filling in the gaps with either swirling lines of dark or medium tones or brushing in lighter tones with a stump. Build up slowly until you get the variety of tones required.

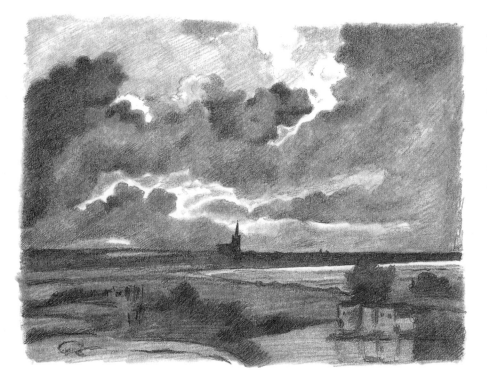

Ironically the land referred to in the title 'Extensive Landscape' only takes up a third of the space. The clouds, drawn in contrasting dark areas with a few light patches, create an enormous energetic sky area in which most of our interest is engaged. The land by comparison is rather muted and uneventful.

First, mark in with light outlines the main areas of cloud, showing where the dark cloud ends and the lighter sky begins. Draw in the main areas of the landscape, again marking the lines of greatest contrast only.

Next, take a thick soft pencil (2B–4B) and shade in all the darker and medium tones until the sky is more or less covered and the landscape appears in some definition. Finish off with a stump to smooth out some of the darker marks and soften the edges of clouds. The more you smear the pencil work the more subtle will be the tonal gradations between dark and light. Afterwards you may have to put in the very darkest bits again to increase their intensity.

THE SKY AT NIGHT

One difficulty of drawing at night is the dark. For this reason a townscape is a more obvious choice because you can position yourself under a lamp-post and draw from there. In the first of our two examples light provided by the moon is spread across the scene by the expedient device of the reflective qualities of a stretch of water. In the second, moonlight also comes into play, although less obviously. Night scenes are always about the lit and the unlit, the reflective and the non-reflective.

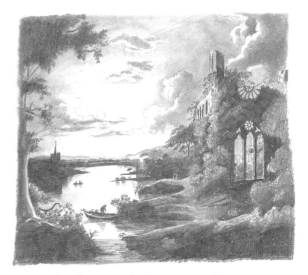

The classic picturesque scene was for many years the whole point of landscape painting. Artists would find a rugged, untamed spot that would appeal to Romantic sensibilities and drew it at a dramatic moment. In this copy of a Harry Pether painting of Anglesey Abbey, a ruin in the best Gothic taste is shown against gleaming water and moonlit sky. The clouds are almost as carefully designed as the position of the ruins. All elements in the picture combine to create an atmosphere of delight in the airy qualities of the nocturnal scene.

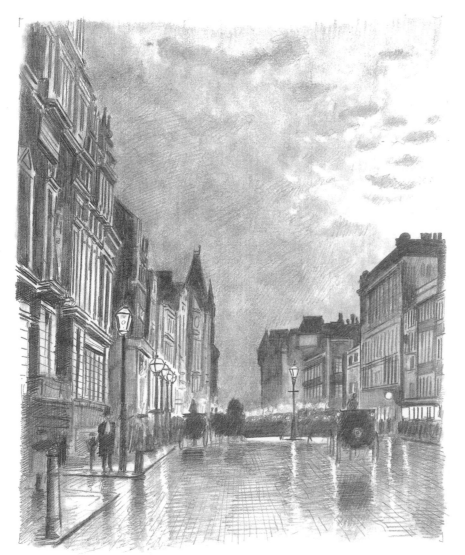

The British artist Atkinson Grimshaw was known for his depictions of the city after dark. After 'Piccadilly at Night' captures the effects of a dark cloudy sky with the hint of moonlight and dark, looming buildings lit by street lamps, windows and cab lights. A recent downpour helps to emphasize the brilliance of the light.

Study the two stages opposite leading up to the final drawing.

As you draw in the main elements be aware of the perspective effects of the buildings along the street. Leave white paper to show where the lamps are and also their reflections on the wet street. Put in very strongly with dark lines the pillars, cornices, window ledges, etc., of the buildings.

The light and dark areas in the sky should appear softer in contrast to the lines used for the buildings. The lighter areas can be smudged across with a stub to keep them looking lighter but not as bright as the lamps. The only white paper showing should be to denote the source of light and the reflections of it. The whole of the sky area should be softened with the application of the stub. When you have uniform greys and darks over the whole area, take a putty rubber and lighten up the clouds nearest the moon's glow.

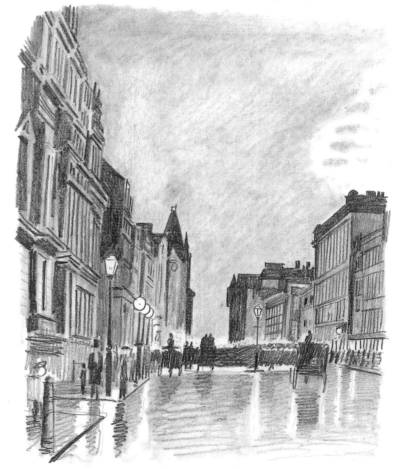

Manipulating Space

THE SPACE IN A LANDSCAPE IS TAKEN UP BY foreground, middleground or background. The difference between these three grounds is mainly one of distinctness. The more distant the feature, the softer the shape and less distinct the details. The examples given in this section show you typical examples of the three grounds and how they relate. In the first set of images, you will notice that foreground features are usually in the lower part of the picture, to either side or sometimes framing the whole view.

Usually the main point of a picture resides in the middleground, because this is the area containing the most interesting features, although there are rare examples of

pictures with no middleground. Sometimes the background holds the main feature – for example a mountain or the sea. Even when it does not it should never be regarded as of no account. A background amounting to little more than a clear sky can be invested with interest, perhaps by the addition of a few atmospheric clouds.

It is best not to be too dogmatic about which area is the most important. Essentially, all three grounds should work together to give the effect of space. Be prepared to be surprised by the way these grounds can be used in combination to alter a view. It is very important to decide how the grounds relate in a particular view. Once you have decided on their respective roles, you can then adapt your drawing techniques to emphasize – or at least show clearly – the change that takes place as the eye moves into the depths of a picture. Remember that drawing is an illusion of space and reality, appearing to show the impossible – depth on a flat surface. Using the right methods will help you to maintain this illusion and cheat the eye. The artist is a bit like a conjurer. The satisfaction we get from seeing an illusion well constructed is part of the fun of making pictures. As you will see, sometimes one part is more important and more dominant than the others. Sometimes one area disappears all together.

When you are next in the position to enjoy a long view of the landscape, make the effort to work out which is your foreground and where it ends, which is your middle ground and where it begins and ends, and where is your background and where that begins. This systemizing of your vision will help you to draw what you see convincingly.

LEAVES, GRASS AND FLOWERS

Plants carefully drawn instantly tell us that they are very close to the viewer and help to impart a sense of depth and space to a scene, especially when you contrast the detail of the leaves with the more general structure of whole trees further away.

A very good practice, when you are unable to find a satisfying landscape view, is to draw in detail the leaves of plants in your garden or even in pots in your house. This exercise is always useful and never a waste of time because it helps to keep your eye in and your hand exercised. The information you get from it about growth patterns will also help when you start on a full-blown landscape.

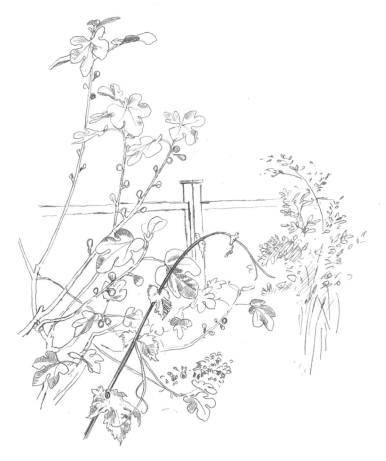

Our first example is of a fig bush with some vine leaves growing up from below a window and across the view of the fig. An exercise of this type gives you the chance to differentiate the closer plant from the further by altering your drawing style.

Tall grass, either ornamental or wild varieties, or cereal crops, can give a very open look in the forefront of a scene. The only problem is how much you draw – putting in too much can command all the attention and take away from the main point in a scene.

You will find these next two exercises useful when you have to draw large amounts of grass. Note the overlapping tufts and smaller plants like clover tucked in at their bases.

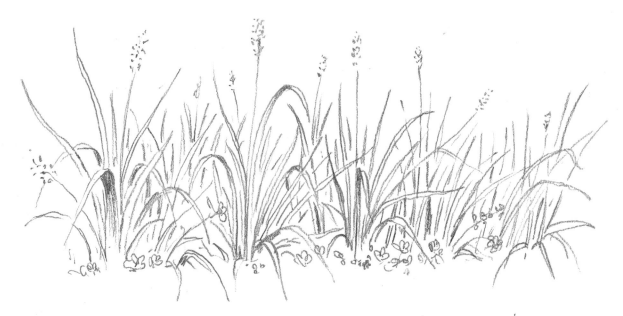

Drawing a single tuft of grass can be painstaking but provides a useful reminder of the growth pattern of grass. Note how long, thin leaves bend out from the main plant with its seed-carrying stalk rising above them.

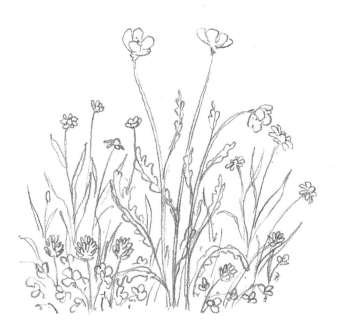

A few clumps of flowers placed towards the front of a scene can quickly engage the eye and add to the freshness of your picture. Whatever variety of flower you choose, make sure you observe them closely to capture their habit and principal characteristics accurately.

FOREGROUND DETAILS: NATURAL STRUCTURES
Now we turn to the rock formations that lie under the vegetation and help form the bone-structure of the landscape. First of all, find a few chunks of rock from wherever you can, from a garden, a beach or a park. My examples are actually geological samples, but you don't need to go to the same trouble. Most well tended flower-beds will have a few stones in them. If you are really stuck, dig a hole in a piece of wasteland or your backyard. You won't have to dig very deep before stones show themselves.

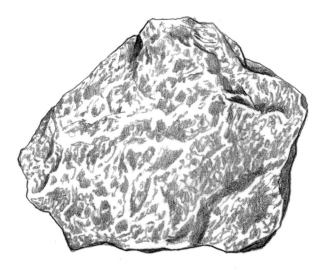

Dunite

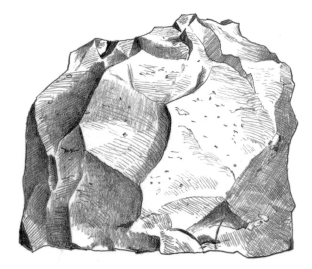

Comendite

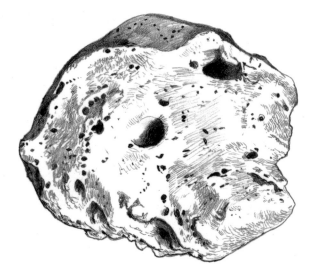

Pumice

These shining examples of rock were obtained from the geological section of a museum where they sell small pieces of rock to help you learn to identify the various types. They were chosen for their clearly defined differences. Note the differences in regularity and holes in the surface.

Even in relatively tame landscapes quite magnificent pieces of rocky structure can be found, such as the one shown. Practise drawing the main shapes and how the texture repeats or contrasts in different areas.

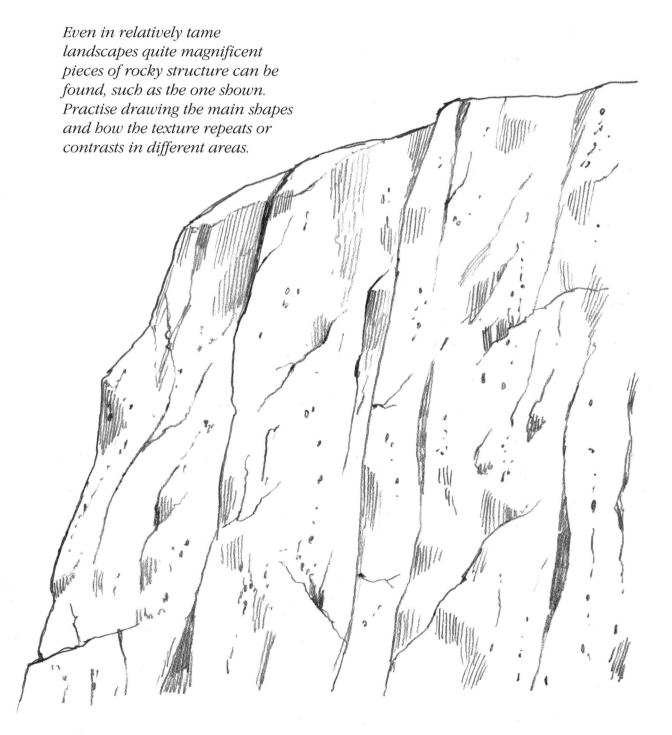

FOREGROUND: FRAMING THE PICTURE

Here are two sketches I did while holidaying in Greece. Note how in each picture elements in the foreground combine to provide a perfect frame for the view. I was not aware of this natural frame until I started to consider the view and how best to draw it. Allowing us to see what is in front of our eyes is one of the aspects of drawing that never fails to delight me.

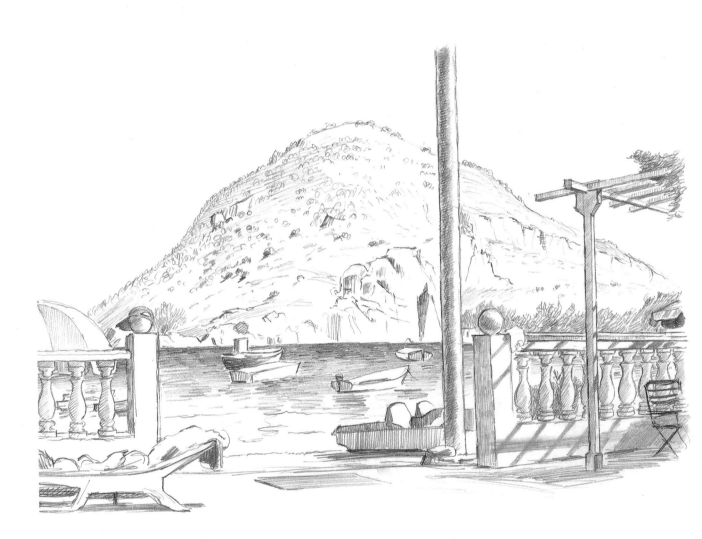

The man-made world of the holiday beach of Tolon is the main subject here. In the foreground there is a suggestion of a pergola, and sun loungers, pedaloes, a solid post for lighting and a sturdy veranda wall are in evidence. Framed between these details is a strip of sea with its moored pleasure boats and rafts. Across the stretch of water we can see an island, which is known locally as Aphrodite's Breasts on account of its twin hills. The carefully built foreground helps to create the feeling of serenity and well being.

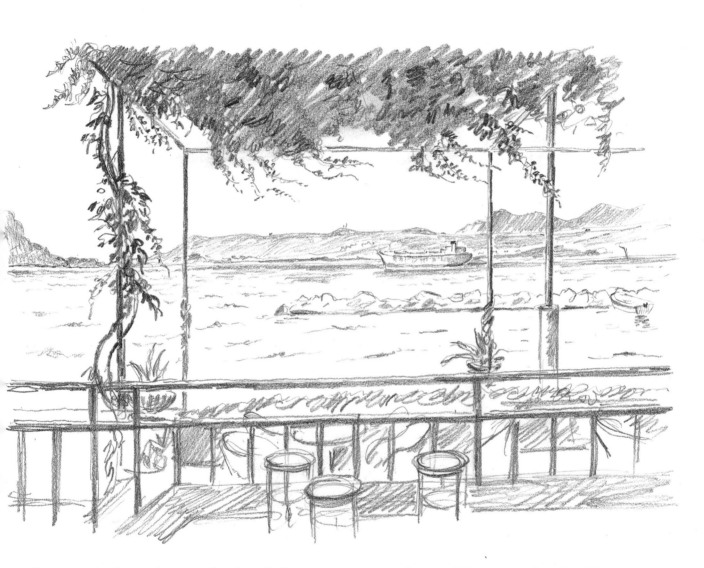

Once again the inclusion of a decidedly man-made foreground, this time in the shape of seats and railings, helps to temper the rugged naturalness of the sea and rocks. The view is of Navarino Bay as seen from Pylos.

INDICATING DISTANCE

In most landscapes you visit there will be man-made objects that can work in your picture as an instant pointer to the distance beyond or the distance between the viewer and the object. In this next series of drawings the subtler aspects have been purposely left out in order to show how foreground objects give definite clues as to size and distance

A picket fence looks simple enough but to draw it is quite an exercise if you are to get the structure correct and capture its tones and texture. Placed in the foreground of a picture,

it can be used as an indicator for the rest of the view, enabling us to relate to the size of the pickets and so judge the distances behind.

Now let's look at a fence alongside a country road with an open field and trees behind it. The fence must stand at waist-height at least, so giving the trees and spaces behind it a sense of distance, although these are drawn without any real effort to show distance variations. The croquet hoop in front of the fence provides another size indicator, but it is the fence that shapes our idea of depth in the picture.

A little way past the fence in this drawing you will notice three trees which act as a sort of frame for the landscape behind. We can tell by the line of the turf in which the trees are standing that they are a few yards from the fence and so we get some idea of their size. The field and simple depiction of tree lines behind the trees in the foreground give an indication of not only the space behind the fence and trees but also the slope of the landscape, dipping away from us and then rising up again towards the horizon.

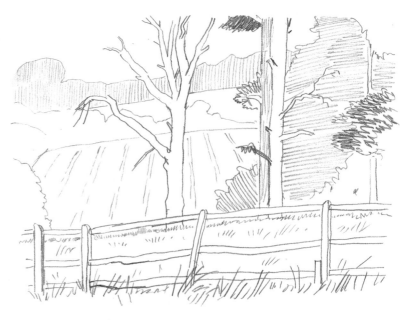

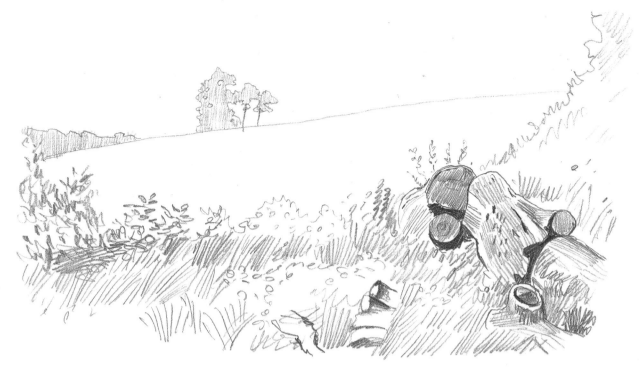

This example doesn't actually show a man-made object, but one affected by the activity of man. The large chunky logs, half hidden in the long grass next to a low hedge, give a very clear indication of how close we are to them, and also how far we are from the stretch of hillside with its isolated trees on the skyline. The log offers a simple yet effective device to give an impression of open space.

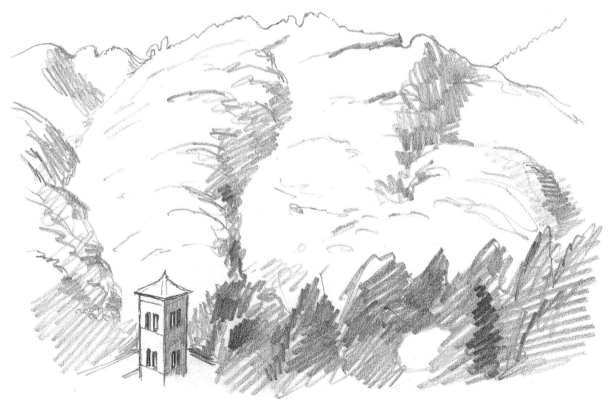

Our next scene is quite unusual and one I happened upon in an old village called Boveglio, near Lucca in Italy. The view is across a steep valley. On the opposite side thickly wooded hills sweep up to the skyline. The rather diminutive looking tower below belongs to a church in Boveglio which is in fact large enough to house a couple of bells.

PRACTISING FOREGROUND FEATURES

Urban environments offer opportunities for practising drawing all sorts of objects you may want to include in your compositions as foreground details. A garden table and chairs or machinery such as a bicycle are found in most households and can be used creatively to make satisfying mini-landscapes. It is amazing how ordinary objects can add drama to a picture.

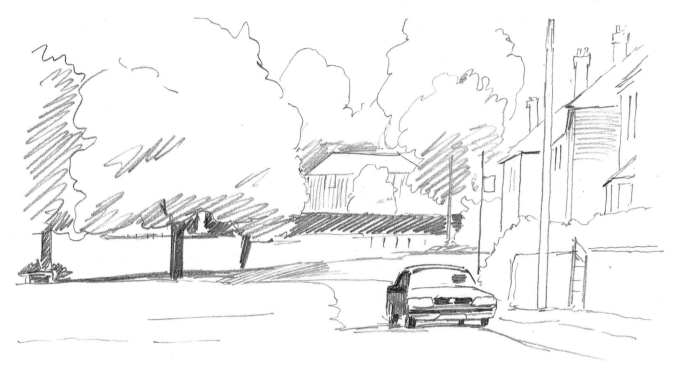

The houses to one side of this village green in southern England are useful visual indicators of size, but even more effective is the lone car parked on the pathway, because this tells us something about the distance between it and us. It also gives us a good idea of the space behind the trees in the middle distance and the hedges and house behind.

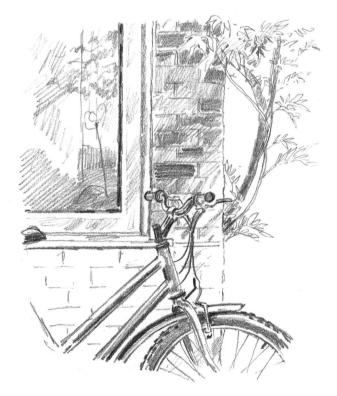

The bicycle lends an air of habitation to the blank corner on which it is balancing, with the vine curving around and up the brickwork. If part of the landscape could be seen past the corner it would give a very sharp contrast between our position as viewers and whatever was visible behind. Even a small garden would give an effect of space. If the landscape was a street the contrast would be even more dramatic.

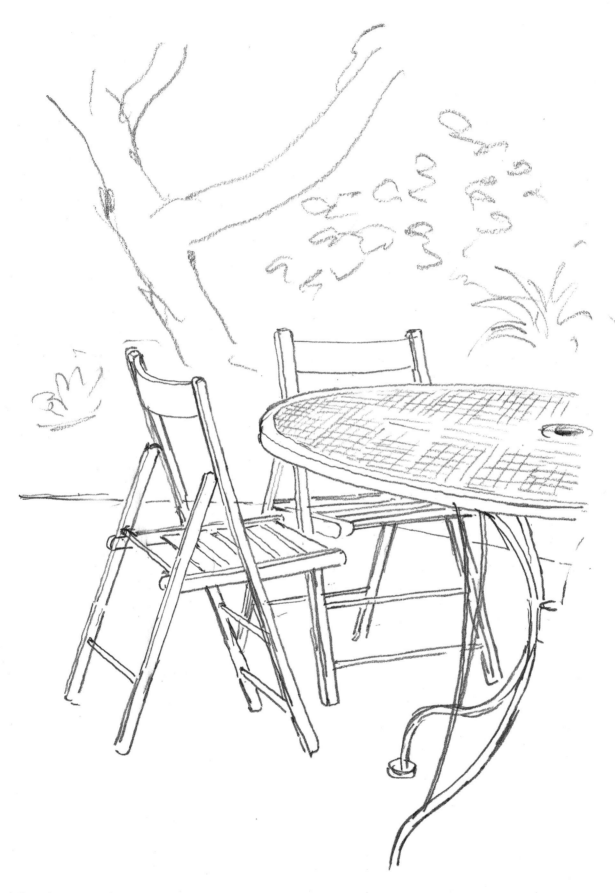

The faint indication of trees and bushes behind this sketch of chairs around a table gives a sense of open space, whether we are viewing the scene through a window or from a terrace outside. There is also an impression of life going on, but momentarily interrupted.

PRACTISING FOREGROUND FEATURES

Architectural features abound in town and country, in fact anywhere there is human habitation. Any details of architecture that clearly give an impression of age and sometimes disrepair are always good points of interest to include in a picture.

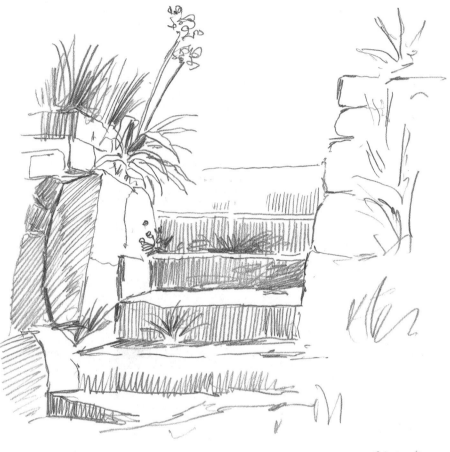

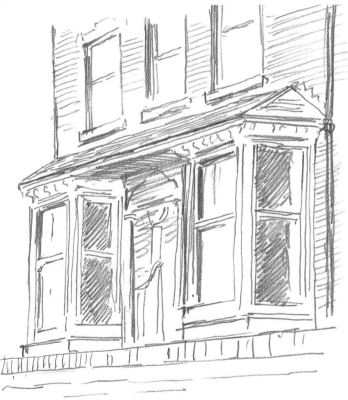

Steps or the front of an ordinary house are the sorts of foreground details you might well want to include in a larger composition. They are very good examples of the kinds of practice you will need if you are to develop your skills.

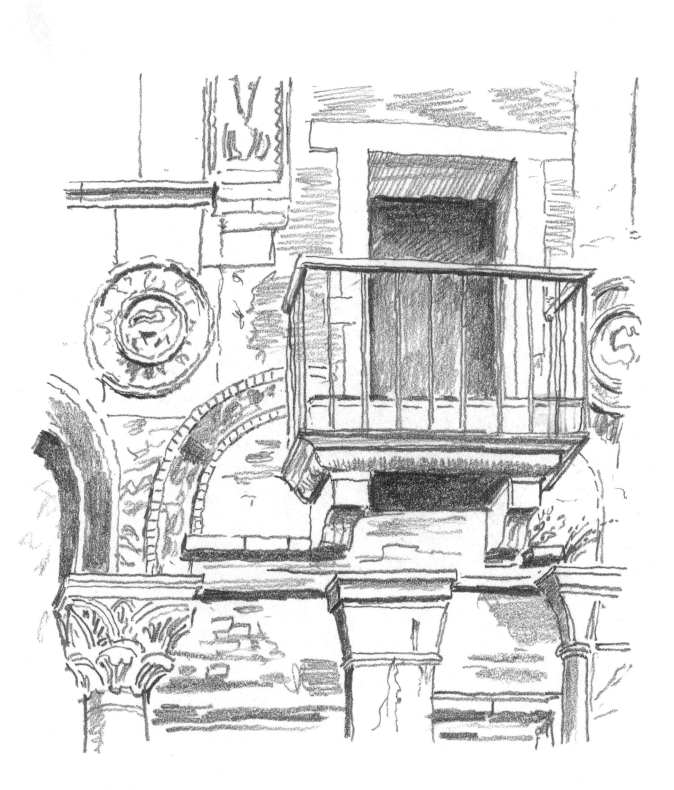

This remarkable piece of Venetian Gothic architecture could easily act as a scene-setter for a larger view of this historic city. Such details add an historic – and often very attractive – dimension to a picture.

REFLECTIONS OF SPACE

Water always works well in landscape because it introduces a different dimension as well as helping the viewer to gauge distance and space in a picture. Reflections of any kind present difficulties for the artist but they are fascinating to draw. Once you begin to see how the tones and marks work you will find them less problematical. Practising drawing puddles, ponds, lakes or rivers will quickly improve your ability to handle water. Use the ideas thrown up in the following examples for practices of your own devising. Remember: every bit of practice will serve you well at some point and is never a waste of time.

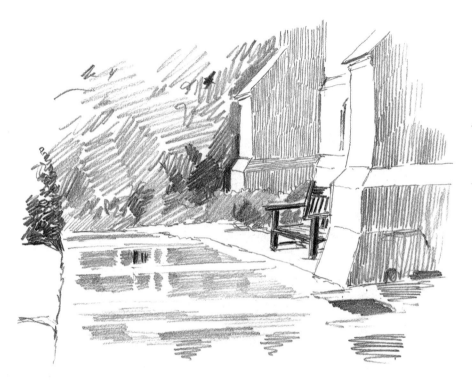

The puddles of rainwater on the path of an old country church help to produce an extra dimension of space as well as interest. What the wet path does very well is to define the flatness and space between the viewer and the walls and plants. The effect of the water on the path gives the surface a bright quality that contrasts well with the elements in the rest of the picture.

The pond in front of old houses is what takes our interest here. It provides a space that separates us from the buildings without obscuring anything. I have left out the details of the buildings to emphasize the pond's effectiveness in denoting distance. Note how the plants on the near side of the pond also act as visual indicators of distance. However, it is the smooth plane of the water, with its reflections of the darker parts of the house, which forms our sense of space.

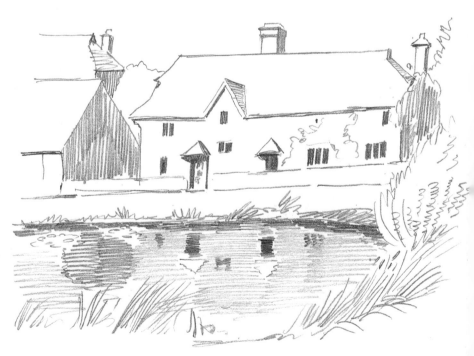

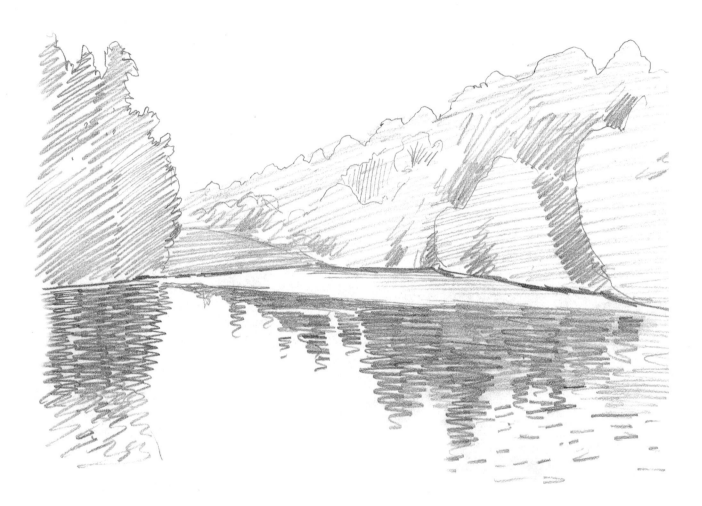

The main point of this example is how the reflections of the trees and sky on the surface of the lake provide an instant impression of spaciousness. Note how this works: from the viewer to the distant background vertically, downwards into the reflections and then upwards, where the sky is made more prominent by its reflection below. I have simplified the rest of the picture so that the effect of the reflection can be more clearly observed.

THE MIDDLEGROUND

If a foreground has done its job well, it will lead your eye into a picture, and then you will almost certainly find yourself scanning the middleground. This is, I suppose, the heart or main part of most landscape compositions and in many cases will take up the largest area or command the eye by virtue of its mass or central position. It is likely to include the features from which the artist took his inspiration, and which encouraged him to draw that particular view. Sometimes it is full of interesting details that will keep your eyes busy discovering new parts of the composition. Often the colour in a painting is strongest in harmony and intensity in this area. The story of the picture is usually to be found here, too, but not always; some notable exceptions will be among the examples shown. The eye is irresistibly drawn to the centre and will invariably return there no matter how many times it travels to the foreground or on to the background. The only occasion when the middleground can lose some of its impact is if the artist decides to reduce it to very minor proportions in order to show off a sky. If the proportion of the sky is not emphasized the eye will quite naturally return to the middleground.

Let us now compare and contrast some treatments of the middleground, starting with two sharply contrasting examples.

NB: In order to exphasize the area of the middleground, I have shaded the foreground with vertical lines and the extent of the background is indicated by dotted lines.

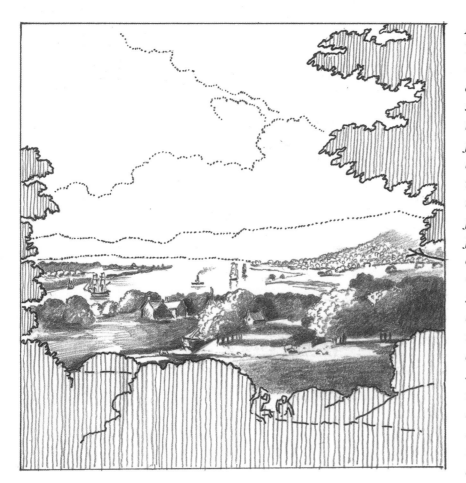

A CLASSICAL APPROACH
The centre of this picture (after John Knox) contains all the points of interest. We see a beautiful valley of trees and parkland, with a few buildings that help to lead our eyes towards the river estuary. There, bang in the centre, is a tiny funnelled steamship, the first to ply back and forth along Scotland's River Clyde, its plume of smoke showing clearly against the bright water. Either side of it on the water, and making a nice contrast, are tall sailing ships. Although the middleground accounts for less than half the area taken up by the picture, its interesting layout and activity take our attention.

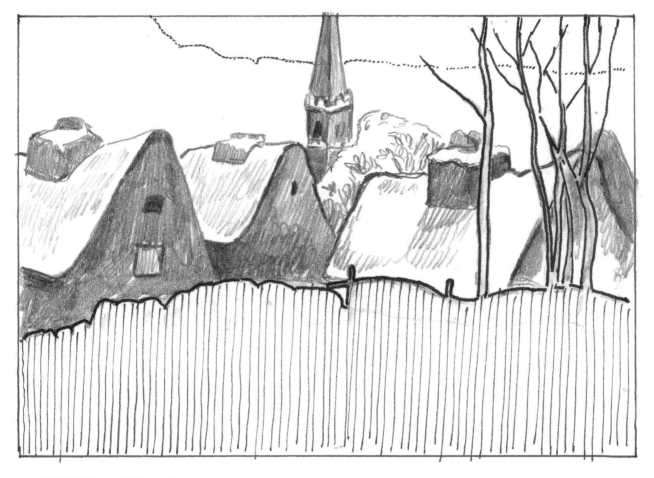

AN UNUSUAL APPROACH

In this snow scene (after Gauguin) the foreground, middleground and background take up about the same space. The primary importance of the middle area is suggested by keeping both foreground and background very simple and devoid of features. The only details we notice are the tree pattern stretching from the foreground across both middle- and background and the church steeple bisecting the background. The interest in the picture is framed between these two empty spaces which are made to seem emptier still by the snow. By contrast the central area is full of shape and colour.

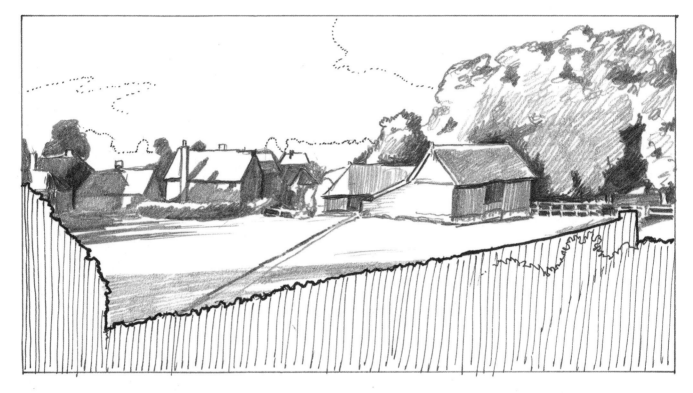

A GROUND BREAKER

No attempt has been made here (after Constable's picture of his uncle's house at East Bergholt) to centralize or classicize the arrangement of buildings. Constable believed in sticking to the actuality of the view rather than re-composing it according to time-honoured methods. The result is a very direct way of using the middleground, a sort of new classicism. Our eye is led in to the picture by the device of the diagonal length of new wall dividing the simple dark foreground from the *middleground. The sky and a few treetops are all there is of the background; note how some of the sky is obscured by trees in the middleground. Everything ensures that the attention is firmly anchored on the middleground, where the main interest of the buildings is emphasized by the small space of the garden in the front. The composition is more accidental looking – and therefore more daring – than was generally the case at that time.*

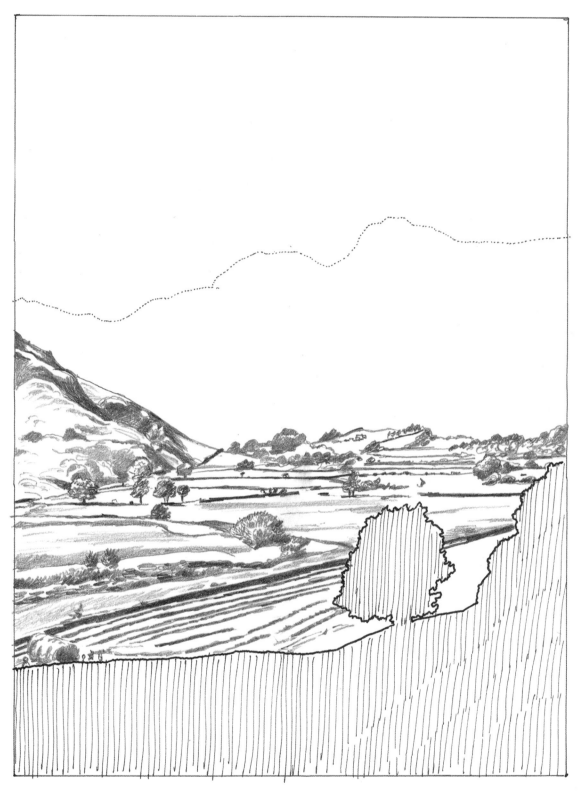

STEPPING BACK FROM THE MIDDLE

The point of this picture is actually in the background. The foreground is simple and effectively a lead-in frame. The middleground is full of interest as the floor of a flourishing valley. But the picture was framed purely for the reason of showing the mountains in the background. This time the middleground is merely a foil to make the mountains look better.

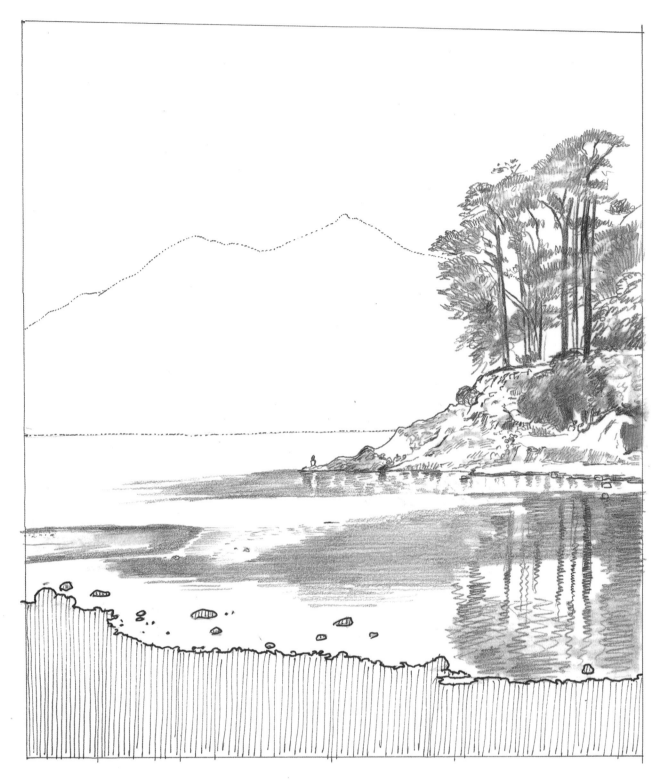

POINTING OUT THE SPACE

This view of Derwentwater in the Lake District offers a very simple yet effective way of highlighting the importance of the middleground. The majority of this area is taken up with one feature – water. However, as this might prove too bland to arrest the eye, a jutting spur of rock to the right acts as a focal point and keeps our attention well into the centre of the lake. The spur is almost like a finger pointing to the water to make sure we don't miss it.

The reflections in the water also give the expanse of lake a little more liveliness, although the smooth surface is uneventful.

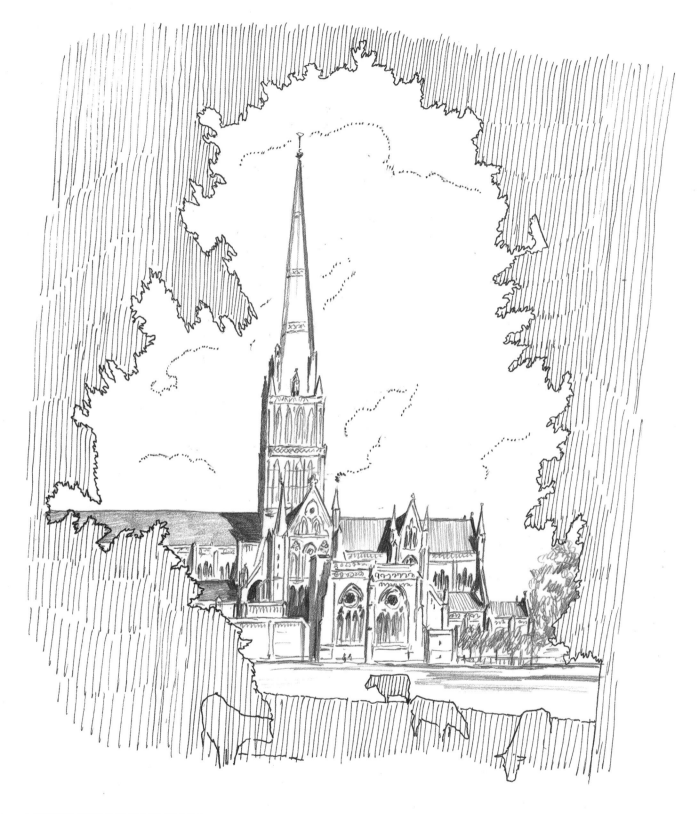

A TRIUMPH OF ECONOMY

Another picture after that master of landscape, John Constable, this time from his later years. The subject of the picture is Salisbury Cathedral, and that is just what you get. The foreground is a frame of leaves and a few cows grazing, brilliantly vignetting the building. The background is all sky, but a lively one. The magnificent spire and long nave of the Cathedral account for the whole of the middleground.

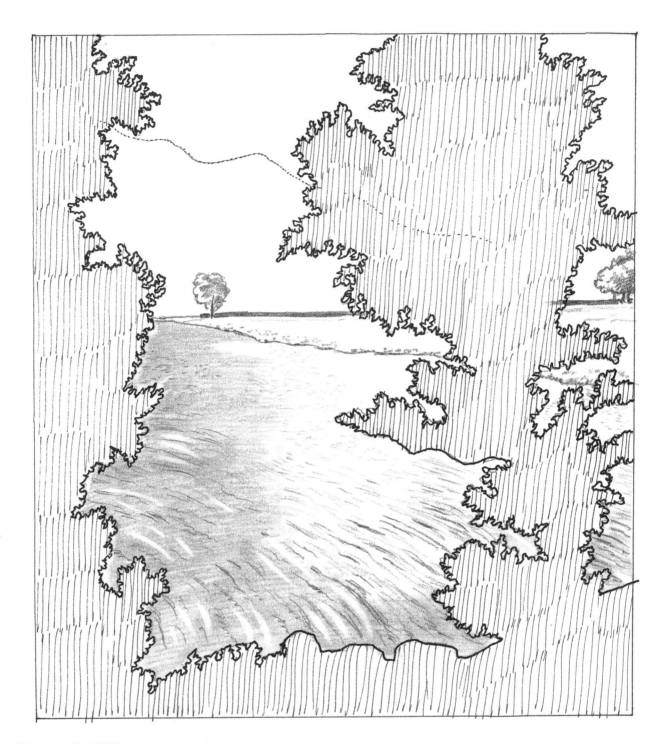

WATER FEATURE

This picture uses a similar device to that seen in the copy of the Constable (see preceding spread) but with a different result. The foreground of trees and rocks vignettes the middle and background, although less precisely, by having one tree obscuring almost half the scene. The tree is actually less solid than it appears here, and some of the scene is visible through its leaves. The background is just a mountain backdrop. The whole point of the picture, Buttermere in the Lake District, is almost the whole of the middleground. There is just a small strip of land on the far side with a tree at each end to anchor it down, but the real focus for our attention is the water.

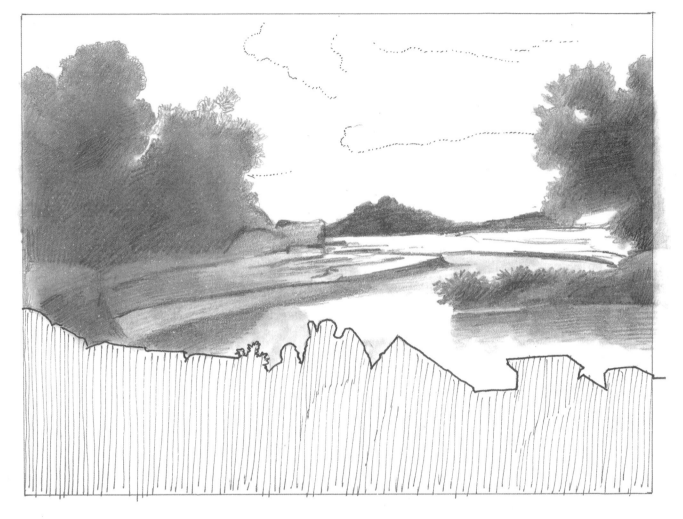

MIDDLEGROUND AS BACKDROP

We come full circle, to an example of a classic approach to landscape, this time after the redoubtable Poussin, French artist of Italian scenes. In this picture the point of interest is transposed, from middleground to foreground. The middleground is purely a landscape that takes our eye off into the distance, to a misty range of hills and some soft clouds. The real action is in the foreground, which has the figures of an angel

and St Matthew at the centre point. Although the middleground is at least one third of the whole surface area, it and the background are just beautiful foils to the rocks and two figures in the foreground. It takes a great artist to turn convention upside down and succeed brilliantly. Now that you know how it is done, try it for yourself and see if you can make it work.

THE BACKGROUND

A little experience of the way artists use the background soon changes the misconception that it is a passive part of any scene. Obviously treatments differ. Some artists make the background so important that it begins to take over the whole picture, while others may reduce it to minimal proportions. However, whether its proportions are large or small, the background is important and the only means you have of stopping the main parts of the picture being isolated. Always remember that the background, however simple, is the stage on which the action of your picture takes place. Without it, your picture will look stilted and without depth.

NB: Only the background is drawn up; the foreground and middleground are shown as toned and blank outlines respectively.

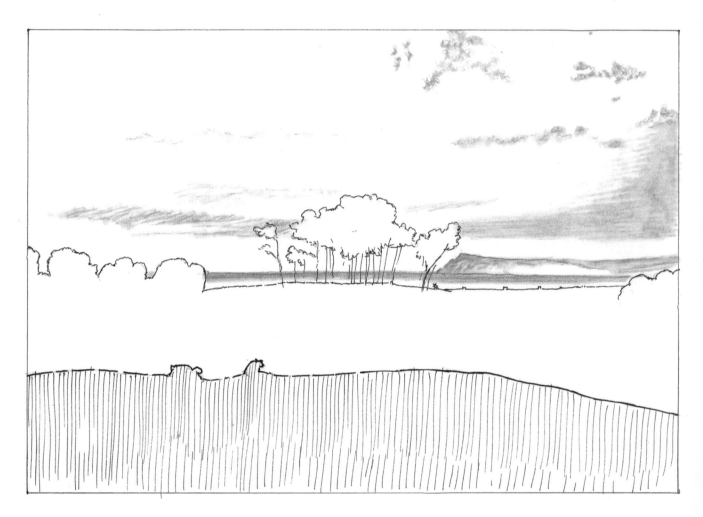

SUPPORTING ACT

This background (after Turner's picture of Pevensey Bay) is most retiring and unassuming. All the interest in the picture is in the fore- and middlegrounds. Neither the very slim layer of sea and cliff on the horizon nor the peaceful looking sky insists on being noticed. This background exists solely to provide a backdrop to the interest in the main parts of the picture.

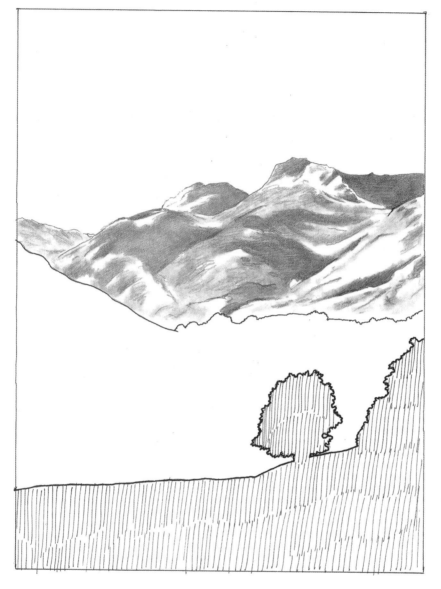

ATTENTION GRABBER

Here we see the background of the picture whose middleground we studied on page 141. Easily the most striking object in the scene, the mountain crag is the whole point of the picture. The viewpoint emphasizes its importance, the background rising majestically out of the foreground vegetation and the valley floor which make up the lower levels of the picture. The background dominates the picture, even though its tonal qualities are less intense than those of the fore- and middlegrounds. Our attention is caught by the mountain's sheer bulk.

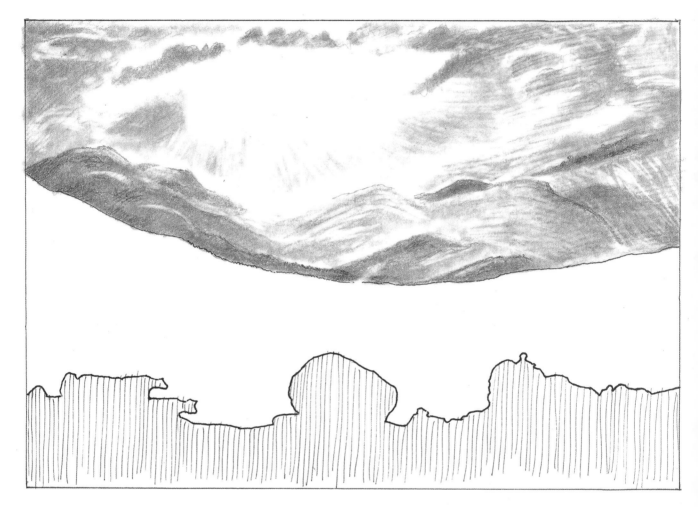

INCIPIENT DRAMA

Simmer Lake (after Turner) begins to show that great artist's interest in the elemental parts of nature. The background of sky and mountains does not have the restlessness we associate with much of his work but is nevertheless fairly dramatic. The great burst of sunlight coming through swirling clouds and partly obscuring the mountains gives a foretaste of the scenes Turner would become renowned for, where the elements of sunlight, clouds, rain and storms vie for mastery in the picture.

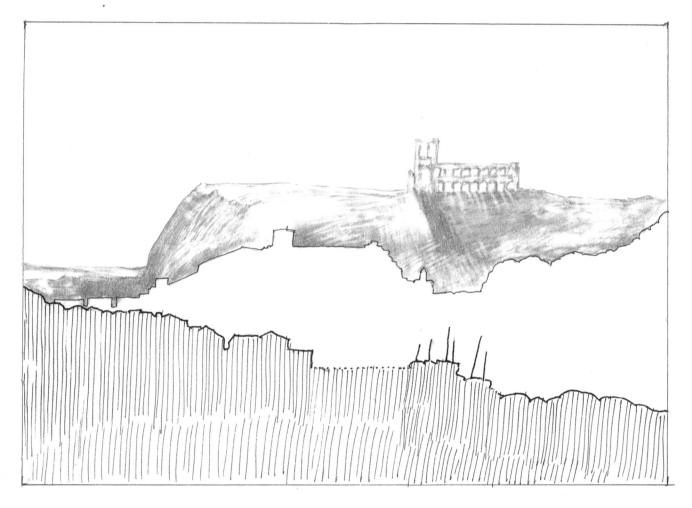

A KNOCKED BACK FOCAL POINT

In this view of Whitby (after Turner) the background is dramatic and prominent in shape while reduced in intensity. The Abbey on top of the cliff with the sun flooding through its arches creates a marvellous soft focal point above the buildings of the main part of the town. The clear bright sky helps to silhouette the background feature while also diminishing its strength in the picture by making it look almost insubstantial against the darker and more solid buildings in the town.

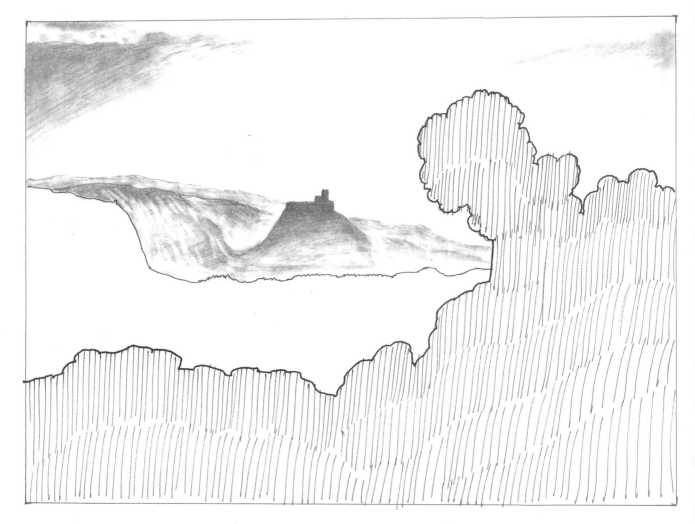

A DISTANT FEATURE

The title of this picture (again after Turner) is the name of the building silhouetted in the background, Prudhoe Castle. The picture is a brilliant piece of design by a master landscape artist. The interest is very clear because the castle is almost dead centre in the composition, and yet because of its lack of detail and its depth in the picture it seems to be both out of reach and also a beacon. Despite its distance from us, the castle's position and the way it is framed by both foreground and middleground ensure that our attention returns after scanning the rest of the picture.

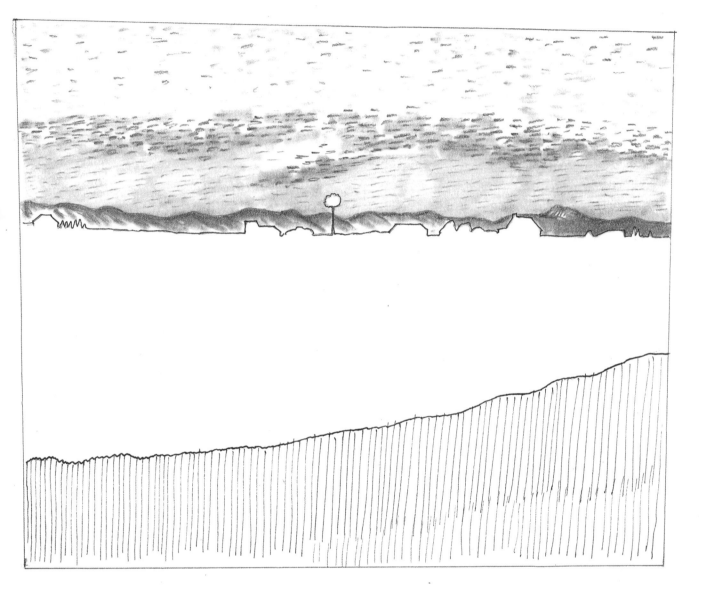

MINIMAL BACKGROUND

The main feature of this picture (after Van Gogh) lies in the middleground, where many peach trees are depicted in blossom. In the original, Van Gogh reduced the background to a very minimal range of hills only just appearing above the housetops. He painted the lively sky in small patches and strokes of paint which match the hills for intensity. By treating them in the same way he manages to create a backdrop where sky and hills, although clearly defined, produce a similar effect.

REDUCED EFFORT

This example (after Monet's picture of a small cabin on the rocky coast at Varengeville) does away completely with the middleground and places the foreground against an immense, serene space of sea and sky that merge into each other. The curve of the edge of the coast frames this rich looking tone with just a couple of tiny spots of white that we read as sails. The overall texture of the background makes a very effective surface on which to place the rocks, vegetation and cabin of the foreground.

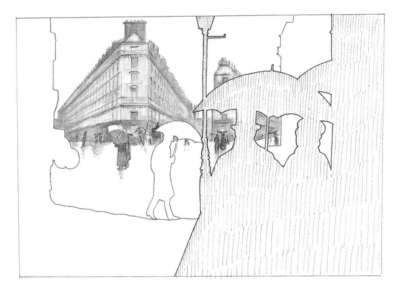

BACKGROUND PRESSING IN

Here, in a scene of a wet Paris street (after Caillebotte), is a strange arrangement of foreground, middleground and background. Large buildings or busy streets often make up the backgrounds in pictures of town- or cityscapes. These backgrounds often seem much closer than those of open landscapes. Caillebotte reduced his foreground effectively to one side of the picture and made his middleground form a deeper frame around the picture. The large blocks of apartments become very strong statements, but are still very much a background to the people and activity in the streets. In effect the background is brought much closer to us as viewers and yet does not take our attention away from the figures. The background has the effect of showing us what cities do to humanity.

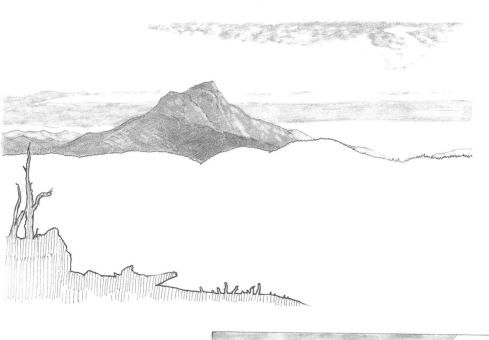

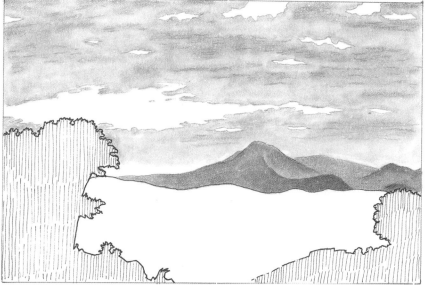

SIMILAR BACKDROPS, DIFFERENT EFFECTS

Here we have two backgrounds to American landscapes that appear similar in space but are focusing your attention in different ways to get their effect. The more you study landscape paintings and drawings the more interesting these subtle effects become.

The first picture (after S. R. Gifford) is of a lake at twilight. It just so happens that behind the lake is a large mountain peak that dominates the area. The calm sky and remote peak provide focal points but they don't hold the attention, which will keep returning to a hunter and his boat in the middleground (not shown). The middleground takes up almost half of the area, whereas the background of

sky and mountain account for about one-third, accentuating the distance separating them and our sense of what is the most important feature in the picture: the man and his boat.

The second picture (after F. E. Church) is very much of its subject, Mount Ktaadn. The artist has kept the background landscape rather diminished but with an enormous expanse of sky with clouds reflecting the sunset. The darkness of the mountain makes it almost a silhouette, thus increasing its air of mystery. The middleground and foreground are reduced in size, between them only taking up one third of the picture.

153

Special Places

*I*N THE NEXT SECTION WE WILL LOOK AT PLACES that offer very different challenges from the ones usually met when we draw landscapes. The sites chosen fall into one of two categories: either extraordinary natural phenomena or man-made features that give the landscape a different look.

Natural landscapes are usually untouched by man's influence, and as a result invariably situated in out of the way places that are not easy to get to without a great deal of preparation. If you are the sort of person who enjoys adventure

holidays in remote areas of the world you will probably be spoilt for choices of subject. All you need is to pack a sketchbook in your rucksack and take the time to record the spectacular sights you witness on your travels. For many of my examples I have had to rely on photographs, first-hand descriptions and my imagination to help me convey their specialness.

Man-made edifices can also have the effect of dramatically changing the look of a landscape. When they are very old we can even believe them to be natural structures, because that is how they seem to us. Many pre-historic sites look so in tune with the landscape that they don't strike us as being like anything normally associated with man. In many cases legends have grown up around them which say they were made by the gods or giants or erected by magic.

In the course of making travel and living more convenient for ourselves, we humans have built many large structures. Some of them are ugly, some are very beautiful. Ugly or beautiful they are usually dramatic and can be immensely rewarding to draw. Some are now so well known that they have become clichés in our mental imaging.

People always condition the landscape they find themselves in; on a domestic scale the construction of a garden is the most obvious example of this. Whatever country you are in, some of the landscape has been altered and tamed over the centuries by farmers, landowners and industrialists. You may not always like what you see, but if you look objectively you will find much to take your interest as an artist.

Let's look at the places I have chosen to show you.

WILD PLACES

If you are lucky or adventurous enough to draw in the desert or some other vast area of wilderness, you have to realize that a small view never works in such places. You will need to show quite a large expanse of land to recreate it for a viewer. The more you can show the more effective is the feeling of wildness and space. If you show only a small part you end up with something akin to a close-up view of the moon's surface, terrain that could be anywhere. As soon as the eye can take in a large expanse of the surface, the character and thus identity of the place become obvious.

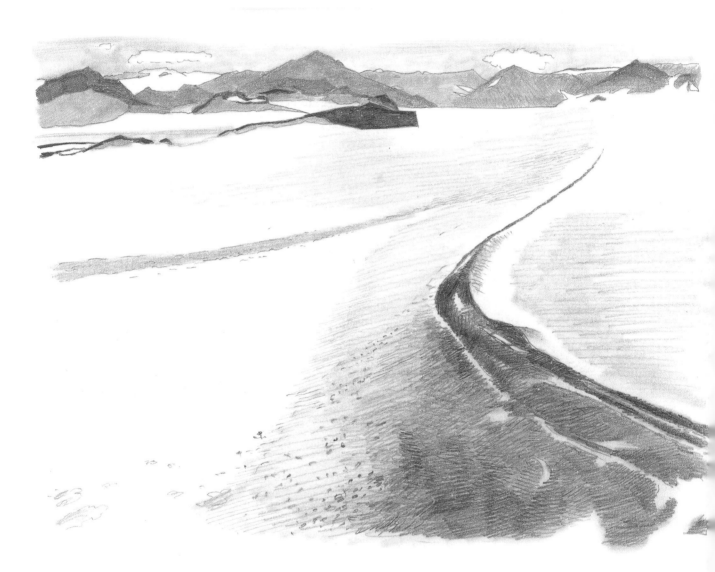

Look at this view across a glacier in Antarctica. If you saw only a quarter of this picture it would make very little sense. The great empty sweep of white frozen snow with some small ridges of windswept rock running across it gives the picture its sense of desolation. In the background the sharp peaks of the rocky mountains help to give a sense of scale. Without these clues it would not be clear that the scene was so empty of life.

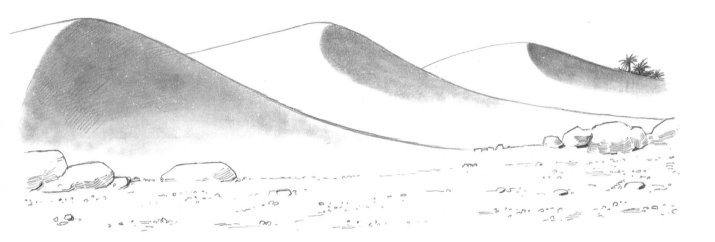

This view across a hot, dry desert somewhere in the Middle East is similarly devoid of features for the eye to dwell on. A very wide view is necessary for us to be impressed by the grandeur of such terrain. This particular view is helped by the existence of a few small rocky outcrops in the foreground and, just visible beyond the most distant of the three rises, a clump of palm trees, suggesting the location of an oasis. These are two very small points of focus but very effective in lending interest where a landscape is largely uniform.

MONUMENTAL PLACES

I would love to have visited these two great landmarks, but as even intrepid travellers would face formidable difficulties trying to get access to them, I was content to make do with photographs. You would need to be a very committed and brave person indeed to get these views. Both are stunning natural features presenting great dramatic possibilities which I have tried to capture by using bold yet quite detailed tonal mark-making.

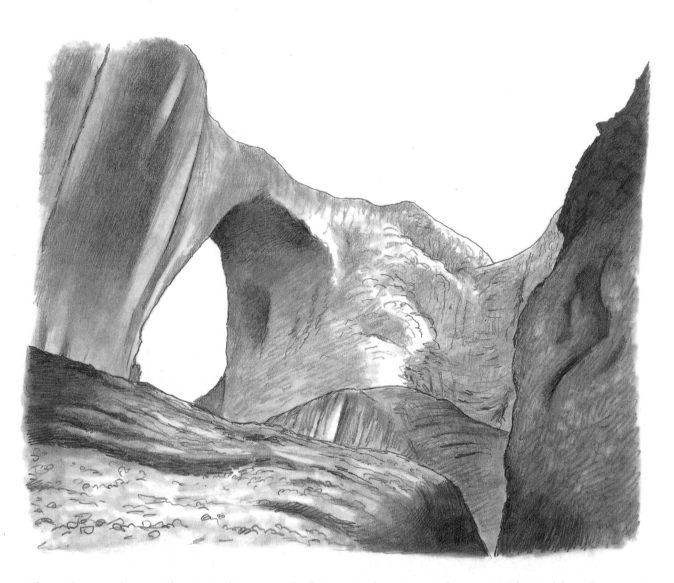

After the explorer Shipton discovered this dramatic natural feature in China, it became almost impossible for people who did not live in the area to locate it. The wild rocky terrain in which the Arch is situated even put the local people off from going

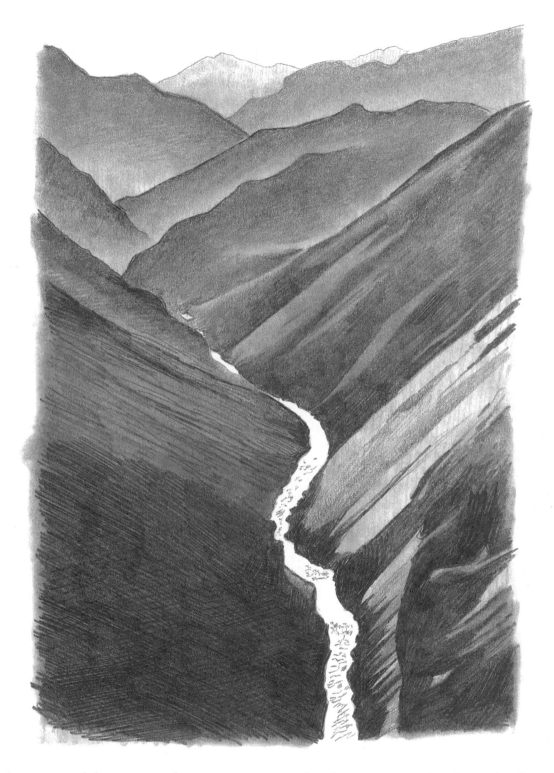

Another natural feature not known to many is the great Colca Canyon among the Andes in Peru, with its amazing river full of dangerous rapids running through it. The lure of places untouched by tourism is great. However, I suggest you serve your apprenticeship as a landscape artist in the suburbs or in the comparatively manicured countryside closer to home. You will find countless places of interest, albeit on a smaller scale, on your doorstep. Out of these you should be able to make very effective pieces of art.

159

The Romantic artists of the 19th
century vied with each other to
produce dramatic landscapes
of towering crags and toppling
mountains. Gordale Scar by
James Ward belongs to this
great tradition, its effect so
powerful as to almost
overwhelm the first-time viewer.
Many other painters at this
time in Europe and America
were producing works of
staggering size and powerful
dramatic effect, such as John
'Mad' Martin, Friedrich,
Church and Bierstadt.
Sometimes size does matter.

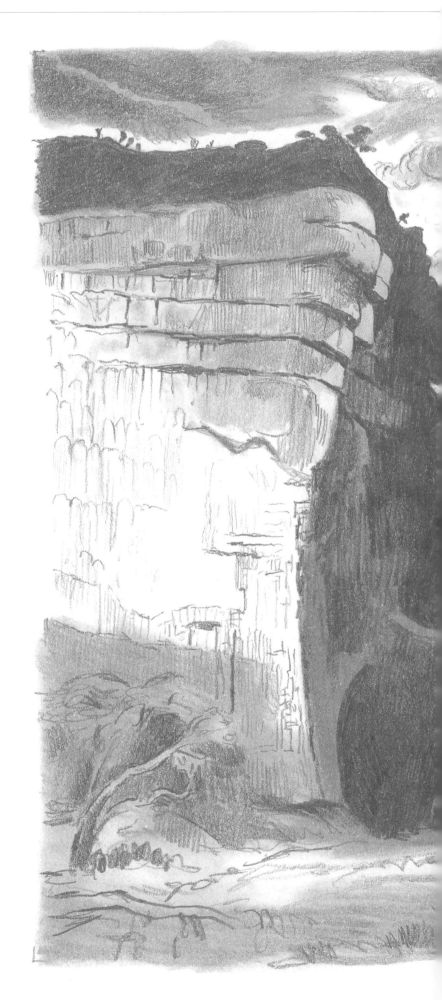

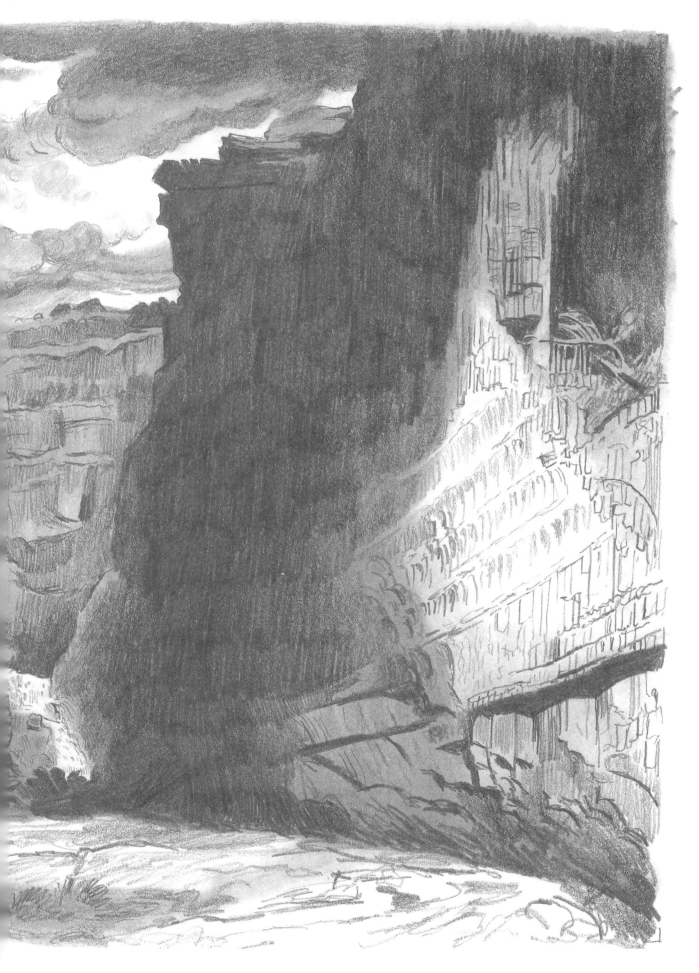

PERFECT WORKS OF ART

All of the following were made with the hand of man, not Mother Nature, and yet they seem to have been part of our consciousness for so long that they are almost accepted as being natural landmarks. Age-old, they have impressed people for hundreds of years. If we can convey something of this sense, our drawings of them will be more interesting.

Ancient places seem to possess both power and drama even if we are not sure of why they were built or the purpose they once served, as in the case of Stonehenge.

Like Stonehenge, the famous figures sculpted out of raw rock on Easter Island in the South Seas present an enigma. The fact that nobody knows their meaning does not detract from their extraordinary presence. This monument demands to be noticed.

The Taj Mahal with its amazingly balanced pristine beauty is probably one of the most well known pieces of architecture in the world, although not too many people know exactly where it is. I am told that when you see the actual building its beauty and harmony far exceed anything captured by a photograph of it. It is very difficult to give full value to a piece of architecture of this nature in a drawing, even if you are lucky enough to go to India and draw it from life.

GARDEN LANDSCAPES

The tamed landscape of a garden can sometimes seem a rather limiting space for the artist. However, if a garden has been designed with some flair, you will notice that the division of spaces in it create a new proportion of landscape. This may be smaller but it can be just as interesting to draw as a more open, spacious view.

In these three examples, the gardeners have brought a clever aesthetic quality to the manipulation of plants, walls, hedges, etc. which is very rewarding to draw.

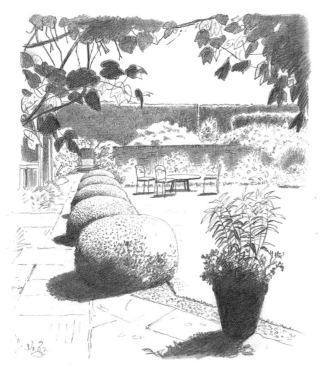

Here the hedges and bushes have been carefully trimmed to produce edges to pathways and more open spaces. The effect created is of an enclosed paradise garden. Seen from under an overhanging vine, the formal bushes clipped into large cushions define a route towards the end of an old wall, behind which stand tall clipped hedges. Planted among all this formality are clumps of flowers, potted plants, bushes and places to sit. Rather like a beautiful room without a roof, it offers the artist options for drawing from many angles.

One of the main features to catch the eye here is the topiary, which appear like chess pieces set out in rows around a lawn with larger trees seen behind and a terrace with steps leading up to it. More formal than the first example the garden is carefully contrasted against the larger trees gathered around in the background. The total effect is of a sort of natural sculpture.

In both these drawings, the rows of clipped bushes give a good effect of perspective and make the space look larger than it is.

We go from the immense still-life arrangements of the first two examples to a garden that looks like a mini-wilderness. The view I have chosen gives the impression of a wooded glade that somehow has managed to have a bridge built in it. The garden has been carefully designed to look both natural and attractive, with the Japanese moon-bridge creating a stylish reflection in the lake.

INDUSTRIAL MONUMENTS

The need for transport has resulted in the building of quite interesting artefacts. Although there to serve a purpose and not be design features in themselves, we are fortunate that some of them are pleasing to look at. The two examples I have chosen are from different ages and reflect their time in terms of the materials and aesthetic perceptions they embody.

The suspension bridge at Clifton by the famous British engineer of the Victorian age, Isambard Kingdom Brunel. The two solidly constructed brick towers supporting the cables holding up the bridge give the structure a sort of Egyptian style. The beautiful curve of the suspending cable and the vertical cables joining it to the bridge itself produce a fascinatingly monumental and geometrical effect; an aspect which I found very interesting to draw. Generally to get a good view of such a vast structure you have to move around until you get its best angle. A bridge such as this, however, is a gift to an artist, and is so impressively designed that you can get a good view from many different angles.

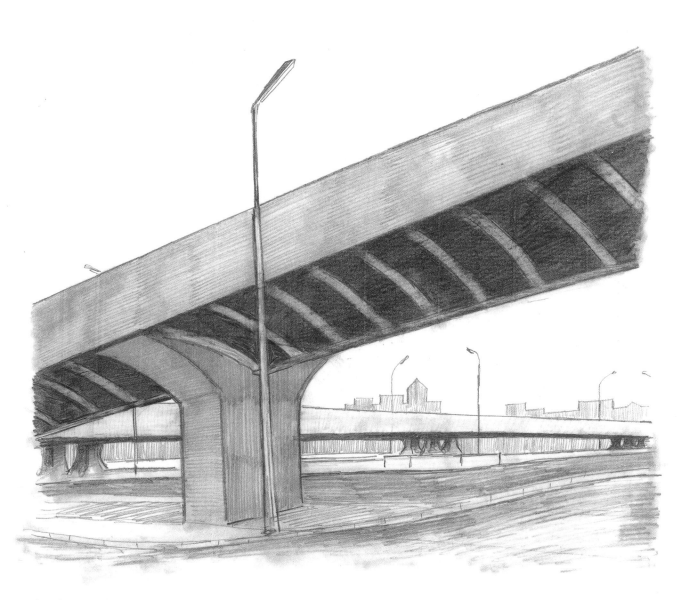

This late industrial age flyover has none of the subtleties of Brunel's great work and is not usually seen as the sort of structure that a landscape artist would want to include in his work. This is to miss the point. For those of you interested in cityscapes, the inclusion of structures of such raw, unvarnished power can bring a very interesting edge to depictions of the urban environment. The strong thrust of concrete against the verticals of modern buildings, for example, can be particularly effective. The next time you pass a flyover, consider how this monument to modern travel might be used to advantage in a drawing.

INDUSTRIAL MONUMENTS

Places such as factories and power stations, while not built for their aesthetic values, are nevertheless very powerful statements of architecture. The very functionalism of such buildings usually gives them interesting shapes. The best examples don't look like any other buildings in history and stand as unique structures. They represent a rewarding challenge for artists interested in portraying the urban landscape.

The rather Victorian looking chimneys and brick built walls of Chelsea power station make the building seem like a leftover from the Industrial Revolution. Set as it is on the edge of the River Thames, it stands out as a landmark among the rest of the buildings in this area. Its brickwork looks very dark against the other buildings around it and the plumes of smoke belching from its two chimneys are very unusual in London today.

This special gas-tank is also now a rather obsolete piece of engineering, although I find its shape and size particularly interesting. Almost futuristic in appearance, it would not look out of place on the set of a science fiction film. It looks good from almost any angle and both close-up or from further away gives a very satisfying shape to the usual urban environment.

Now derelict, Battersea power station once supplied electricity to a large area of London. The vast towers of chimneys on their enormous plinths look very much like special columns for some strong religion. Because of its immense size the building can be seen from many angles and allows many views in which it features as a striking urban focus. Because of its size it is difficult to see the whole structure except from a distance. For my drawing I deliberately chose to leave out some of the structure and get a close-in view in order to intensify the monumental effect.

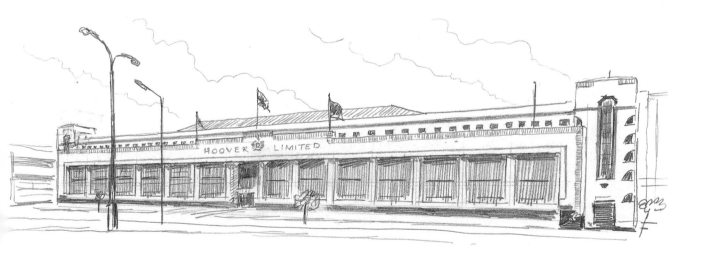

This building was a temple to commerce when it was first built and now is listed as a masterpiece of Art Deco industrial design. The pseudo-Egyptian appearance of the factory makes it look like a place of worship rather than a site dedicated to the production of vacuum cleaners.

Imaginary and
Symbolic Landscapes

NOT ALL LANDSCAPES PRETEND TO BE REAL in the sense of being a portrayal of an observed incidental scene. Imaginary landscapes, for example, are an attempt to \produce something that is real in a philosophic sense. Sometimes they are skilfully blended so as to resemble a scene that we might recognize, but sometimes not even this attempt is made.

The intentions of the artist are often worked into a scheme that demands certain ways of showing the natural world in order

to teach a doctrine or lesson about life, religion or the next world. Most pictures of the Garden of Eden or Paradise are of this nature. Although they can be very naturalistic in theme, the landscape doesn't resemble any particular place, but is a representation of an ideal super-natural environment. At the beginning of the Renaissance period, there were many artists producing religious paintings for churches and chapels who took this ideal state of nature as a basis for their depictions of events in the Bible.

Many cultures have been quite clear that the landscapes they produce are not of the world as it appears, but as it ought to be, or is in its true perfection. Many Oriental artists have created pictures of landscapes not one of which would you actually come across in life. These artists are trying to capture the essence or spirit of the landscape, and consider this to be much more important than producing a mere facsimile of some part of the world. This is not to say they don't use natural forms – they do, but carefully re-arranged to show the underlying qualities of the landscape at its most perfect, and to convey something of their philosophy of life.

Some artists don't even use naturalism for the main part of their picture. They rely instead on carefully designed shapes and symbols to produce an almost totally artificial landscape, even inventing new plant-like structures to give a feeling of naturalism but as if in a dream.

So, a landscape may be real, super-real or even surreal in its effect. Let's now have a look at a range of good examples of this exciting and stimulating area of landscapes.

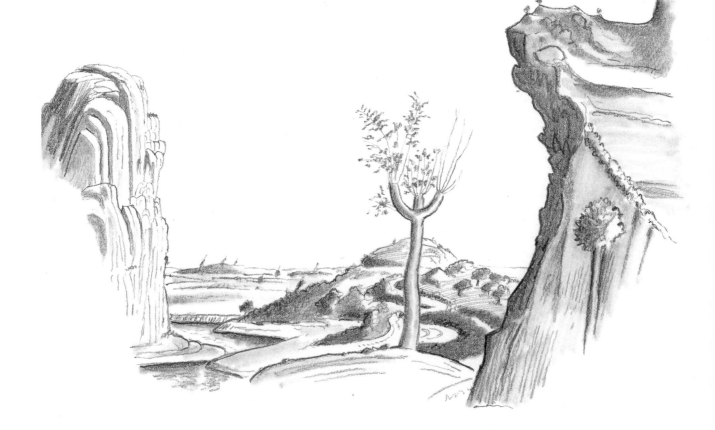

BACKGROUND TO ADORATION OF THE
SHEPHERDS – AFTER MANTEGNA

The rocky backdrop is a typical Italianate landscape often found in pictures of the birth of Christ. The implication is that the birth of a saviour will bring back to life the barren, parched land. The passion of his death is foreshadowed in the cross-like tree set at the foot of the hill. The water of the river at the base of the rock indicates the water of life and also baptism. The two stony crags either side of the open space give an effect of the Old World being set apart by the new.

The landscape is based on natural forms, although these are fairly exaggerated. Even the tree is unusual in shape so there is no danger of its not being read as a metaphor. Nature is brought into use in order to give a natural effect, but this is certainly an imagined, designed landscape.

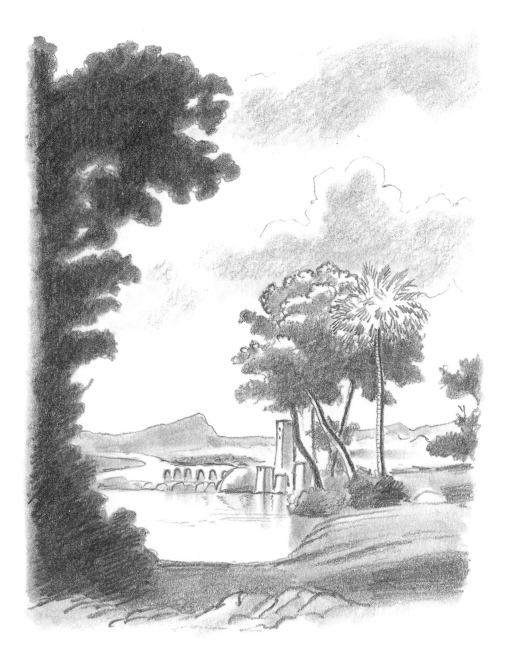

MOSES SAVED FROM THE BULRUSHES – AFTER CLAUDE LORRAIN

Coming one hundred years after Mantegna's landscape, Claude Lorrain's seems to be a view of a real place, the trees and buildings intended to add to our conviction that what we are looking at exists somewhere, perhaps around Rome. However, we are meant to believe this is the River Nile and that the future prophet Moses is being discovered in bulrushes along its banks; I have left out of the foreground the group of figures making this discovery. Apart from the palm tree set by the bank the trees are of a European cast. In the distance is a distinctly Italianate bridge or viaduct. To modern eyes Egypt is largely conspicuous by its absence. In Lorrain's time, however, this would not have mattered, and tourists were so rare two hundred years ago that most people would not have known any difference. The landscape is secondary to the story, which contemporary viewers would have 'read' through the artist's use of symbolism.

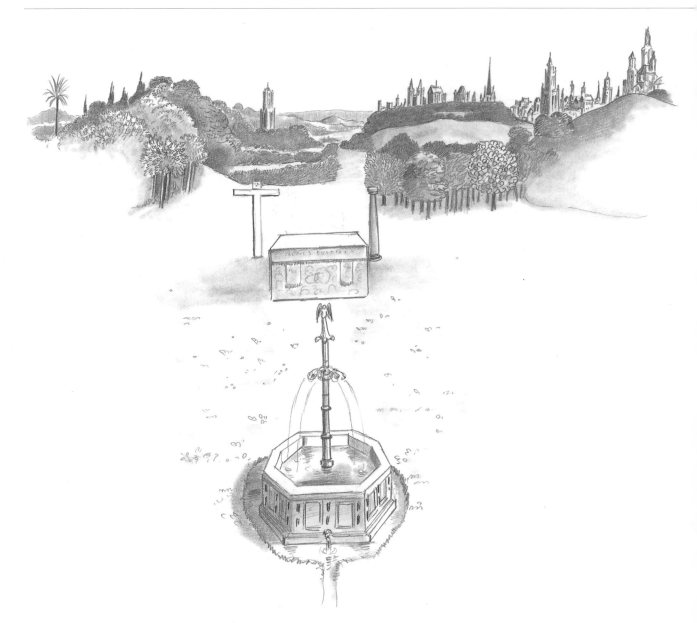

*THE GHENT ALTARPIECE (CENTRAL PANEL) –
AFTER H. & J. VAN EYCK*

In the original there is an open garden-like landscape, comprising soft lawns, flowers, trees and bushes, which provides a backdrop to the main business of the painting – a coming together in Heaven of saints, angels and doctors of the church to worship God in the form of a lamb. In our copy, I have left out all the people and the central figure, and indeed the Holy Trinity shining their light from the sky onto the scene, because I want you to consider the landscape alone.

Bang in the centre is the high altar with a crucifix and a pillar either side, symbolizing Christ's martyrdom. In the front of the scene is an ornate fountain spurting water into an octagonal basin to symbolize

the water of life. In the background, beyond the carefully trained and neatly trimmed trees and shrubs, we glimpse some impressive Gothic and Romanesque buildings. It is as though the full panoply of the medieval Church is peeping over the nearer hills so that we do not forget its association with the great ceremony going on in heaven. The inference, which would have been widely understood at the time, is that only the best aspects of the world are worthy of being with the presence of the Saints and God. This naturalistic world is marked by simplicity and restraint, with only the most desirable buildings and vegetation included in the picture. No accidental or badly designed areas are allowed in Paradise.

174

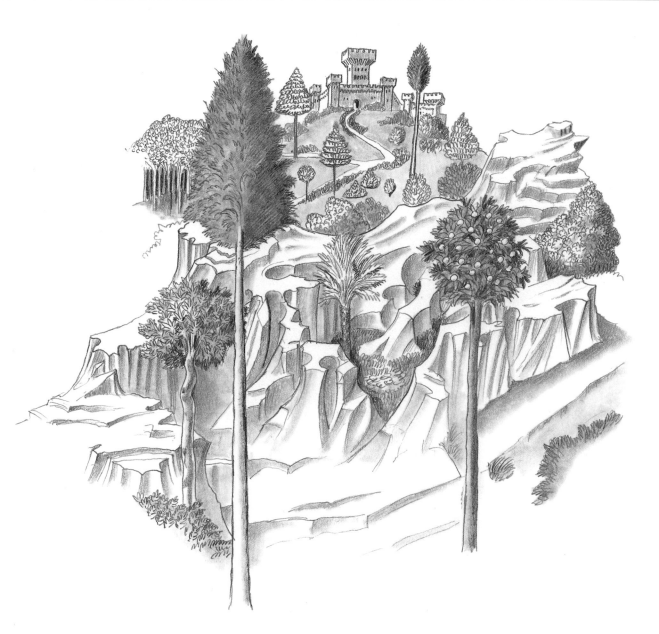

PART OF THE PROCESSION OF THE MAGI FRESCOES – AFTER BENOZZO GOZZOLI

Gozzoli's Procession of the Magi fresco cycle was painted for the chapel of the Medici family's town house in Florence. In this copy I have again left out people and animals to concentrate on the landscape, which is not by any means a natural view of the countryside around Florence. To begin with there are no rocky outcrops like this in the area – in fact, not in any area, because Gozzoli has used a medieval convention and envisaged the landscape by draping cloth over scaffolding or boxes. He could easily have painted realistic rocks, but the convention of using traditional forms so his public would not be disturbed by innovation outweighed the Renaissance desire to study nature. He has, however, put in plants found in the area, although idealized to an extreme. Some of the details are familiar – the castle in the background representing Jerusalem, for example, resembles the Medici Villa at Caffaggiolo – but overall the impression is of a formalized and carefully tidied-up landscape to suit the artistic design of the fresco cycle. Even the perspective is reduced, purposely so; Gozzoli would have been aware of the principles taught by Brunelleschi. Everything is secondary to the telling of the story.

175

THE GARDEN OF EARTHLY DELIGHTS –
AFTER HIERONYMOUS BOSCH
Painted at the time of the Renaissance, Bosch's original is an extraordinarily artificial construct, although it does include some natural features. As in the examples by the Van Eycks and Gozzoli, the trees and bushes are tidily clipped and controlled, the grass lawns are smooth and the few rock features are so obviously constructed that no-one could think them naturalistic. The water features are neatly dug ponds in someone's estate. But what are the other artefacts? There are extraordinary edifices spiking upwards across the horizon, and strange global devices scattered around the lawns and floating in the ponds. Some of them look like vast jungle plants of doubtful ancestry. But none of it seems real, and indeed the viewer is not expected to believe that it is in the normal sense. In the original the whole scene is teeming with people engaging in what appear to be either odd or dubious activities. Although everyone seems to be enjoying themselves, we viewers are left feeling uncomfortable. In his many didactic pictures, Bosch tried to warn of the dangers of putting the pursuit of pleasure above the pursuit of goodness. Everything in this garden looks pretty and pleasant on the surface. But note the sinister quality of those plant-like edifices, which look as though they might be capable of delivering a mighty lesson on the instigation of some higher authority.

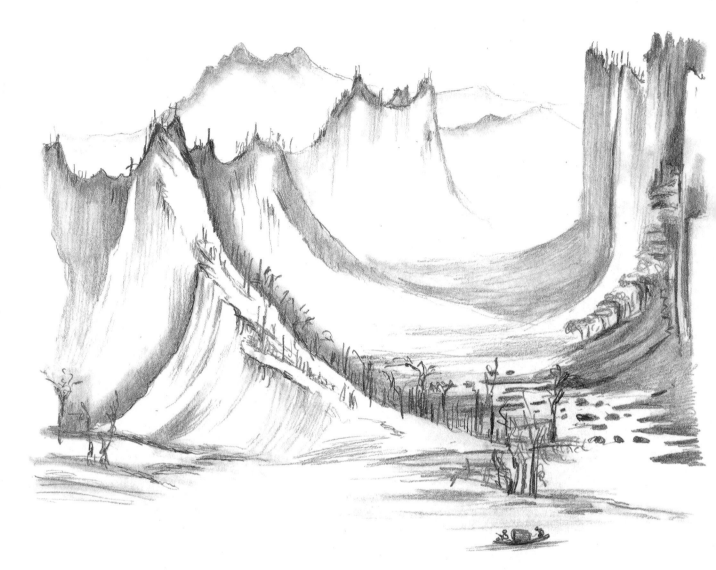

FISHING IN A MOUNTAIN STREAM –
AFTER HSU TAO-NING

This is the earliest example of an imagined landscape included in our selection (about 11th century). The style is markedly different and the technique astonishingly advanced for the period. No artist in Europe would have been expert enough to give an impression of receding space with anything like this effect. The size and spaciousness of the landscape *with its vast perpendicular mountains and gaping gorge is almost breathtaking. The notable characteristic this landscape shares with the other examples is that it too is a depiction of perfection, with the artist shaping the various heights according to his design and editing out anything that upsets the unworldly harmony and beauty of the scene.*

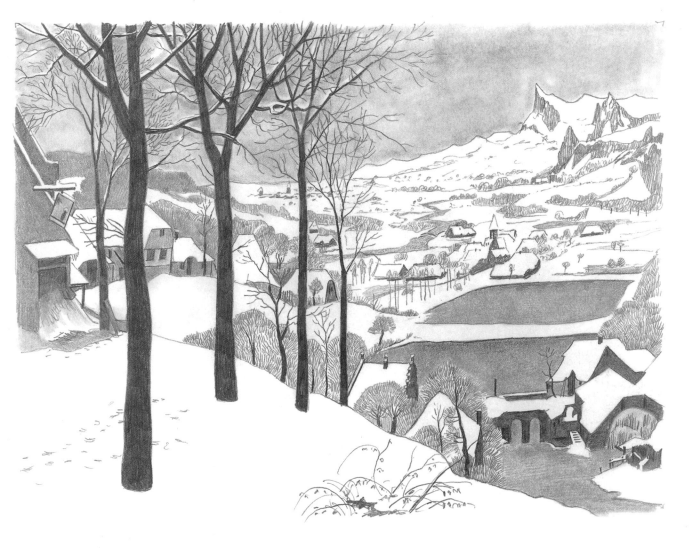

HUNTERS IN THE SNOW –
AFTER BRUEGHEL

Once again, I have left out the figures; in the original there are hunters in the foreground and myriad people active across the middleground. The landscape at least looks natural and you would be unlikely to think Brueghel was depicting an idealized scene. There are, however, a few pointers to indicate

that this too is a constructed scene. Look at the alpine mountains in the background. They are cleverly done but not quite like any mountains you would see in the real world, especially being so closely tucked in against the rather flat Flemish landscape.

THE BOW-MOON – AFTER HIROSHIGE

The Japanese landscape painter Hiroshige took his forms from nature but was more interested in the spirit or essence of his scenes as works of art. He didn't want to produce simple facsimiles of what he saw. He looked for the key points and balance in elements of his choosing and then carefully designed the landscape to influence our view. Only the most important shapes and how they related to each other were shown. Usually their position and place was adjusted to imbue the picture with the most effective aesthetic quality. The landscape was really only a starting point for the artist, whose understanding, perception and skill were used both to bring the picture to life and to strike the right vibration in the onlooker. The experience was not left to accident.

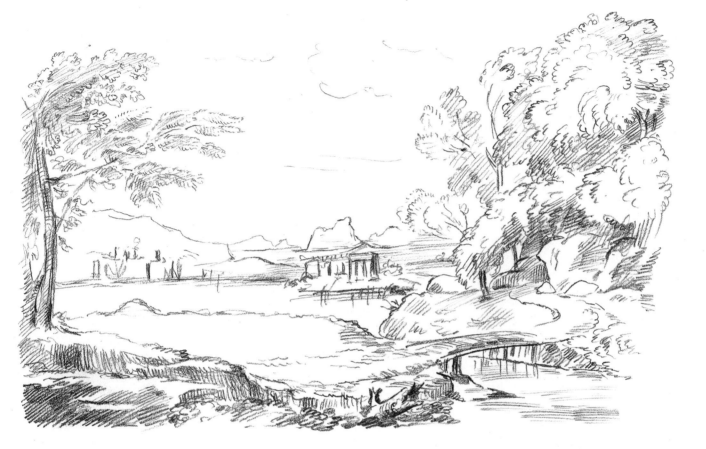

PASTORAL LANDSCAPE –
AFTER CLAUDE LORRAIN

As in the Brueghel on the preceding spread, this landscape looks entirely natural at first glance; there are not even odd-shaped mountains to give the game away. Everything looks just as a part of the Roman campagna might have looked at this time. But Claude Lorrain hardly ever just produced a simple study picture, and certainly not on this scale; his direct studies were invariably of small details of landscape. The title reflects absolutely the content of the picture. The great French artist was renowned for beautiful scenes of unspoiled countryside, with some Roman remains, magnificent trees, water and a focal point (such as the bridge included here). No doubt every part of this picture is based in reality, but not in this particular arrangement. Claude would not have wanted to disappoint his aristocratic public by leaving anything to chance. On the other hand he would not have been satisfied if any aspect of a landscape of his had looked less than totally natural.

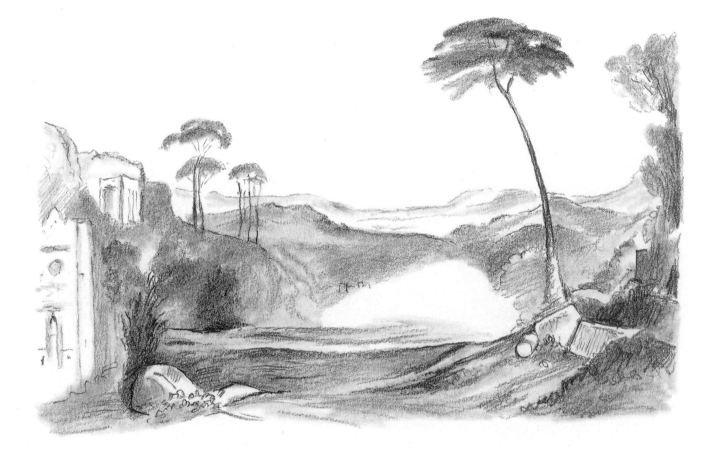

THE GOLDEN BOUGH – AFTER TURNER

I have deliberately left out all the figures to enable us to consider Turner's skill. Notice the sweeping space of the foreground and the beautifully placed pictorial trees. See how the far horizon also repeats this open, empty central area with hills buttressing the sides. The architecture is in a mix of styles – some Classical, some Gothic, as would be appropriate for the landscape around Rome in the days of the poet Virgil who tells the story of the mythical golden bough in his epic, the Aeneid. The scene is naturalistic enough, but entirely imagined, the atmospheric quality more like that of Britain than the Italian peninsula. However, Turner's topographical skill allied to his brilliant imagination helps convince us that this must be how the landscape was when the incident happened.

THE BIRTH OF THE WORLD –
AFTER IVAN RABUZIN

This extraordinary image, of a world made up solely of trees, carefully graded and lined up neatly, is a typical effort of a naïve painter producing a pre-history or mythological subject. Great care has gone into each tree, obsessively repeated over and over again, with the clouds repeating the image in the sky.

Nothing looks as though it just happened; only a very careful gardener would produce an effect like this. Of course this landscape is not meant to be mistaken for reality. Its very formality contributes to its strength, making you aware that the whole scene is designed for a purpose.

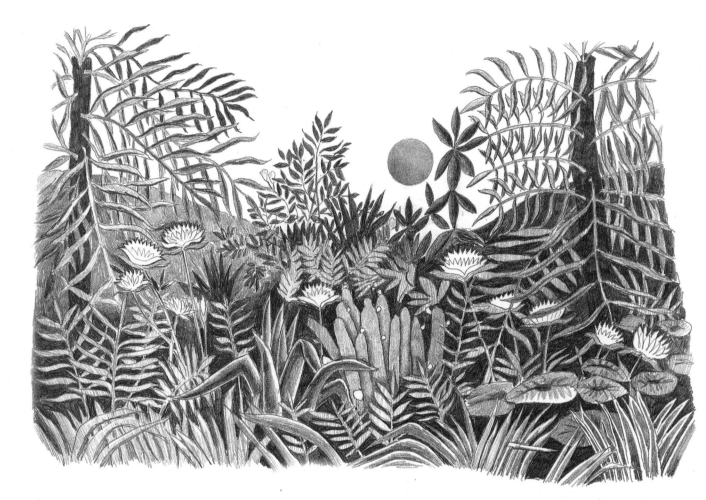

VIRGIN FOREST AT SUNSET –
AFTER ROUSSEAU

There is no disguising this is an imaginary scene. The lush vegetation conveys the feel of the jungle, although the plants themselves look very much as though they have been copied from the engravings that were current at this time in geographical books and magazines. The artist probably also supplemented his knowledge by visits to the botanical gardens in Paris. In the original, figures and animals are set within the carefully composed disorder of luxuriant plants; left out in this version. Although obviously the view of an urban dweller and naïve in style, the overall effect is very impressive.

TOWER OF BABEL –
AFTER PIETER BRUEGHEL

This is a marvellous piece of imaginative architecture-dominated landscape. The great mass of the tower with its multiplicity of structures rises out of a plain, although apparently constructed on a rocky outcrop.

The amazing completeness of the architectural concept and the landscape laid out behind it, with a port and sea or lake to one side, is a brilliant evocation of the Biblical story.

185

PERSISTENCE OF MEMORY – AFTER DALI

The Surrealists were very keen on producing symbolic landscapes, although sometimes no one was quite sure what the symbols meant. Dali produced several pictures that look straightforward enough on the surface but turned out to contain layers of meaning. This distinctly odd example still bears a relation to the other landscapes we have seen in that space and distance are distinguishable.

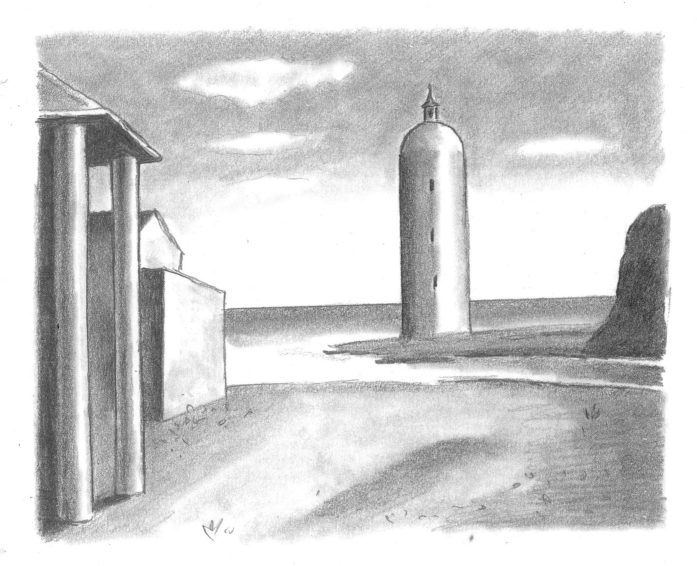

THE LIGHTHOUSE – AFTER CARRA

Carra's landscape looks almost natural except for the strange quality shared by the buildings, which are highly simplified. This is the world of images in the mind, the mental image being considered nearer reality than the physical appearance that we usually consider to be real. Having said that, where does the image of a landscape we look at appear but in our minds? How do we know what is 'out there', except by the evidence of our own senses? Whether the mental image we receive is any less real than the apparent dimensional outer world is not easy to decide.

IMAGINARY LANDSCAPES: PRACTICE

Now that you have studied a wide range of imaginary landscapes, it is time to consider trying it yourself. As with any type of landscape, you begin by deciding what to include. By this time you should have built up quite a stock of studies of details and features you have come across on sketching expeditions Look through them and select details you think might work well together.

Shown below are several features that you would typically find in a landscape. Obviously you will want to concentrate on producing a picture in your own style and including features you are familiar with, but don't be shy of using other methods and indeed scenes by other artists to help you. Artists have done this down the ages to hone their skills. You will of course have to adapt any 'borrowings' to your own design, but that is not too difficult. If you want to experiment at the extremes of imaginary landscapes, look at the work of the Surrealists and artists like Bosch for inspiration.

Rocks in the Chinese style

Trees after Lorrain

Water after Vermeer

Clouds after Bellini

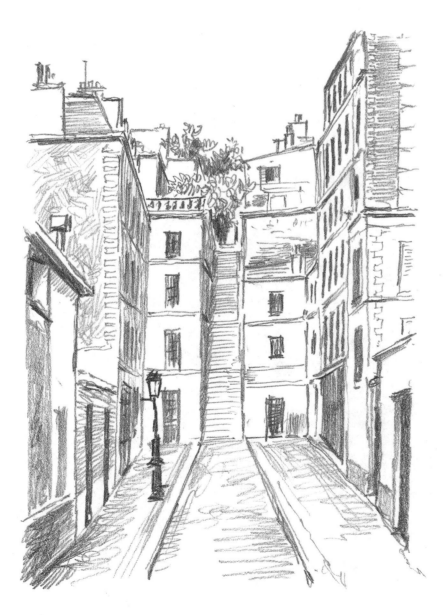

Buildings after Utrillo

Creating a Landscape

T HE FINAL PROOF OF THE PUDDING, as they say, is in the eating, and so I would now like you to plan out a landscape of your own, using the model provided here as guidance. You might also like to refer back to the First Steps section at the beginning of the book.

Sometimes you will go out and just happen on a view that you want to draw. This sort of happy accident is often the basis of the way we choose our landscape pictures. But often it is not good enough just to pick any view from wherever you happen

to be. This exercise is a planned event and must be organized accordingly. It doesn't matter if this is your first attempt. Whatever your level of expertise, there is a right way and a wrong way of approaching a landscape. The right way is effective and produces a good result. The wrong way wastes your time and may put you off altogether. I am going to show you a useful way, which will stand you in good stead for all future landscape endeavours.

Go to an area convenient to you, where you think you have a good chance of finding attractive views. Take a couple of sketchbooks (A3 or A4) and then move around the area, assessing the merits of various places that look interesting. The drawings and sketches you do at this stage are part of the preliminary work every artist undertakes in preparation for a final drawing. They will help you to decide which view or composite views you are going to attempt. Then you can make out a drawing incorporating all the features and details you expect to include in your drawing. At this stage another visit to your chosen area might be in order so that you can draw up your selected highlights in more detail and check your final viewpoint. On another occasion you will need to draw up a full-size outline sketch of the whole picture, then incorporating all the information you have decided to include, you can embark upon your finished piece of work.

Accept that the whole exercise may take several days of your time. As long as you are methodical and keep track of your progress, this time can be spaced out over several weeks. Don't hurry any aspect of the process or the end result will suffer. Let's start the exercise.

Start and Finish

LOOKING FOR THE VIEW

First choose an area that you would like to draw. Most people prefer to draw a country scene, but if that is not very convenient maybe there is a large park or country house with extensive grounds near where you live.

The countryside nearest my home is Richmond Park, which has within its boundaries magnificent woods, hills, a stream and ponds. I knew I would find good views across the landscape, this being the highest point of the land in the area. I decided at the outset to ignore the park's decorative lodges because they might complicate matters and would certainly take longer to draw.

As you can see from the plan of my route, I undertook quite a hike to assess the various viewpoints. It was a lovely summer day, just right for drawing in the open. Part of the fun of this type of exercise is searching for scenes and details that spark your interest.

All the views and details referred to in the following pages are included in the key below. You will need to draw up a similar map to ensure that you have a record of what you have done when you return to the scene later. Don't think you can rely on memory alone, you can't and if you try you will only succeed in ruining what is an immensely enjoyable and rewarding experience.

Key to Viewing Points and Features

VP1	View across parkland
VP1A	Detail of ferns
VP2A	View to left across park from hilltop
VP2B	View to half left across park
VP2C	View to centre across park
VP2D	View to centre right across park
VP2E	View to right across park
VP3	Shattered oak tree
VP4	Large chestnut tree near café where I stopped for lunch
VP5	Large log
VP6	View of ponds in distance from hill
VP7	View of ponds from lower down

SETTING OUT

As you can see from my map-diagram, I started from the gates of the park and walked slowly up the hill, looking back occasionally to see what the view was like. About halfway up the hill I thought the view looked quite interesting and so I sat down and sketched the main parts

FROM POSITION 1

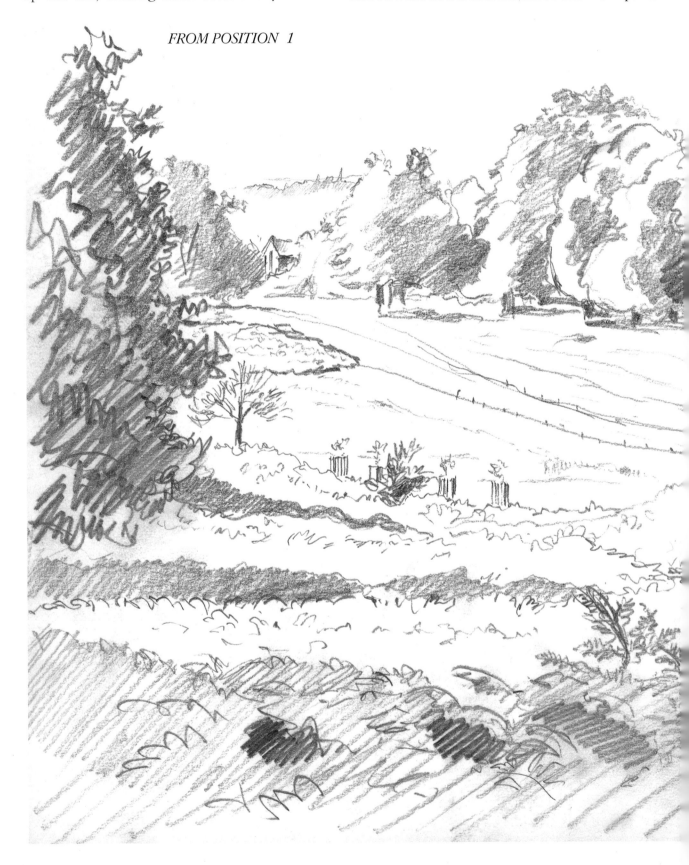

very simply (1). Much of the drawing is very minimal, like a sort of shorthand. This is because I am just looking for possibilities. The purpose is not to produce a finished picture. Some ferns caught my eye and I drew them as a possible detail to provide local colour (1a).

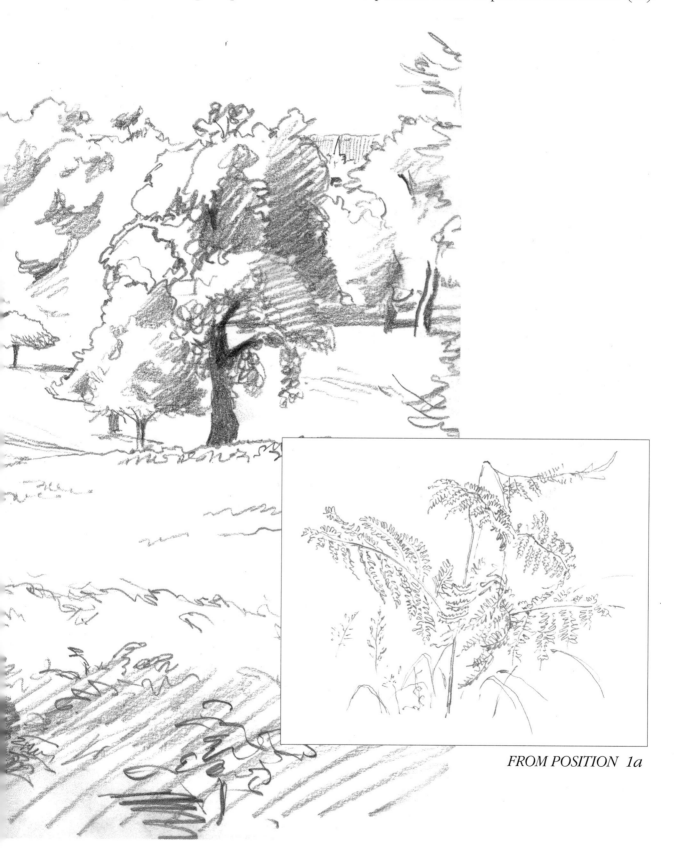

FROM POSITION 1a

VIEW FROM THE TOP

When I reached the top of the hill there was a natural viewing platform offering an enormous sweep of panoramic proportions, more than could possibly be put in one picture. However, I didn't want to miss anything and so I made a series of sketches (2a, b, c, d, e), showing the layout of the whole view in extremely simple outline forms. Arranged edge to edge with some overlaps these drawings presented me with a whole range of views for later consideration.

When you come to do this exercise, include written notes on your sketches to remind yourself of specific subtleties that you would need to include in a proper drawing. In these examples, the trees are put in as blobs of shape with only a rough indication of the darks and lights. Buildings in the distance are rendered as mere blocks to show their size and prominence. I would make detailed notes about the tonal values evident in all these features, including the various trees.

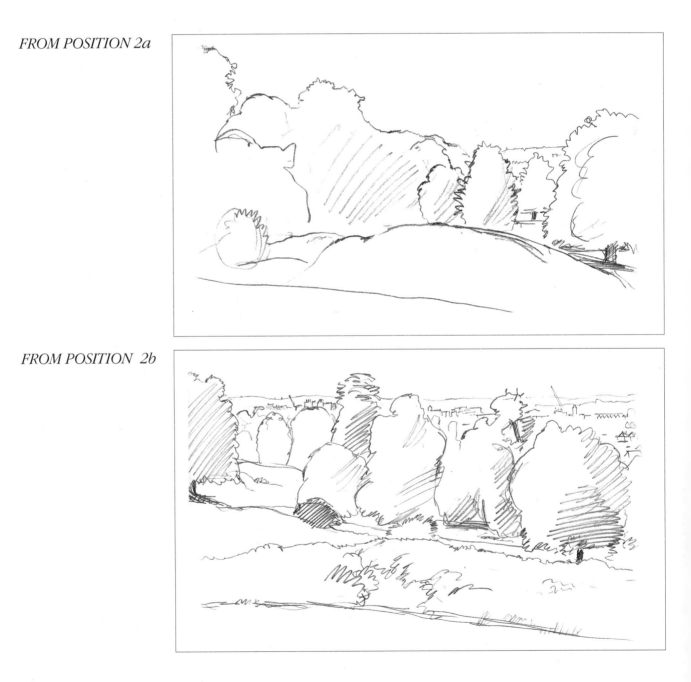

FROM POSITION 2a

FROM POSITION 2b

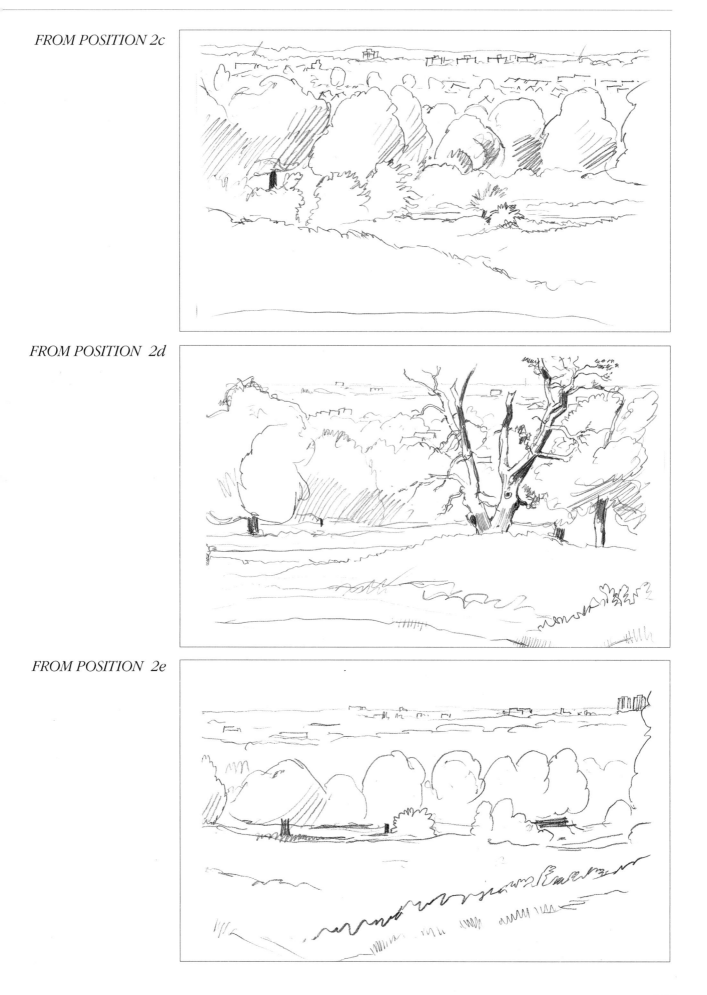

FROM POSITION 2c

FROM POSITION 2d

FROM POSITION 2e

AN EYE FOR DETAIL

In any landscape you need to pay attention to details that might be included in the foreground. In the plantation area of the park I came across a superb blasted oak, mostly dead, its angular branches stabbing up into the sky. As you can see it makes a good focal point, but would you place it centrally in your picture or to the right or left side? Compositional and structural aspects will strike you even at this stage when your main aim is to decide where to draw from.

By this time I was hot and hungry. I went across to the cafe in the park which has a very good view from its windows. Fortified by a

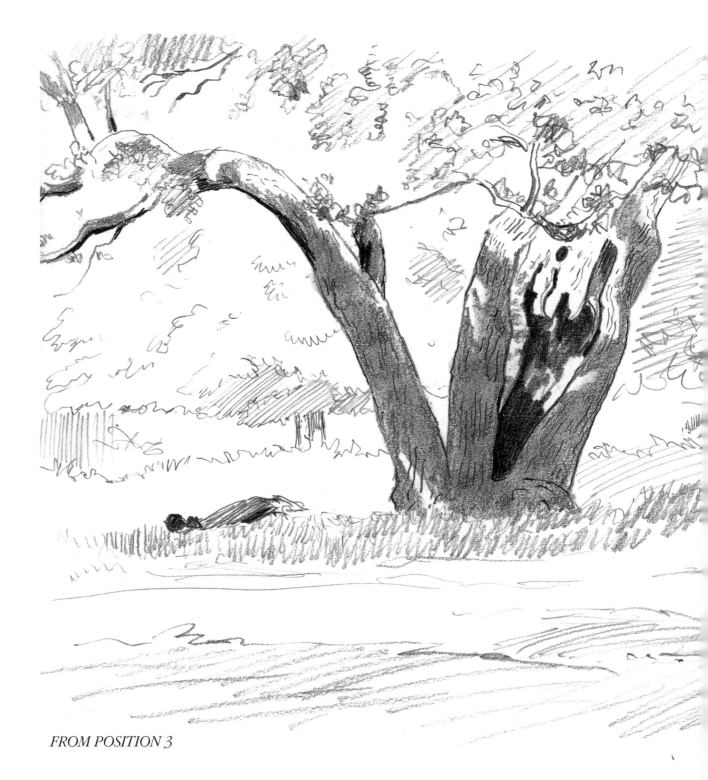

FROM POSITION 3

tasty lunch and cold drink, I returned to my task.

As I walked through the gardens surrounding the café, a superb group of chestnut trees set up on a mount presented themselves. I couldn't resist doing another tree portrait (4). This sort of close-up is useful in a composition that includes a long distance view because it helps to give an appearance of space. This time I produced a more finished sketch. Drawings of groups of trees are always useful and the more information I have about them the greater is the likelihood of including them in one of my landscapes.

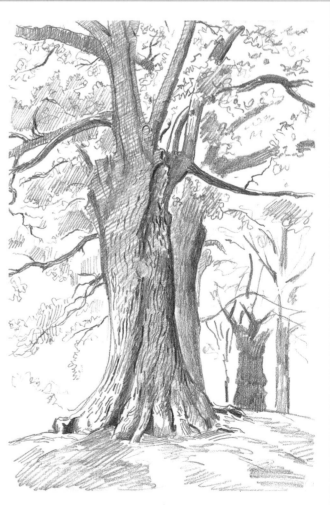

FROM POSITION 4

NEAR AND FAR

Not far from the café was a wood set atop another hill. Woods are often great providers of interesting foreground details, and so in I went. After a few minutes of wandering around, I noticed an enormous log that had obviously lain there for at least a year (5). Stripped of bark it had weathered to a beautiful silvery grey. On the cut end you could see the rings of growth and saw marks. I made a fast but quite detailed drawing before continuing on my way.

As I rounded the wood I could see from the top of the hill a great sweep of countryside framed between two large plantations of trees. In the middle distance was the gleam of two large ponds, which added extra interest to the view. Paths led from my position down the hill towards the ponds, between which ran a sort of causeway. In a quick, simple sketch I put in the main shapes and gave some idea of the sweep (6).

Curious to see what the ponds looked like from closer up, I descended the hill to a point where the path to the causeway and the water of the right-hand pond were much more obvious. The view from here looked rather good, and so I quickly made a sketch of it (7). Now that I had a long view and a nearer view, I had the information necessary to include more detail of the distant parts of the view, if I wanted to. The more viewpoints you have of a scene the greater are your options.

By this time I was fairly hot, my feet ached and my bag with my sketchbooks, pencils pens, sharpener and rubbers was beginning to feel heavy. Keeping to the shady parts of the park, I slowly made my way home. So that is the first stage of the exercise. Allow yourself a day, even if you draw only for half that time, because you never know what you are going to come across.

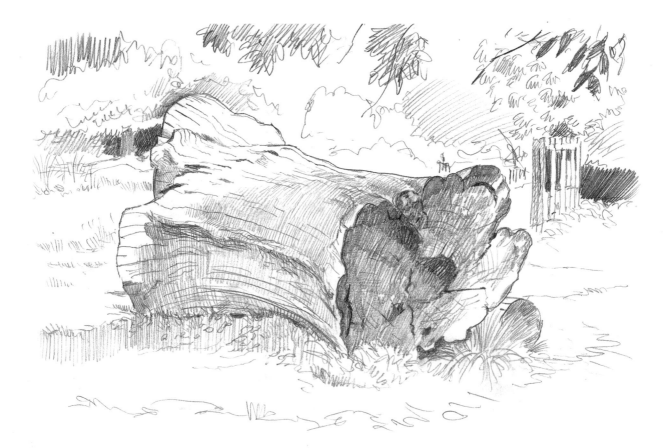

FROM POSITION 5

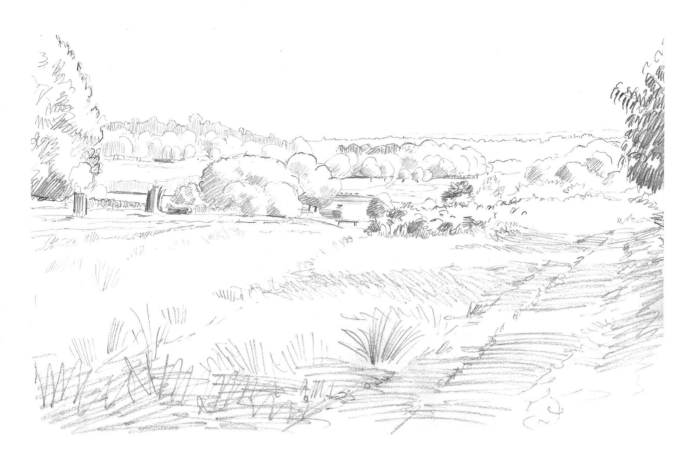

FROM POSITION 6

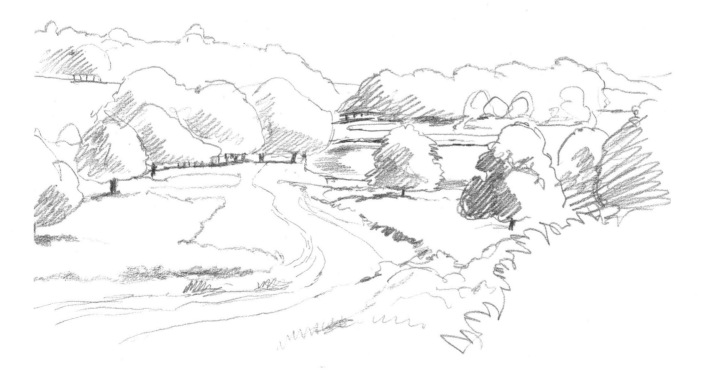

FROM POSITION 7

DECISION TIME

Now comes the decision making, which will be based on your sketches and memory. If you are planning a complicated landscape, you might want to consider taking photographs as well as sketches.

Looking at all my sketches I decided to opt for two particular views, but including one of the large trees or the log somewhere in the foreground.

I quite liked the look of the two centre views (2b and 2c) from the panorama plus the river to the left. I considered shortening the view slightly, keeping the left-hand edge as a finial point and placing the central area with the blasted oak towards the right-hand edge of the picture. Then I thought it would be an effective touch to introduce something nearer to the foreground – here is where one of my

CREATED FROM 2a, 2c, 2d and 5

large trees or the large log would come in handy (5).

Now for my second option, I considered the long view of the ponds first. The trees on either side gave it a good frame, but it needed something else to give it interest. I decided to extend the central area with details taken from the closer view. But what about the foreground, should I add anything there? I thought not, to avoid the picture looking crowded.

Which of these two possibilities did I go for? Or perhaps I decided to do both of them. In the end I opted for the part-panoramic view. The next stage was to draw up a diagram of how I thought this view might work.

THE OUTLINE DRAWING

The penultimate stage is to produce an outline drawing of the whole scene as you intend to produce it, full size. You need to include in it all the details that are to go in your final picture. These can be taken from your sketches, but only if you have all the information you need. If you find yourself lacking in information, you will have to go back to your location, only this time taking your original sketches with you and the diagrammatic drawing.

THE FINISHED DRAWING

Now comes the final effort. This must not be hurried, and if it takes longer than one day, so be it. Recently I completed a picture of the interior of a studio I work in, just for practice, and it took me two full days. I used pencils of various grades, a stick of charcoal for soft shadows, and a stump to smudge some of the mark-making to keep it subtle. The second day was taken up with doing a colour sketch in oils. Never allow time to be a problem.

Everything at this stage depends on your artistic development and your attitude. A large

part of the resulting judgement of you as an artist will be based on how well you can produce finished drawings. Although talent can bring that extra special touch to a work, a great deal can be accomplished with persistence and endeavour. Indeed, talent without these other two qualities will not go far. It is only through hard work and a willingness to learn from our mistakes and the example of others that any of us improves.

INDEX